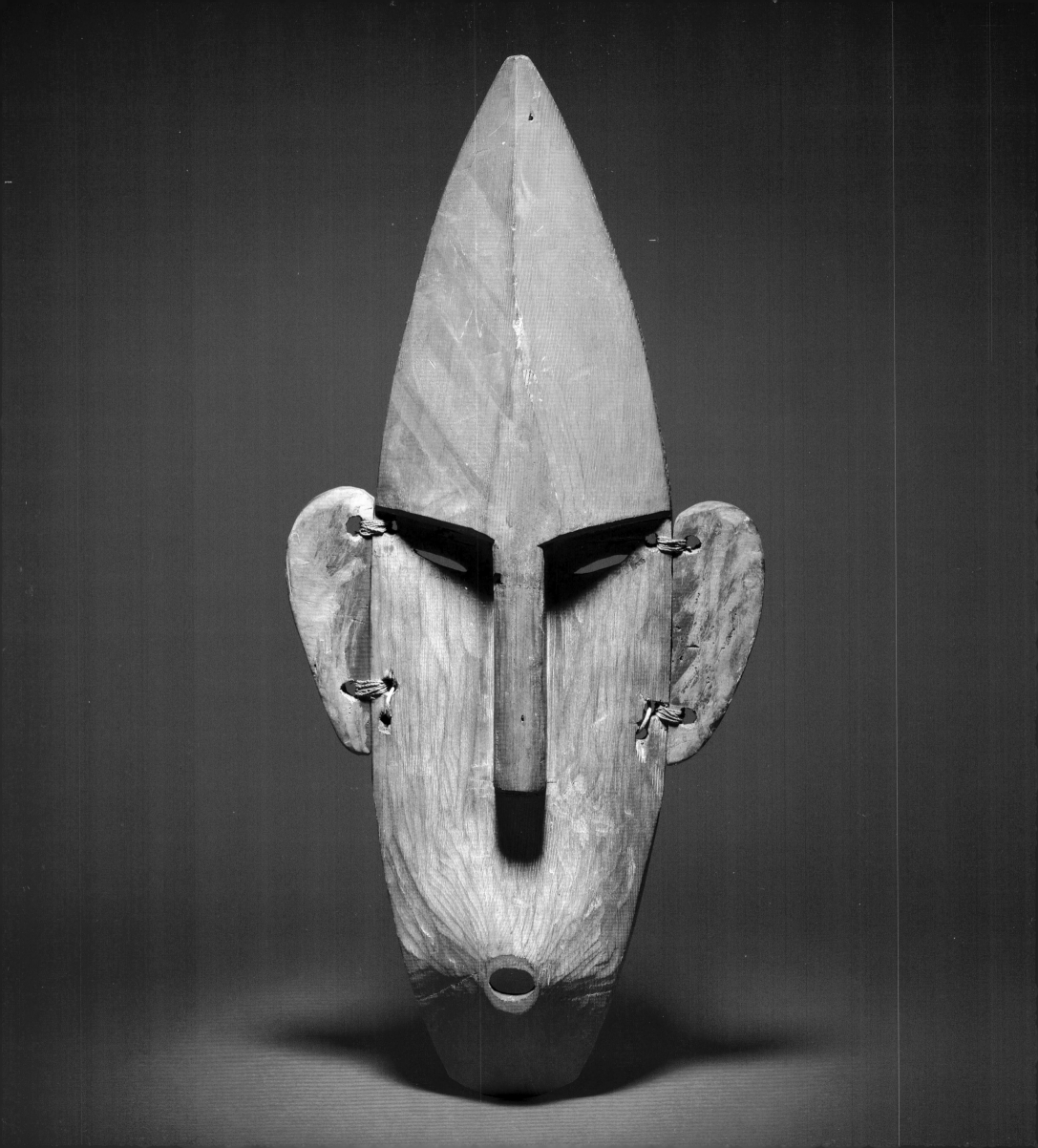

Art of Grace and Passion

ANTIQUE

AMERICAN INDIAN ART

George Everett Shaw

With a Commentary by

Klaus Kertess

ASPEN ART MUSEUM

COPYRIGHT © 1999 ASPEN ART MUSEUM

LIBRARY OF CONGRESS CATALOG CARD NUMBER: 99-66206

ISBN 0-934324-27-1

PHOTOGRAPHS BY DAVID O. MARLOW

DESIGNED BY ELEANOR CAPONIGRO AND

PRINTED IN ITALY BY THE STAMPERIA VALDONEGA FOR THE

ASPEN ART MUSEUM

590 NORTH MILL STREET, ASPEN, COLORADO 81611

DISTRIBUTED BY

THE UNIVERSITY OF WASHINGTON PRESS

POST OFFICE BOX 50096

SEATTLE, WASHINGTON 98145

Director's Note

IT HAS BEEN such a pleasure to be able to write one last catalog introduction before I end my tenure at the helm of the Aspen Art Museum – and a pleasure that it happens to be for this book.

George Shaw has been a longtime friend of mine and of the Museum. His curatorial talents, along with his enthusiasm and generosity, have greatly enhanced our exhibitions. Besides curating a wonderful exhibition of American modernist paintings, he has cocurated excellent exhibitions of pre-Columbian and American Indian material. This exhibition is our most ambitious to date, and George deserves the highest praise for its success.

It began when I suggested a small exhibition of Mimbres pots. George was diplomatic in his response, but soon had me firmly in the grip of his excitement about a much larger exhibition, encompassing a wide spectrum of American Indian material. Before I knew it, we at the Museum were quite enthused about the scope of the show and the prospect of producing a major publication. Once again, Mr. Shaw had set his sights higher than any of ours.

This book is also the result of his vision and of his superior fundraising efforts. We cannot thank him enough for all he has done to make it a reality. George and his wife, Teena, provided the initial gift, with their son, Hunter, participating as well.

Our sincere thanks for their generosity go to the donors to the exhibition and book as well as to the lenders of the beautiful objects. We were also lucky to have the services of a great design team, again thanks to George's concept of the project.

It has been a bittersweet task for me to write this, as I will no longer be the director of the Aspen Art Museum when the exhibition opens, but I have no doubts that it will be a great success.

Suzanne Farver
Executive Director, 1992–1999

Acknowledgments

WITH HEARTFELT THANKS, I reflect on the many people who made this book and exhibition possible.

At the top of the list are the numerous collectors who loaned objects to the exhibition and the generous donors who funded this book. I want to express my gratitude to them all. This project would not have been accomplished without them.

This project came about because of the enthusiastic response I received from Suzanne Farver, former director of the Aspen Art Museum. As well as the time and sound advice she offered, her confidence in allowing me curatorial autonomy facilitated the project greatly.

As usual, the entire Museum staff was there to help. After working with them on three previous curatorial assignments, it was reassuring to know just how competent their efforts, and the results of those efforts, could be. Without Mary Ann Igna, Dana Geraghty, Meggan Humphrey, Cathleen Murphy, and Kathryn Parkin, this project would not have been successful.

Several board members deserve special mention. Nancy Magoon, Joyce Gruenberg, and Susan Marx helped me over many hurdles. The Museum is fortunate to have such distinguished, hardworking trustees.

From the moment this project was under consideration, Aspen Art Museum National Council members Peggy and Charles Balbach, along with Rosina Lee Yue and her husband, Dr. Bert Lies, offered helpful advice and an infectious "go-for-it" spirit. Collectors Elaine and Bill Jarrett generously shared their art objects, knowledge of the material, and keen intellects, enhancing every aspect of the book and exhibition.

It has been a pleasure having Klaus Kertess participate in this endeavor. He intuitively understood the American Indian material and what I was trying to accomplish.

Colleagues Joshua Baer, Tony Berlant, Jeff Myers, Howard Roloff, Chris Selser, Gary Spratt, and Matt Thomas offered very astute insights.

Many others deserve thanks for their technical support. Janet O'Grady and Randy Beier were most helpful in getting me started down the publishing "highway." David Marlow displayed his usual great taste and enthusiasm in photographing the objects, and was ably assisted by Todd Babos and John Sabel. Eleanor Caponigro, the designer, and Martino Mardersteig of the Stamperia Valdonega put forth outstanding efforts in the production of this book.

I could not have taken on a project of this scale without the complete support of my wife, Teena Shaw. Time usually spent with her had to be given up to accommodate work on this book and exhibition. Teena cheerfully assisted with every task the book and exhibition required. In particular, her recommendations regarding the installation of the exhibition, the fundraising, and the photography cannot be overstated. She was there every step of the way. All my thanks and love go to her.

Finally, I dedicate this book to my son, Hunter Shaw, a young man with a good heart, a creative imagination, and a most promising future.

Preface

AN IMPORTANT MOMENT in my life occurred in the early 1970s, as a result of a conversation I had with noted contemporary artist and American Indian art dealer Tony Berlant of Los Angeles. He felt there was a wider audience for the finest examples of antique Indian art than only collectors of American Indian objects. Specifically, he mentioned collectors of great modern and contemporary art, adding that the works offered had to be on an artistic par with the collectors' de Koonings or Rothkos.

Thinking back on that conversation, it is easy for me to understand Mr. Berlant's interest in antique North American Indian art. He is a member of a community that has always been at the vanguard of appreciating and collecting this art.

Artists of the Ashcan School at the turn of the century to American modernists such as Arthur Dove and Marsden Hartley collected Indian art. Surrealists of the early 1940s, including such notables as Max Ernst, André Breton, and Yves Tanguy, collected Northwest Coast and Inuit masks, and Hopi kachina dolls. In fact, in 1946 Max Ernst and Barnett Newman curated a show on Northwest Coast art at the Betty Parsons Gallery in New York. Robert Motherwell, Adolph Gottlieb, and other prominent 1950s artists carried on this special interest the art community had begun to display. The late 1960s and 1970s saw Andy Warhol, Brice Marden, Frank Stella, Jasper Johns, Donald Judd, and Kenneth Noland continue what had come to be a multigenerational passion of modern artists for collecting antique North American Indian art.

Today, several important contemporary painters and sculptors have the same keen interest in this art as did their predecessors.

Prominent museums have also been instrumental in bringing to broader recognition the status of North American Indian art as equal to that of art originating in other traditions. Landmark exhibitions at the Museum of Modern Art, New York, in the 1940s and in 1984 were beneficial in alerting the public to the importance of this material. In 1979 the Aspen Art Museum held an exceptional exhibition of southwestern Indian art. More recently, such museums as the Albright-Knox Art Gallery, the Scottsdale Center for the Arts, and the Metropolitan Museum of Art have all mounted impressive displays of antique North American Indian art.

Against this background, I thought it would be exciting to share with the public premier examples of North American Indian art. Since this show does not emphasize an ethnographic or a historical perspective, not every time period or type of object had to be represented, and I was therefore free to choose examples based primarily on their visual appeal and artistic merit.

I sincerely hope this publication and exhibit will have as profound an impact on you as preparing them did on me. In awe of and with respect and gratitude to these magnificent, unknown North American Indian master artisans, I offer you "Art of Grace and Passion."

Contents

Art of Grace and Passion

GEORGE EVERETT SHAW

IN EVERY CULTURE and time period, only a handful of artisans reach the level of creative genius. They come along infrequently, but their achievements are obvious. This exhibition and book focus on some of the most accomplished American Indian artists, ones who rose above their contemporaries, ones with that rare talent to take a haunting mental image and convert it into a masterwork.

Most often, these artists chose to work within the traditional formats and designs of their culture. Even when working within these stylistic constraints, they achieved a confidence in the execution of their objects that make their virtuosity clear even to the untutored eye. Less often, but with equal effectiveness, these artists chose to execute their works in an unusual and unexpected manner. Because they seem to have been so comfortable with their high levels of skill, they were able to challenge the established parameters of their genres.

Some of these eccentric creations are among my favorites. The artists seem almost to have been saying, "I know I can create anything I want – let's make this one different and see what happens." The point is that both traditional and "aberrant" ideas in the hands of the gifted often lead to dazzling artistic achievements. Therefore, both types of statements are represented here in order to give the reader a clear understanding of the aesthetic range of the most skilled North American Indian artists.

The title of this book and exhibition, "Art of Grace and Passion," evolved from my belief that the best works of American Indian art display both these qualities. When I think of grace, the first words that come to mind are elegance, finesse, charm, and refinement. All the objects were chosen for having those qualities. Art that possesses grace gives the viewer an intangible feeling of pleasure and satisfaction, a feeling that perfection has been achieved. William Hazlitt eloquently expressed this sense when he said that grace is "the outward expression of the inward harmony of the soul."

The other essential quality of great American Indian art is passion. This manifests itself in many emotional ways. An affectionate manner may be seen in a beautiful Navajo serape or a magnificently beaded and tailored shirt from the Plains. The love, labor, and desire to please in these pieces cannot be missed. Other times, passion is demonstrated through anger or rage. This is evident when viewing a ferocious Woodlands war club or an imposing Northern Plains war shield. The club and shield were made for the purpose of invoking a natural power and intimidating the enemy in battle.

As you go through the book and exhibition, look for the grace and passion in each object.

These attributes are the threads that connect all outstanding American Indian objects with other cultures' great works of art.

The most important consideration in evaluating material for inclusion in "Art of Grace and Passion" was visual impact. Several basic questions may always be asked as a litmus test for determining the level of visual power. Does the piece "take one's breath away"? When viewed with similar material, is its greatness obvious? Is there surprise in the concept or its execution which makes the piece unique and powerful? The quality of the materials used, the age, rarity, condition, and provenance of each piece were also considered in deciding whether to include it. However, if an object lacks visual excitement, it does not matter, from an artistic standpoint, that it is merely old or rare.

I feel a book consisting for the most part of unpublished material – pieces stunning enough to be considered universal art statements – is the best way to advance the appreciation of American Indian art. The use of so many previously unseen objects is probably the most salient characteristic of this project. The small number of pieces in this book that have been published before appeared only in auction catalogs, in obscure books, or as poor-quality black-and-white photographs in early reference books.

I believe that the images in this book need little further explanation. Therefore, I have offered only the most basic descriptions: what the object is, as well as its size, approximate age, and place of origin. With great success, many other books have turned their detailed attention to the ethnography of, and other scholarship on, antique North American Indian art. For those readers interested in an academic view of American Indian art, a selected bibliography is included in this volume.

As with any museum show and publication, this project had to concern itself with parameters. In order to make the scope of the undertaking more manageable, I decided to concentrate on American Indian artists who had worked before the 1920s. Having a modest budget and a short planning period, I also decided almost all of the objects would come from private collections in the Aspen area. I am extremely proud of the rich and diverse American Indian material found in this town of only about 5,600 people. The depth and quality of these local collections are what made this exhibition and book possible.

A couple of decisions about the layout of the book are noteworthy. Within their geographic categories, objects were placed to enhance their visual appeal. By alternating the material, rather than grouping all the pots, all the baskets, and so forth, a more satisfying visual experience has been achieved; for the same reason, placing the material in chronological order was not considered. To further showcase the objects and allow readers to focus on their visual pleasure, descriptions have been relegated to a list of plates at the back of the book.

The art in this book has been divided into three broad geographic areas: The Plains and Woodlands, the Southwest and California, and Alaska and the Northwest Coast:

THE PLAINS AND WOODLANDS: The nineteenth-century objects from the Plains were chosen to highlight the extraordinary beading skills and fine

painting capabilities of artisans from this region, which stretched roughly from west of the Mississippi River to the Rocky Mountains. Although the Woodlands Indians occupied the entire area east of the Mississippi, items from this region selected for the exhibition and book are predominantly of Great Lakes origin. The material illustrated dates to the late eighteenth and early nineteenth centuries. Quillwork, used to decorate clothing, and sculptural expressions in wood dominate this group.

THE SOUTHWEST AND CALIFORNIA: The southwestern objects, mainly from Arizona and New Mexico, include prehistoric pottery (before 1500 A.D.) and nineteenth-century Pueblo pottery, kachina dolls, textiles, and baskets. Because of the proximity of California to the Southwest, the small selection of late-nineteenth-century California baskets were grouped with objects from this region.

ALASKA AND THE NORTHWEST COAST: The Alaskan Inuit masks, ivories, and headgear in this exhibition and book date to as early as 200 B.C. for some of the carved ivories, and as late as the end of the nineteenth century for some of the masks. Material from the Northwest Coast consists mostly of nineteenth-century masks and rattles from southeastern Alaska and British Columbia.

* * *

A few parting comments and observations on selected items may be helpful to the reader in further understanding and appreciating the importance of all the material in this exhibition and book:

OTTAWA PIPE BOWL (p. 20): What a special object in the round this pipe bowl is! The maker created a wonderfully intimate, animated conversation between two people. The figures are exquisitely modeled and display a warmth and a sensitivity that immediately draw us into their orbit.

CROW SHIELD (p. 21): This potent image was most likely received in a dream or vision by the maker. It is not surprising that an important item of warfare would have a bear as its dominant image. In this culture, bears were greatly admired for their strength and ferocious manner. The green finger-style work adds a painterly effect to the composition. As for the subject matter, viewers may wonder if the bear is praying to an eclipsed sun or simply emerging from its cave. We will never know for sure.

NAVAJO THIRD-PHASE CHIEF BLANKET (p. 46): The unusual placement of two smaller diamonds on either side of the larger diamond in the center of the blanket contributes greatly to its visual effect. The narrow red pinstriping just above and below the brown stripes is another rarely seen but effective technique. These design variations are what elevate the composition of this textile to brilliance.

APACHE BASKET (p. 47): What an extraordinary effort went into making a basket of this scale and grandeur! This basket was commissioned at the Hubbell Trading Post by an Arizona ranching family at the beginning of the twentieth century. It took the weaver 2½ years of full-time labor to complete this tour de force of three-dimensional

design. The interlocking diamonds that dominate the olla were a perfect choice to emphasize the marvelous form, which gradually enlarges until it rolls in so sensuously at the shoulder and finishes with a tall, dignified neck.

JEDDITO BOWL (p. 51): This bowl has great mystery and appeal. Notice the central figure in black. Was the potter using the simply rendered eyes to suggest a bird, or perhaps a ghost or some other apparition? Whatever the artist intended, I am reminded of an image one might find in a Miró.

SOCORRO BLACK-ON-WHITE BOWL AND PIMA BASKETRY TRAY (pp. 58 and 80): These objects share a secret that accounts for their likability. In each case the artist chose to accentuate the design with a negative color palette. The out-of-the-ordinary predominance of black in both pieces captures our attention and allows us to immerse ourselves in their exciting design statements.

FOUR-MILE BOWL (p. 60): What a commanding presence this bird has! It dominates the bowl with its whimsical and engaging manner. The way the eye is rendered reminds me of what one might expect from a Picasso or some other early cubist composition.

JEDDITO BOWL (p. 61): Here, a dynamic central design appears to float over an energetic splatter pattern. It has been speculated that the central design was stenciled on using beeswax; the artist may then have put the background paint into his mouth and blown it through a reed onto the surface of the bowl. It is also possible that a masking agent such as hide or cloth was used to form the geometric pattern, and that paint was then flicked onto the bowl with a brush. In whatever manner this pot was painted, the completed piece is one the abstract expressionists would have found irresistible.

SOCORRO BLACK-ON-WHITE JAR (p. 65): To a beautifully drawn, but somewhat predictable, geometric pattern, the artist has added a highly unusual checkerboard band, which bisects the entire design of the water vessel. This addition allowed the artist to deviate from the norm to create a water jar that is provocative and visually challenging.

SIKYATKI CANTEEN (p. 70): This is a splendidly decorated utilitarian object. The geometric motif along the perimeter gives us a sense that the piece spins around the parrot depicted in the central medallion.

KWAKIUTL MASK (p. 88): A strong psychological force emanates from this mask. The eerie eyes, sunken cheeks, and black graphite paint enhance the drama of the piece. It would have been a haunting experience to have witnessed this mask being worn in the flickering firelight of a potlatch ceremony.

ALASKAN INUIT HUNTING HAT (p. 96): For me, this visor is among the most imaginative headgear ever conceived. In addition to creating a piece that acted as an eyeshade while the wearer hunted from a kayak or an umiak, the maker showed his concern for animism in the way he decorated the hat.

Animism is the belief that all living things belong to the same spirit world, and that the spirit of a killed animal must be appeased. Several animals are visible on the hat. The ivory panels on the front represent the eye and beak of a bird, and the small, central carving is of a walrus head. The image in total suggests an abstracted walrus face, with the ivory panels becoming the tusks and eyes, and the small ivory walrus head becoming the walrus's nose.

ALASKAN INUIT MASK (p. 97): This object was created by an artist of boundless imagination. The surrealists of the 1930s and 1940s would have loved it. The odd angling of the nose and one eye, the seal emerging from the other eye, and the serpent-like creature draped over the forehead combine to make for a moving effect. The wooden hoop framing the mask rivets the viewer's attention on the stunning face.

<p style="text-align:center">* * *</p>

As you view this book and exhibit, I hope you will concentrate on the beauty inherent in each object. Admire the items for their diversity, high level of technical proficiency, and overall artistic achievement. Remember that in most cases the artisans were not driven by any thought of a market for their work, but by a need for an affirmation of life and a desire to mirror the earth's allure. Reflect on the importance these pieces have as universal art statements. Allow their grace and passion to overwhelm you.

Another View: A Commentary

KLAUS KERTESS

In 1946, as Barnett Newman was on the verge of creating the radiant orchestrations of silence that would embody his quest for the sublime, he curated an exhibition of Northwest Coast Indian paintings for the opening of his dealer Betty Parsons's gallery. Like his abstract expressionist peers Jackson Pollock, Mark Rothko, and Clyfford Still (all of whom also exhibited their work with Parsons), Newman, in his strivings for a new abstraction, was led to investigate prehistoric cave paintings and the art of various non-European cultures.

Writing of Northwest Coast Indian art, he wondered if "modern man has lost the ability to think on so high a level? Does not this work rather illuminate the work of those of our modern American abstract artists who, working with the pure plastic language we call abstract, are infusing it with intellectual and emotional content, and who, without any imitation of primitive symbols, are creating a living myth for us in our own time?"*

Over and over in the course of twentieth-century modernists' questioning of and revolt against existing cultural norms, artists have turned to diverse tribal cultures for guidance and inspiration – and not infrequently to the cultures of those Indian nations so magnificently sampled in this exhibition. In the 1960s, for instance, the generation succeeding Newman's and including such artists as Kenneth

Noland and Frank Stella found much to admire in the Navajos' ability to have so eloquently woven their rhythmic geometries into congruence with the rectangular planes of blankets. And this form of weaving itself paralleled the efforts of Noland, Stella, and their peers to suppress the visible acts of the hand, depersonalizing and subjugating those acts to the planar strictures of painting.

In the 1970s, when Brice Marden and others began to explore new ways to visibly reintegrate drawing into painting, Mimbres pottery came to be highly admired in the New York art world. The linear clarity, directness, and lyrical tautness found in so many Mimbres bowls would be difficult to equal in any culture – as would the subtle poly-phonic play of two-dimensional painting with the roundness of the vessel that is the ground for that painting.

We might endlessly follow such examples back through time, but in so doing we would have to guard against the temptation to annex these tribal arts to the tenets of modernism. Each of the objects viewed in the artificial atmosphere of this exhibition and book was originally conceived as an act of integration within its own culture. In every case the American Indian artist was confirming his or her cultural concept of reality. This confirmation was later called upon to support modernism's questioning

of its own culture – and to justify the hyperelevation of individual achievement.

The invalidated word *primitive*, previously applied universally to tribal art and widely to non-European art, may now be reinvoked to refer to our fragmented, celebrity-driven culture, and the word *sophisticated* more accurately describes the integrated culture and highly supportive working conditions for artists which were prevalent among American Indian tribes in precolonial times.

Most of us relate to this art primarily in a formal way; few are familiar with its iconography or ritual significance. Clearly, the peaks and bands configuring so many Navajo blankets are ritualized condensations of mountains and horizons. But how these glyphic abstractions from nature were conceived and originally understood remains unknown to the majority of us not versed in Indian culture – in the same way a viewer unfamiliar with Christian cultures would probably find indecipherable the differences in connotation between representations of a crucified man and of a hanged man.

The grammar and syntax of these visual languages are different from ours; however, if leading philosophers, linguists, neuroscientists, and anthropologists are correct, a common underlying structure unites our various urges to form language. So, though much will inevitably be lost in translation, we can nonetheless begin to understand these languages. Rather than just permitting the rich, formal correspondences to lead us into the territories of our own cultures, we must try to employ those correspondences as conveyances into territories we may never fully understand. Let us be astounded by their beauty.

* From Newman's foreword to *Northwest Coast Indian Painting* (exh. cat.), Betty Parsons Gallery, New York, 1946 (exh. dates: Sept. 30 – Oct. 19, 1946); reprinted in Newman, *Selected Writings and Interviews* (Alfred A. Knopf, New York, 1990), pp. 105–7.

THE PLAINS
AND WOODLANDS

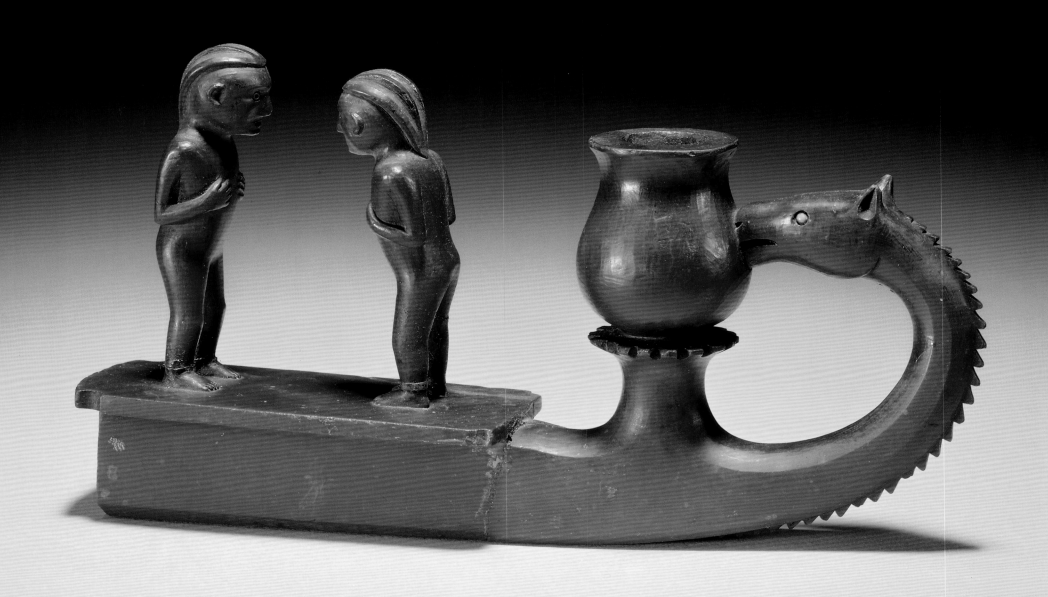

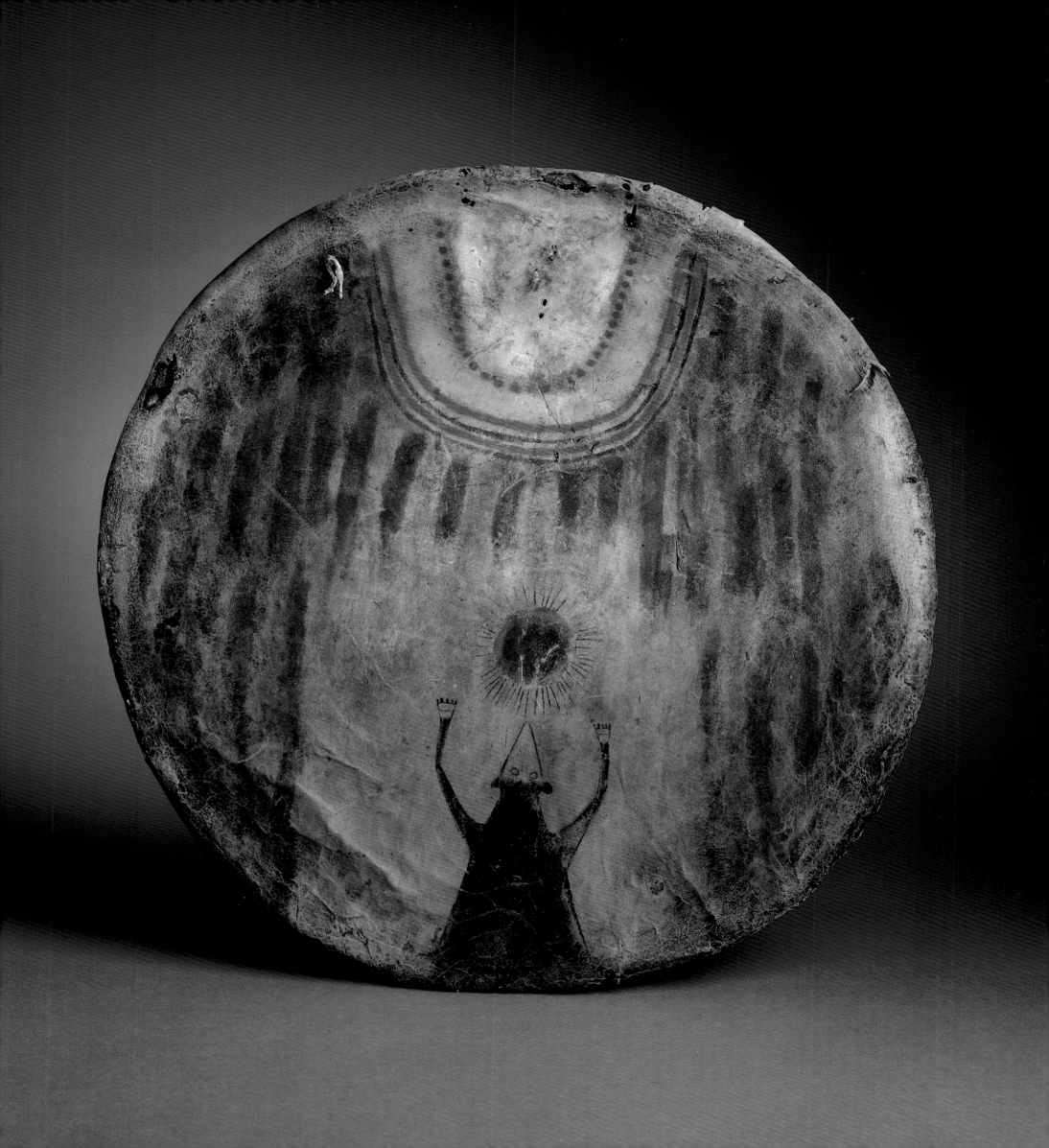

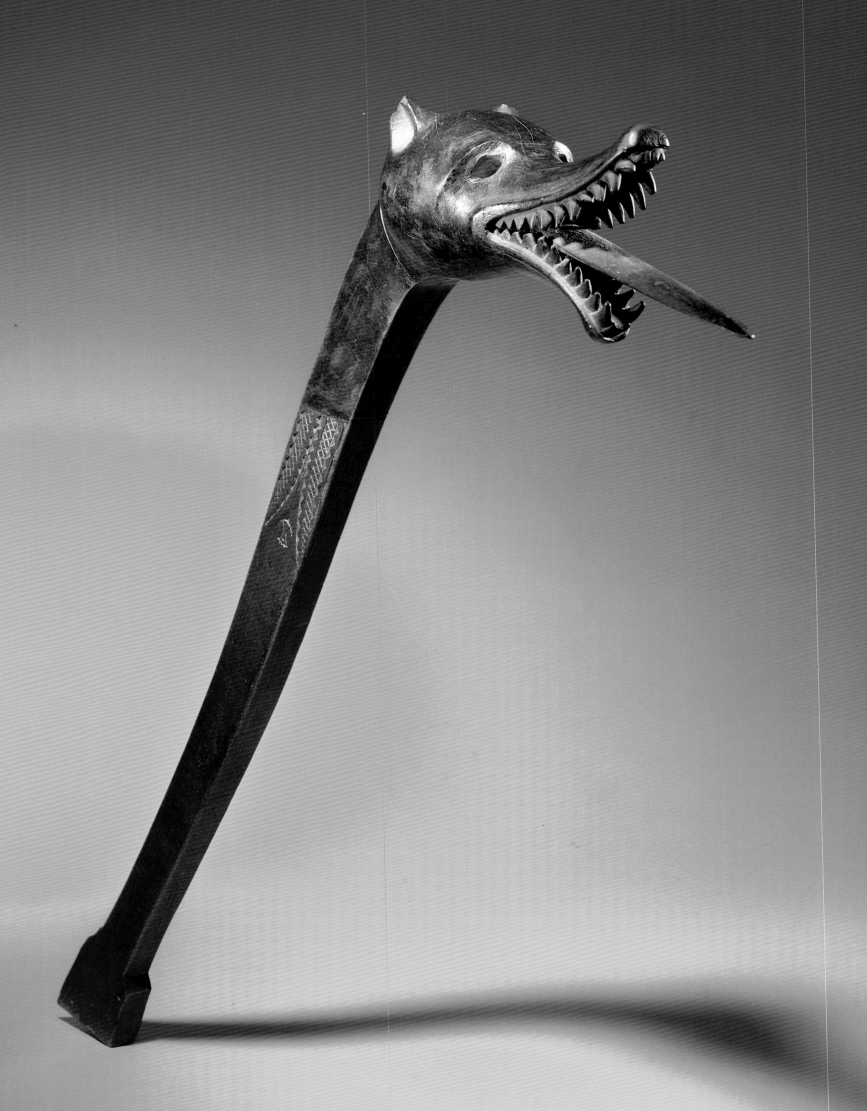

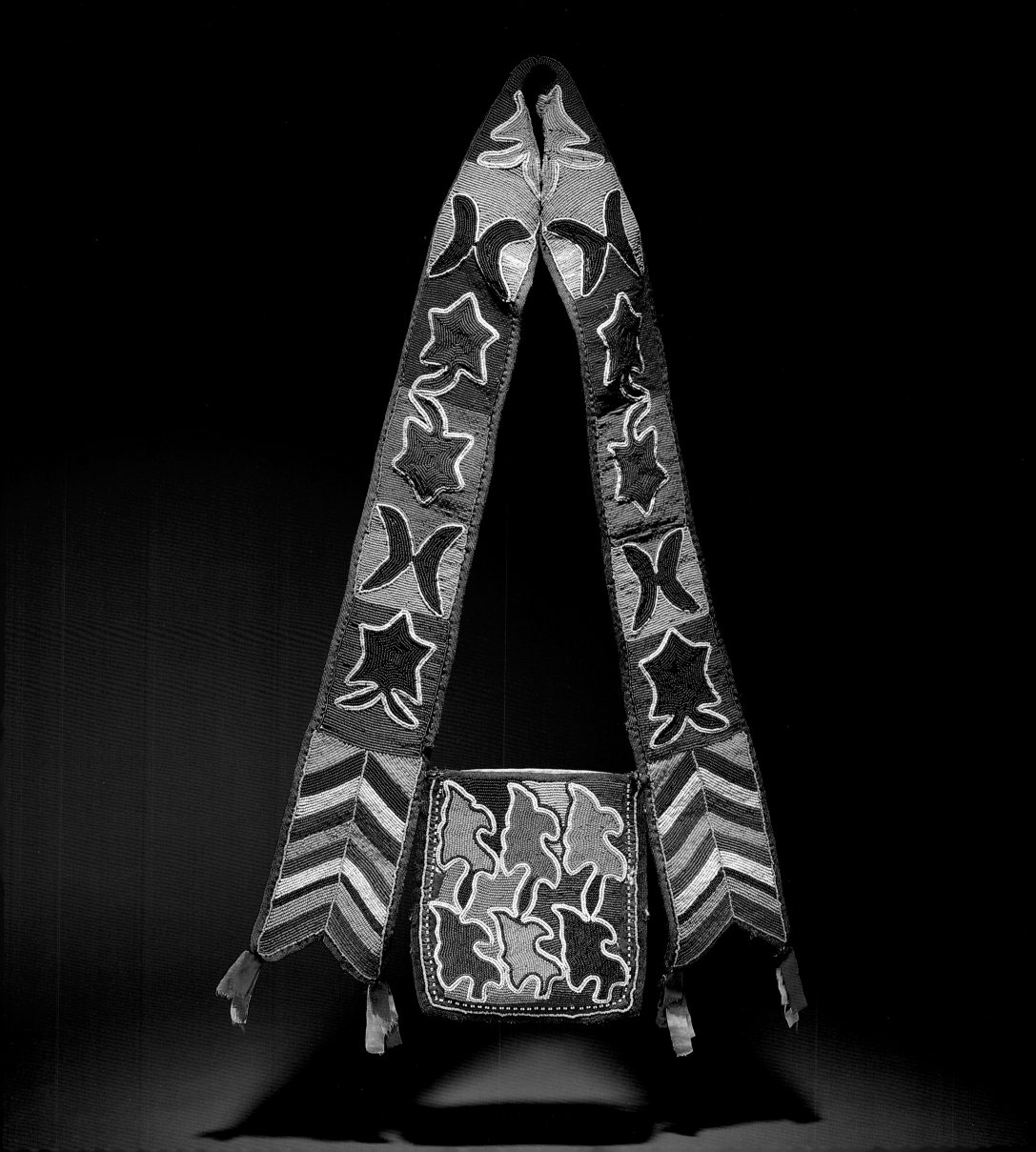

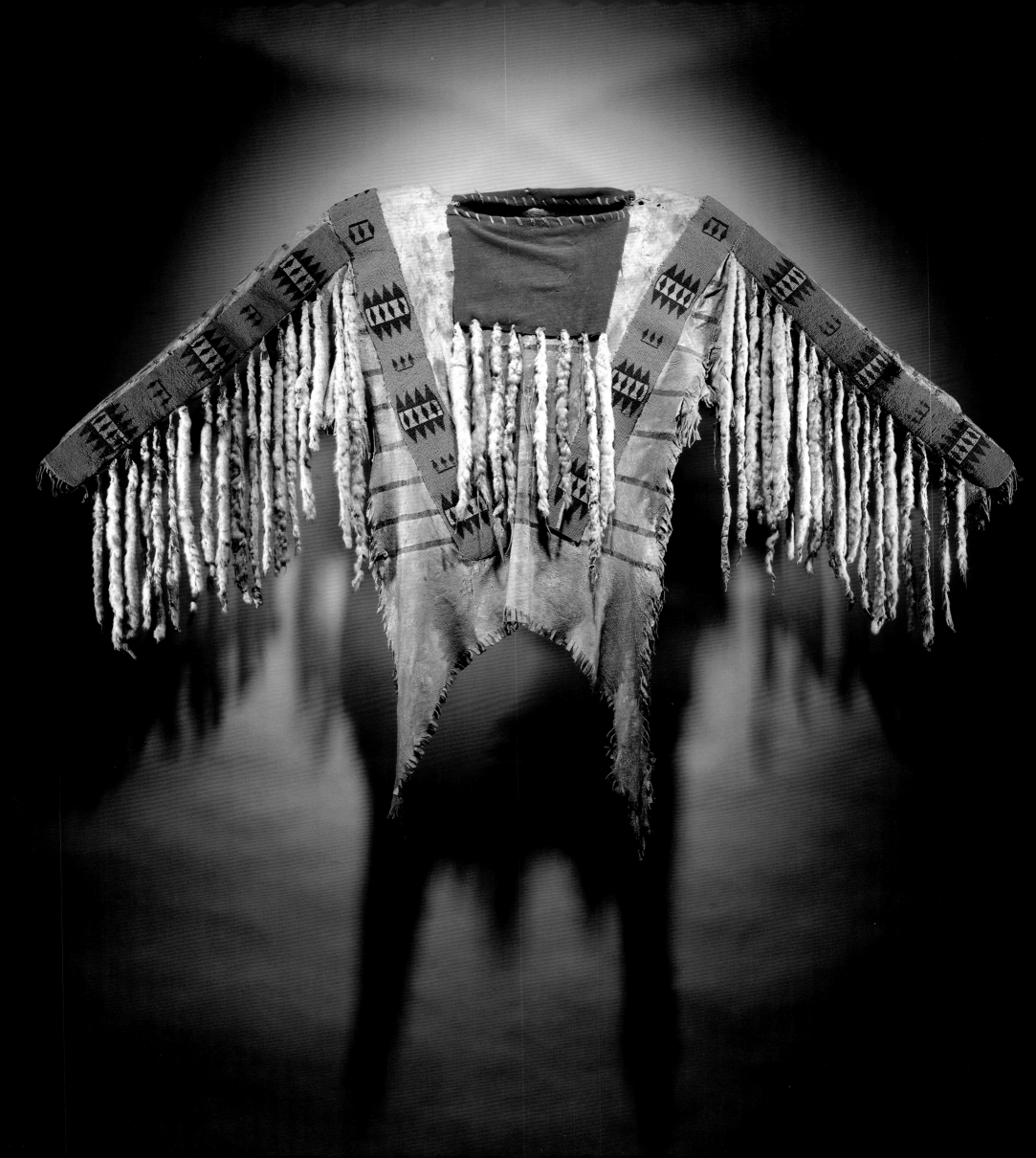

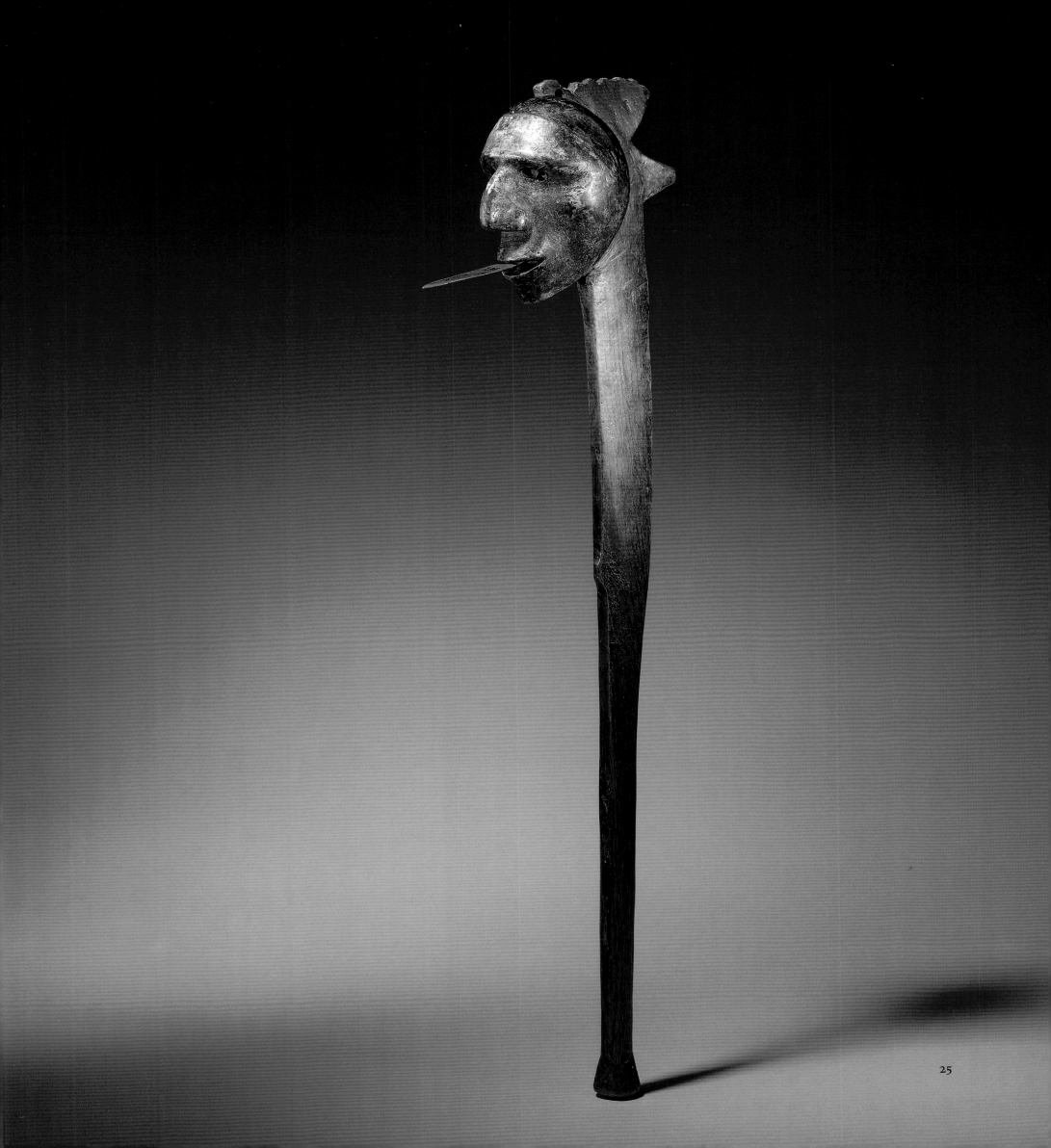

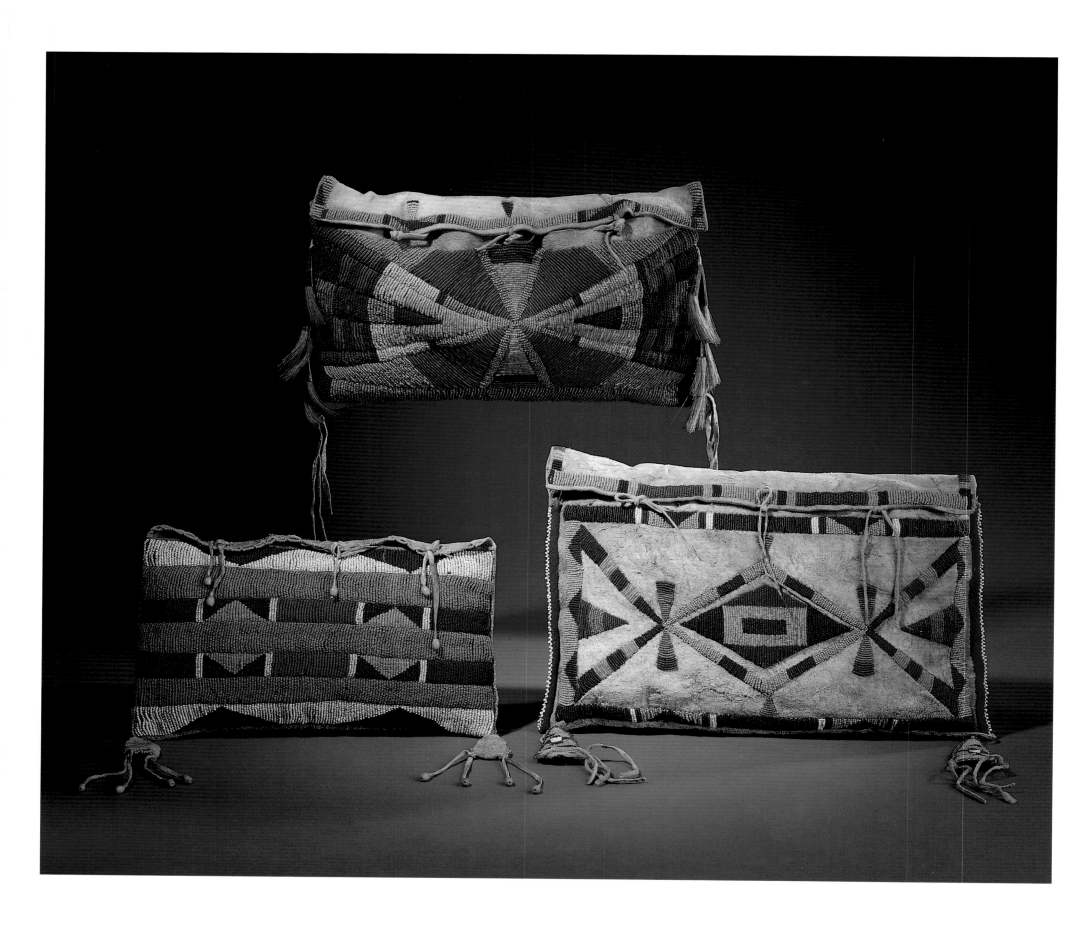

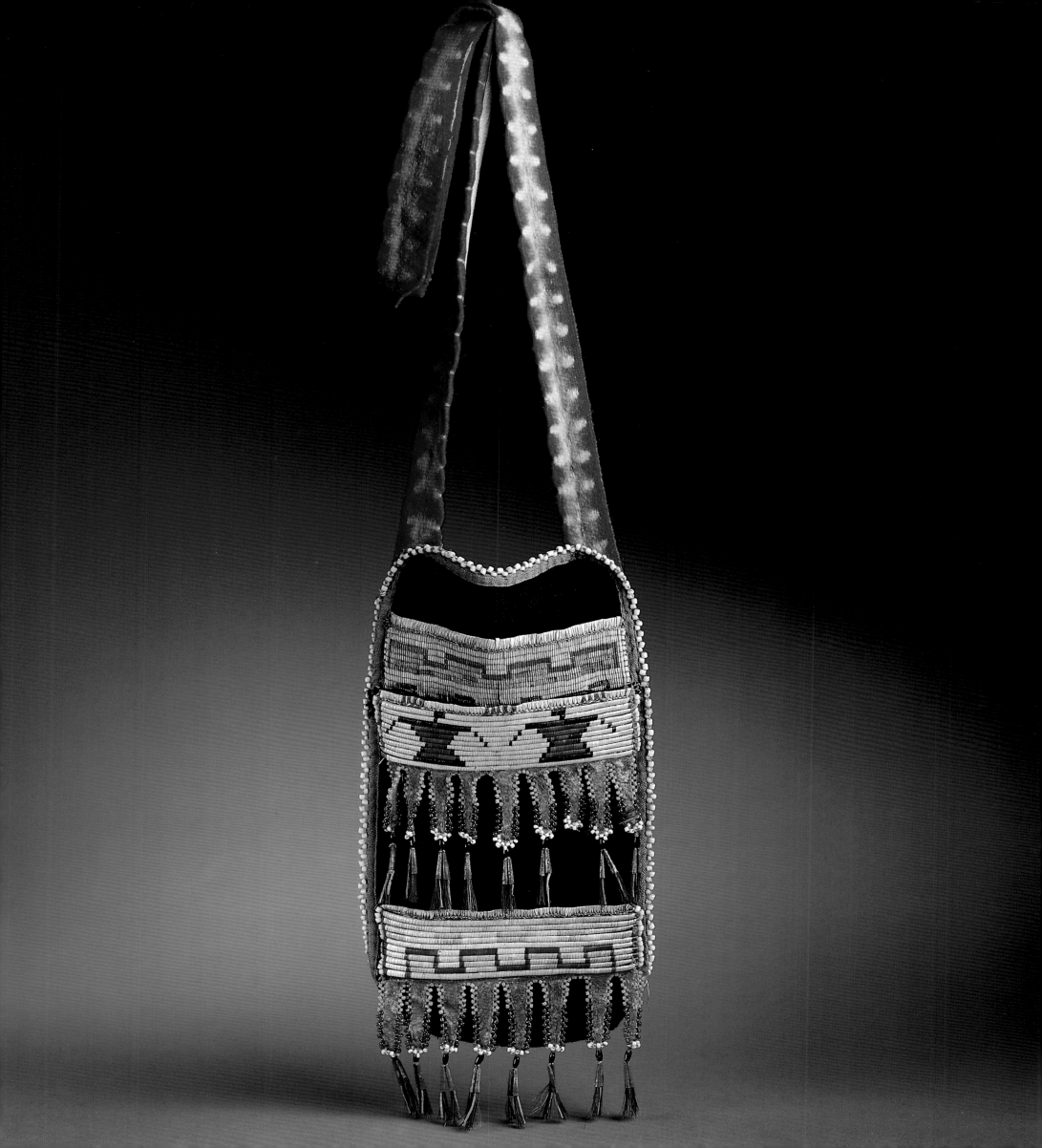

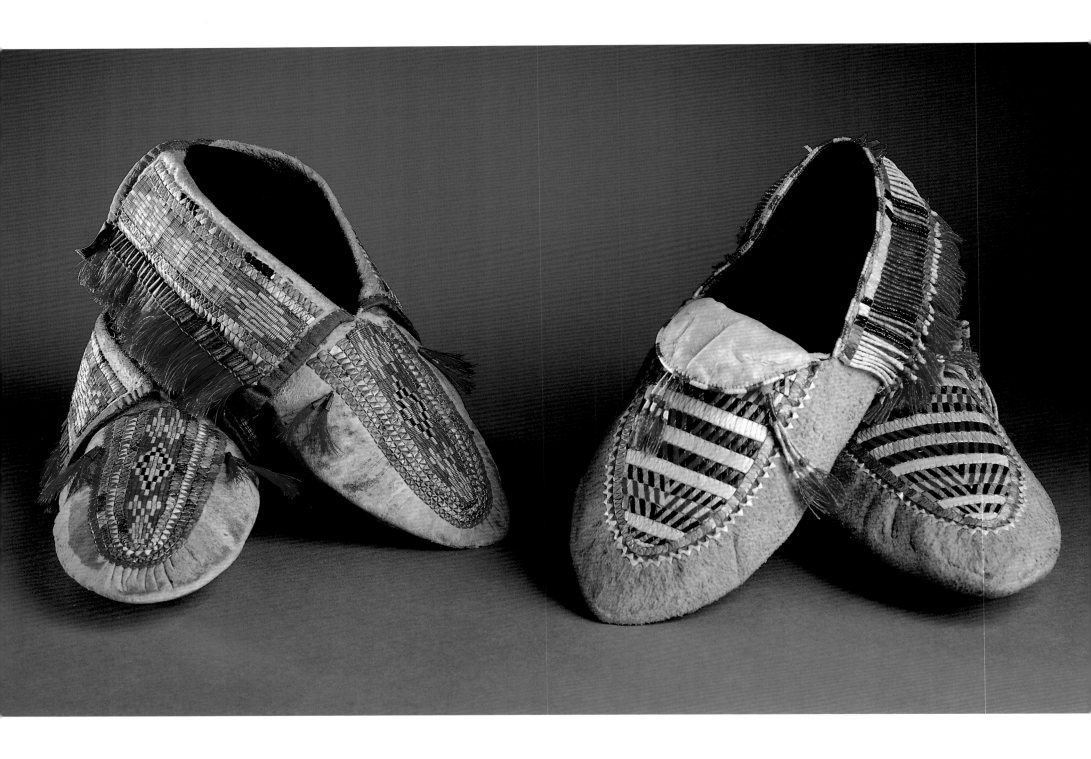

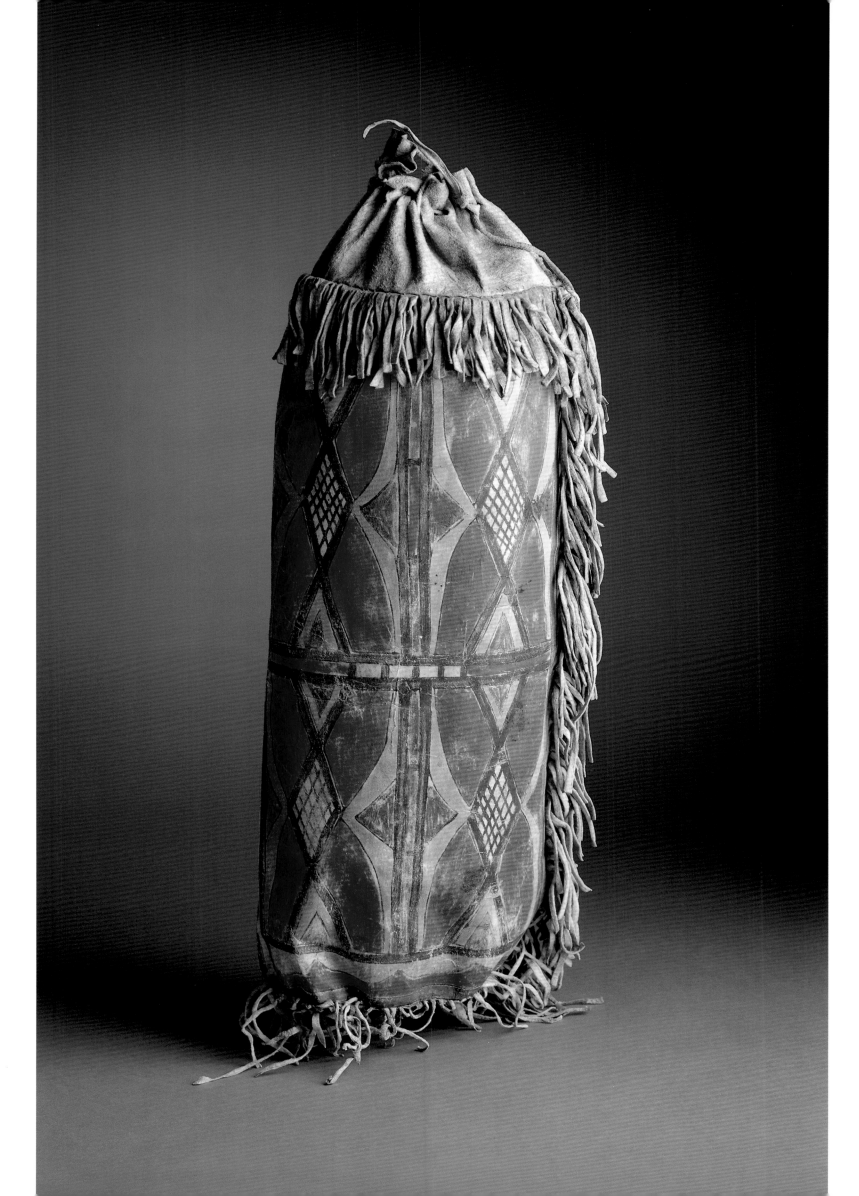

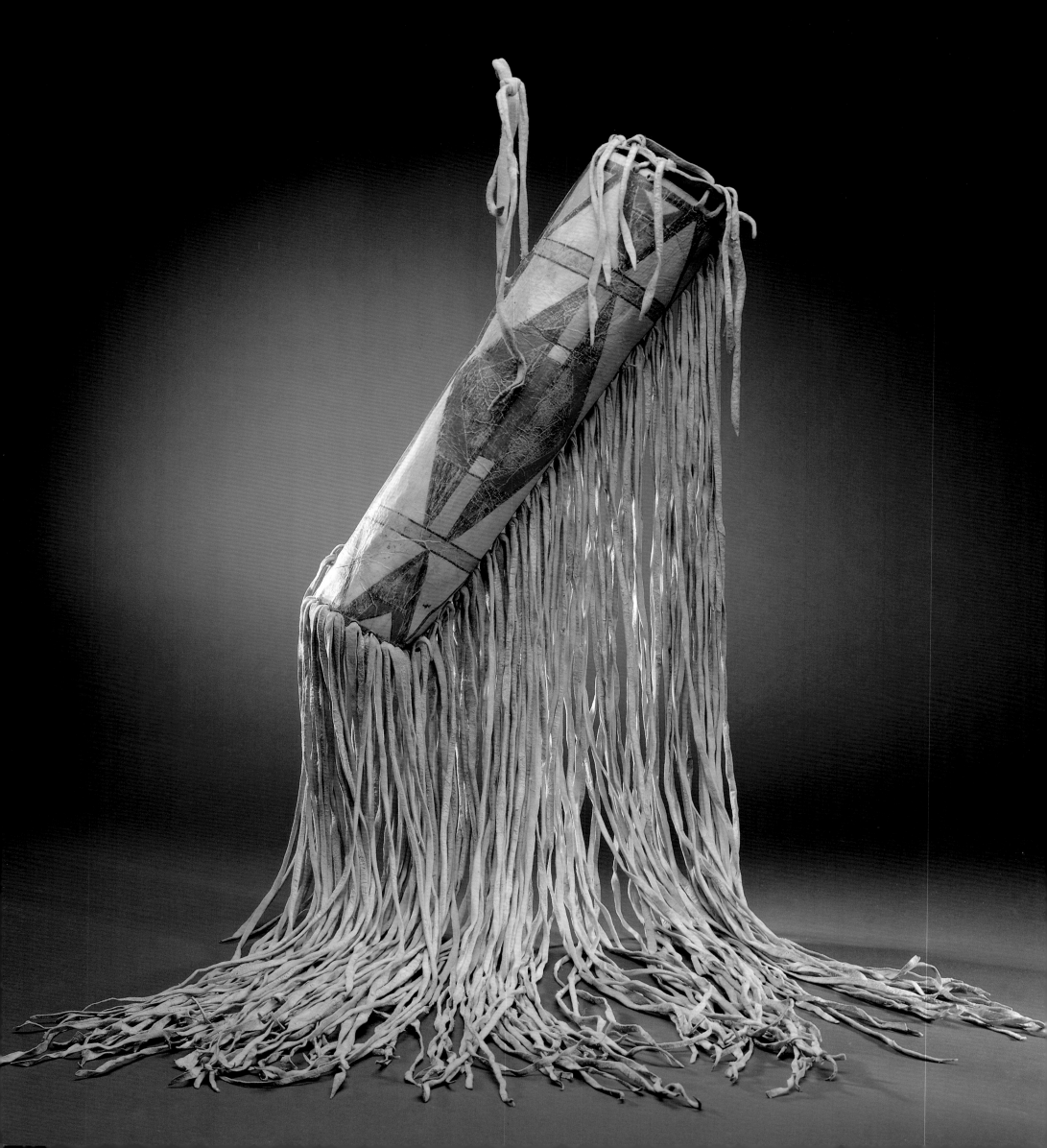

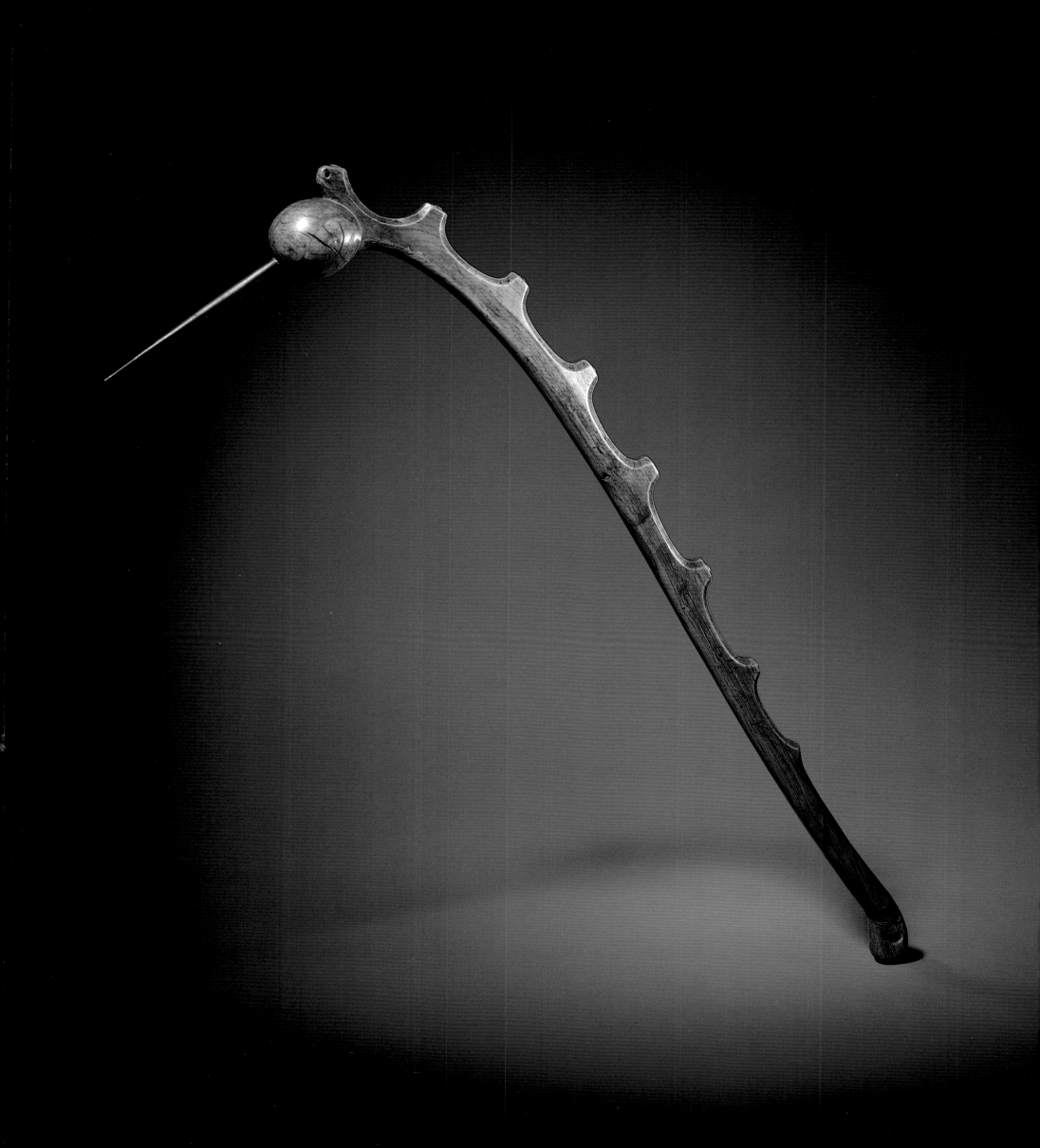

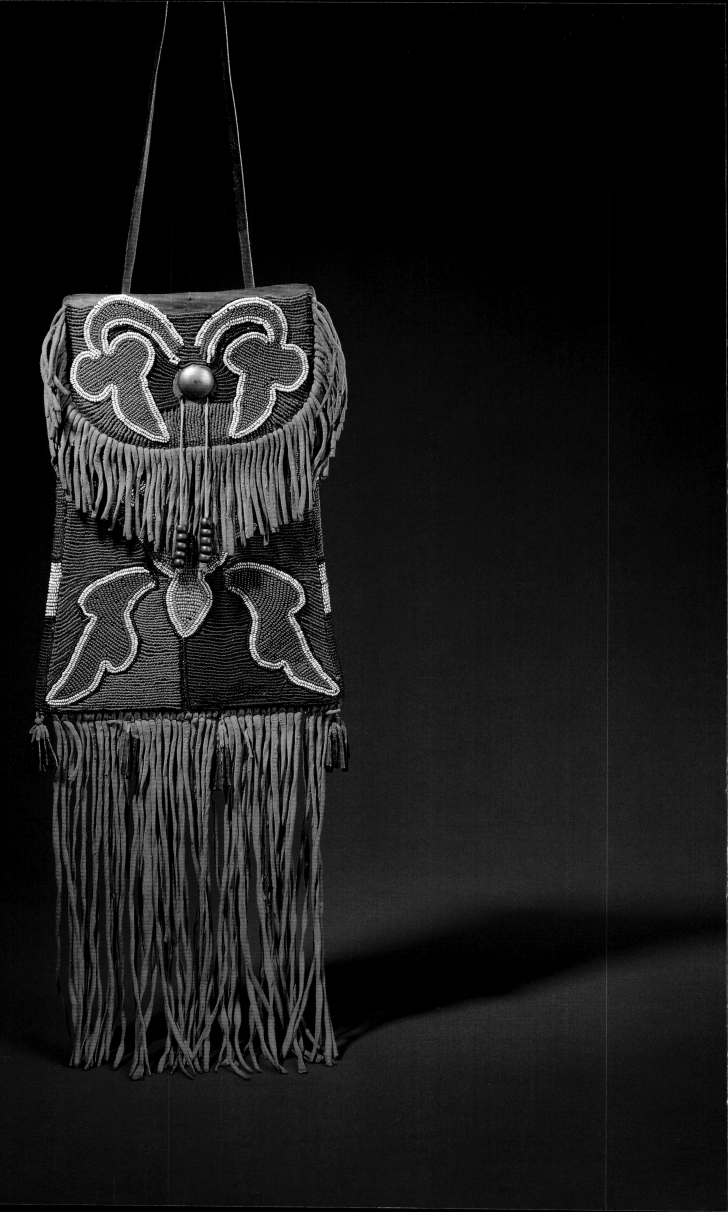

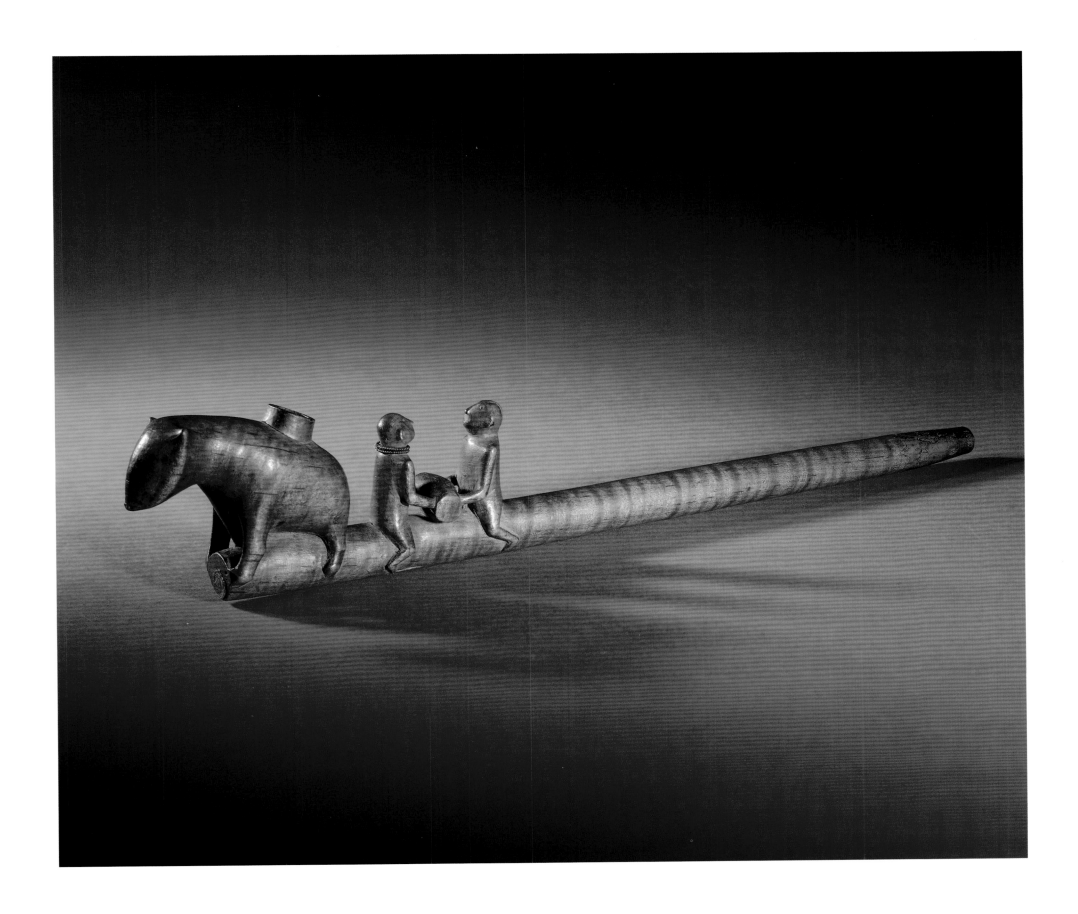

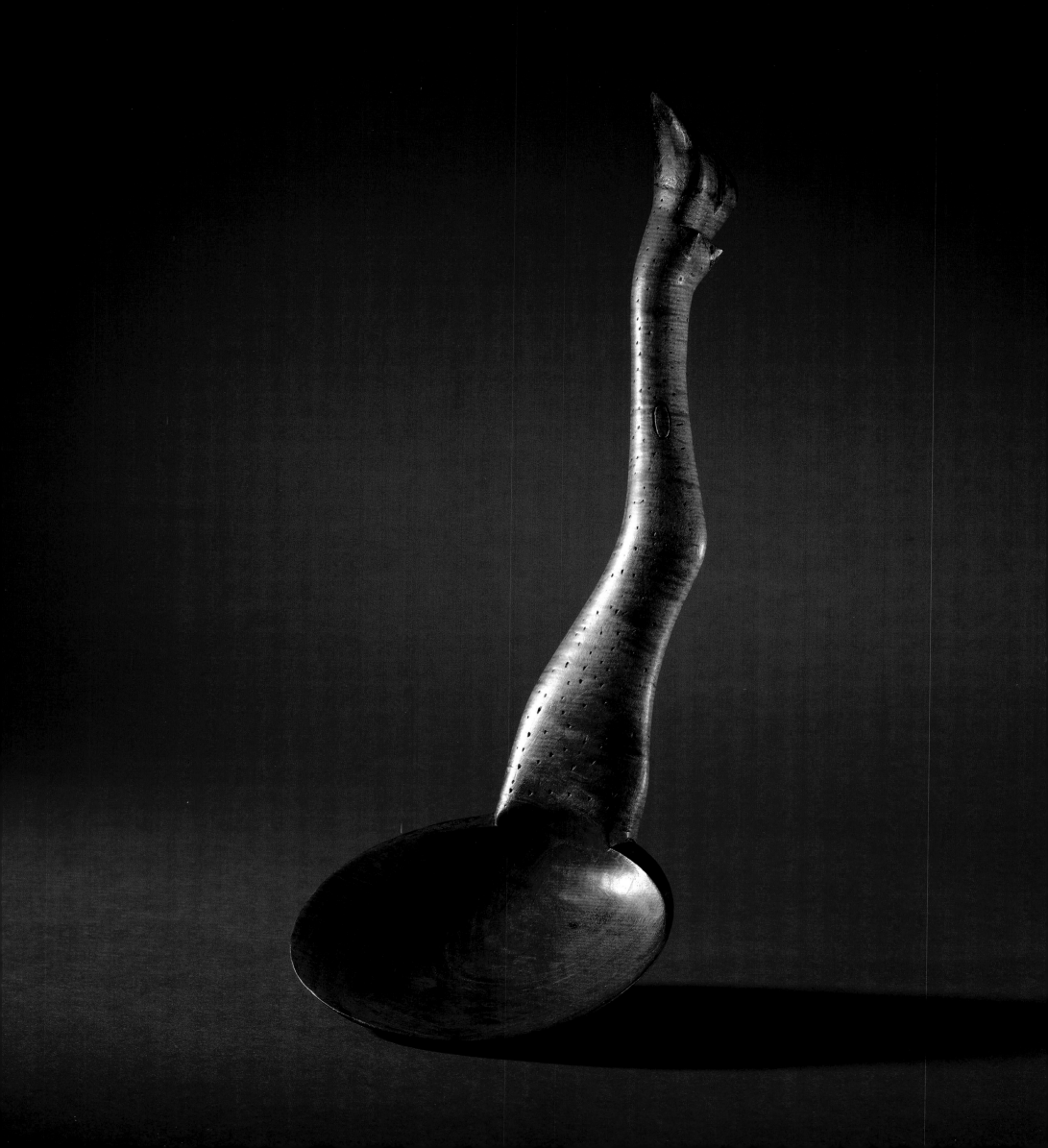

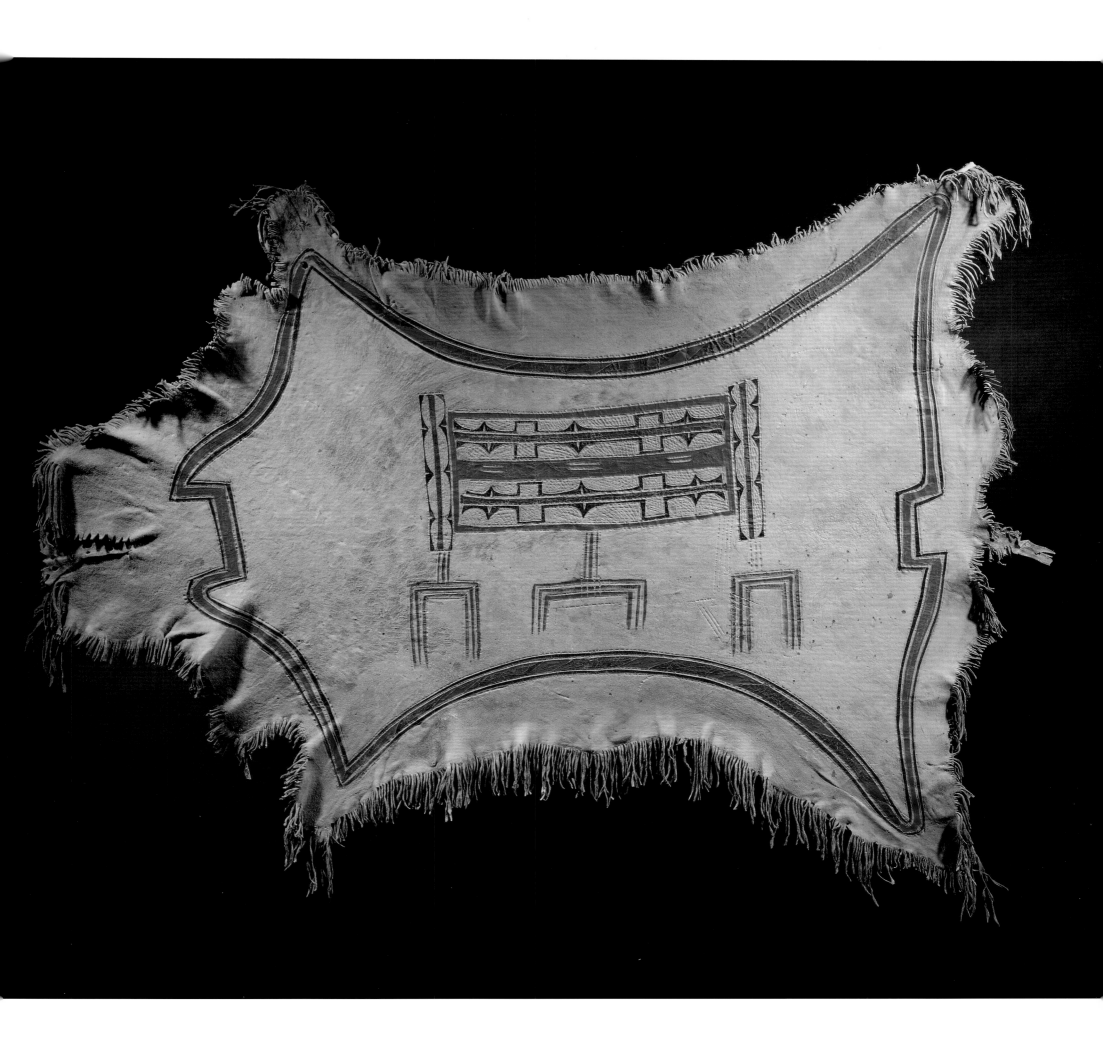

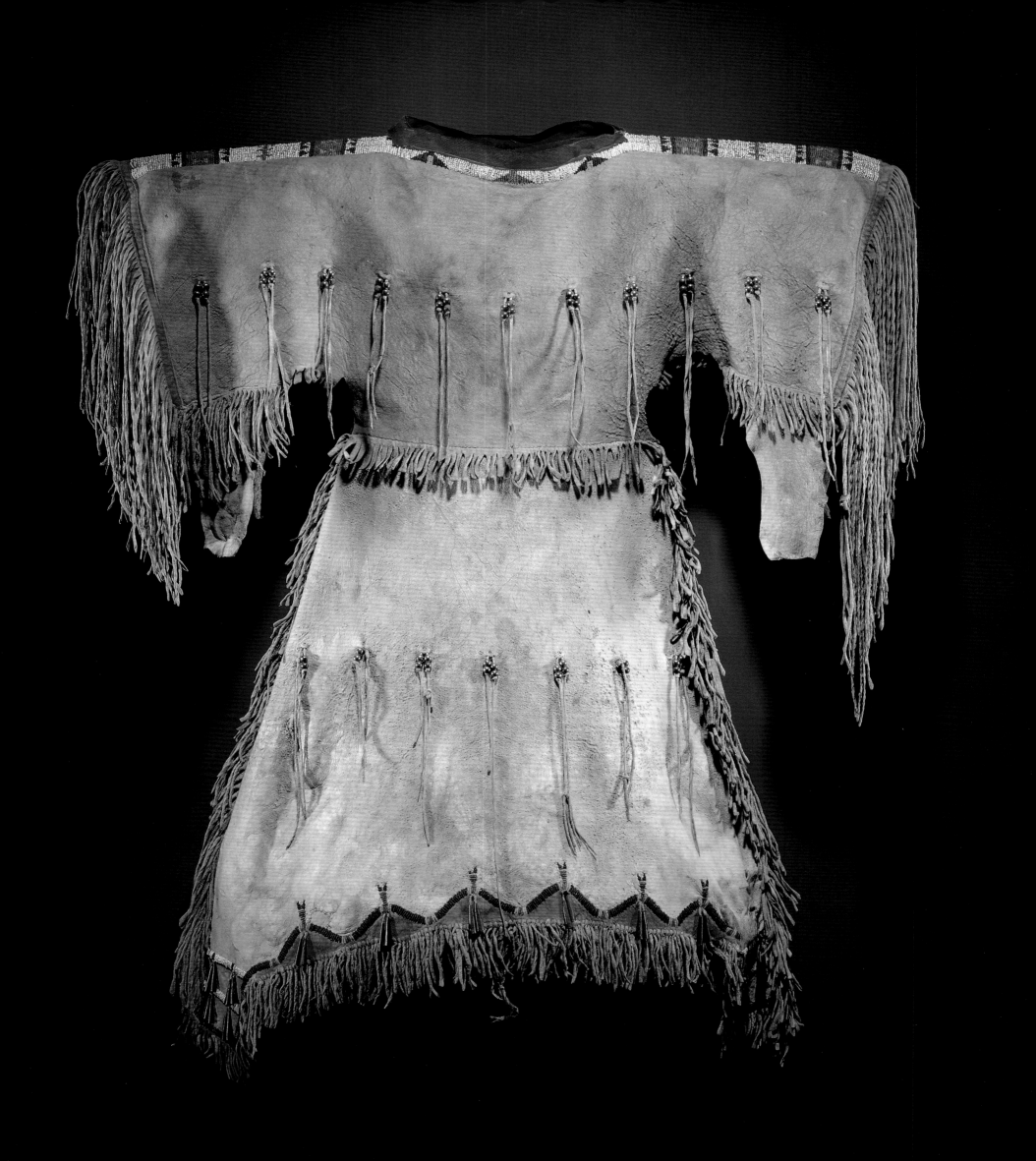

THE SOUTHWEST
AND CALIFORNIA

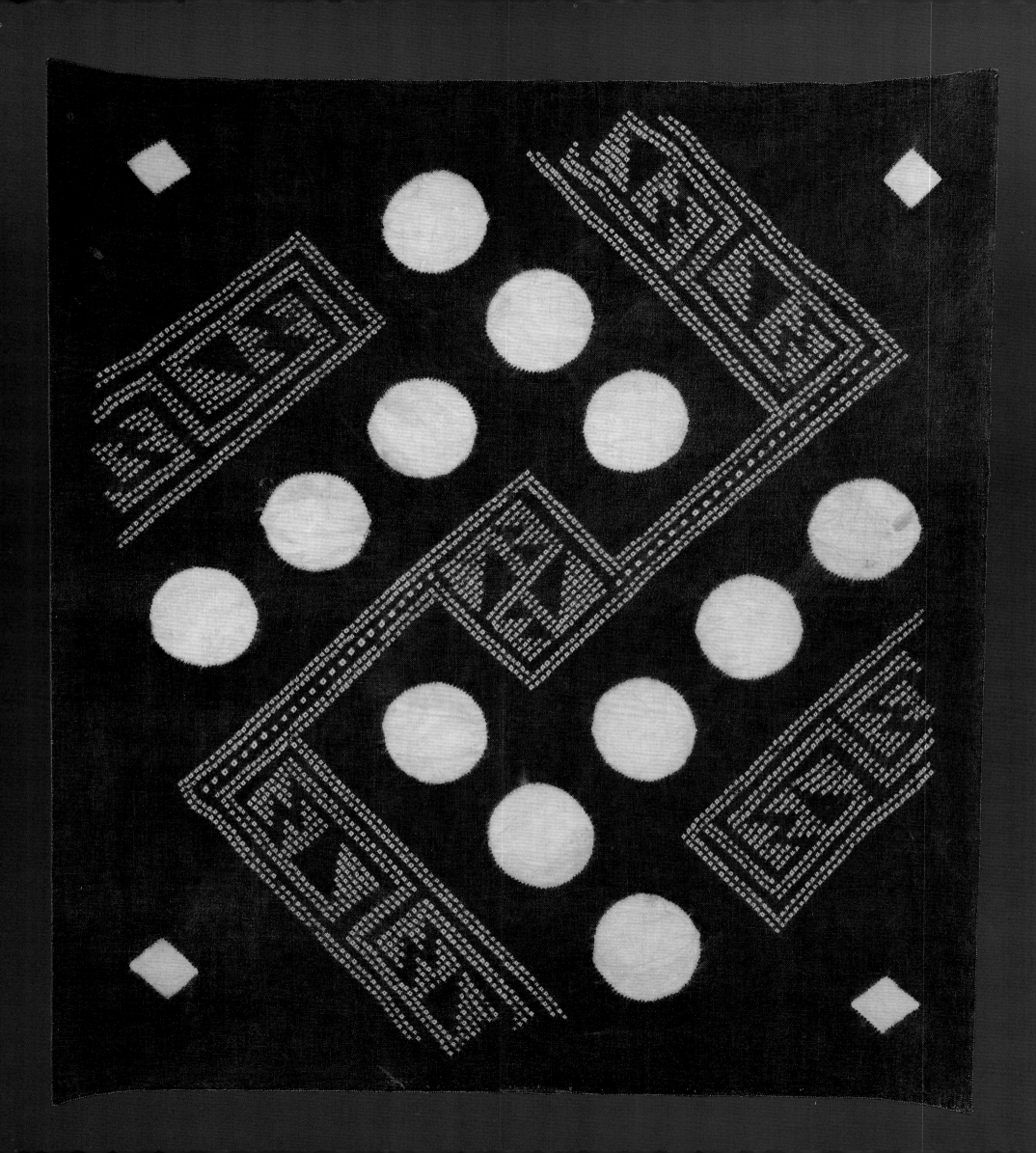

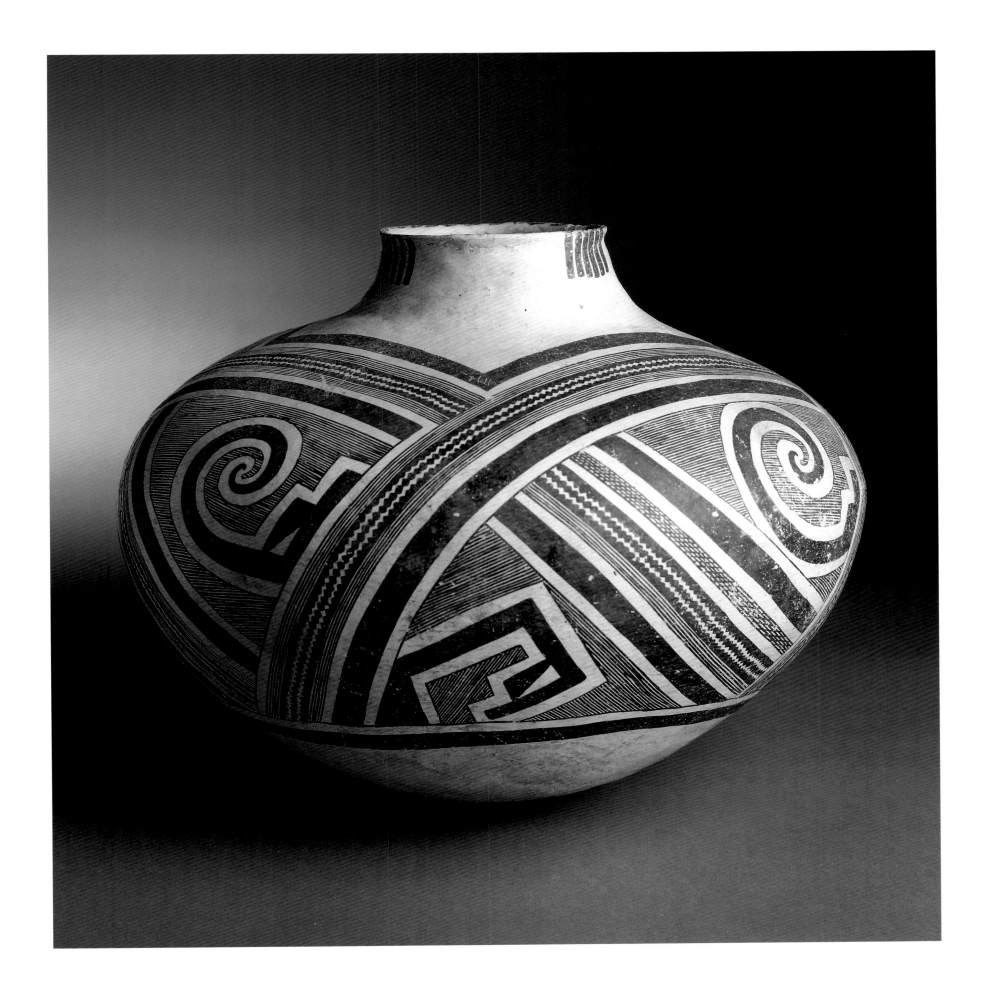

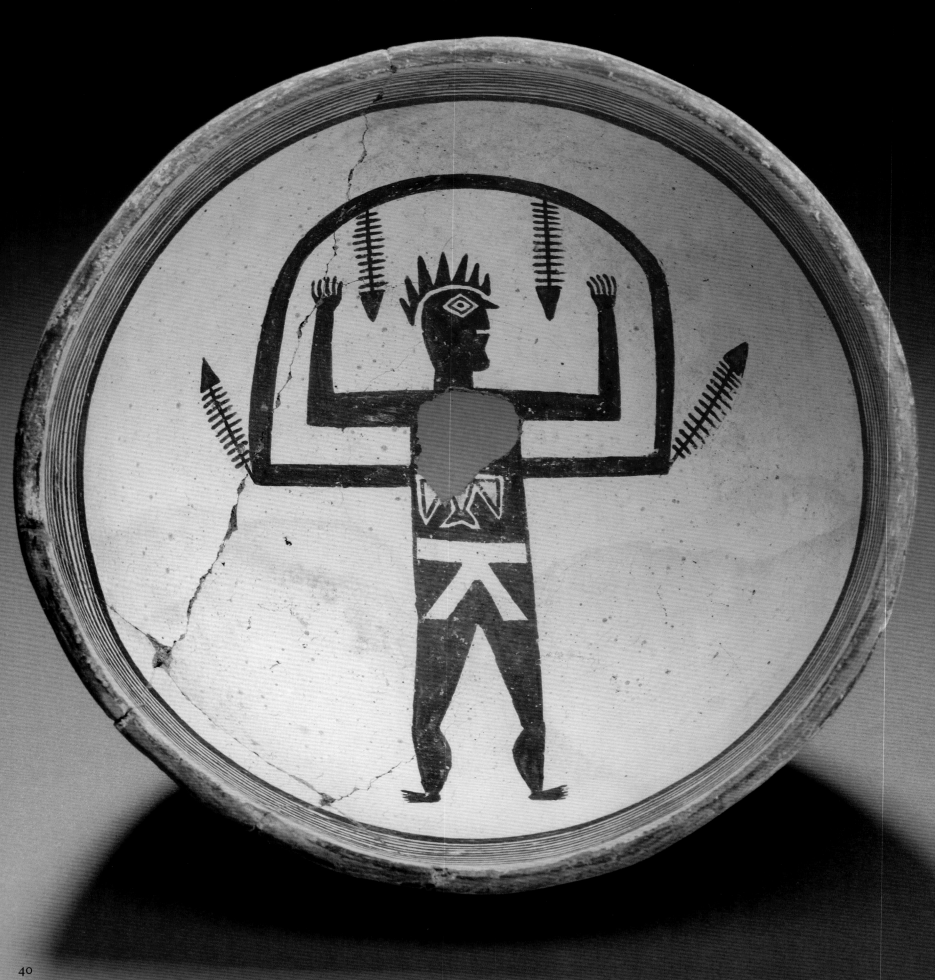

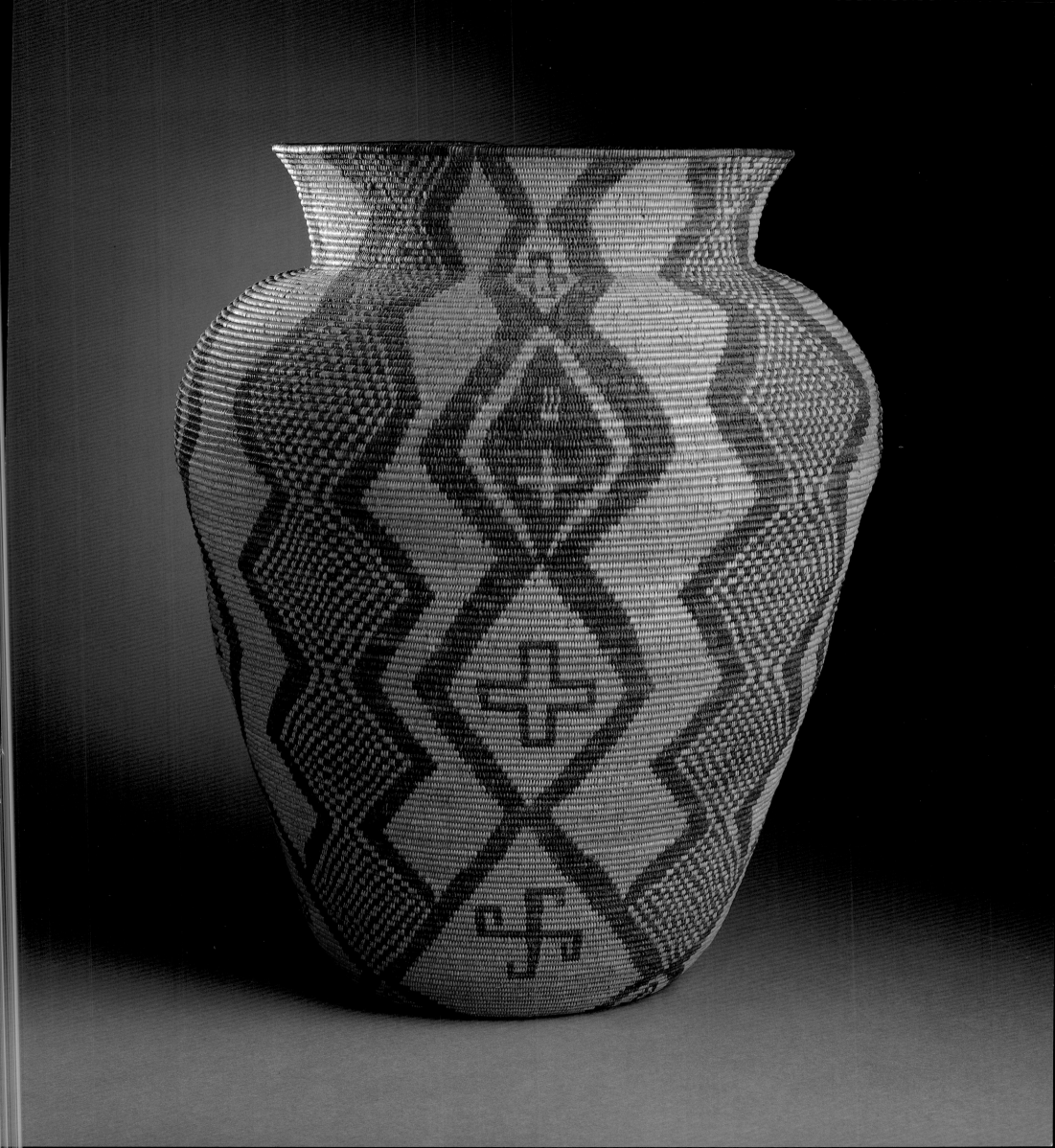

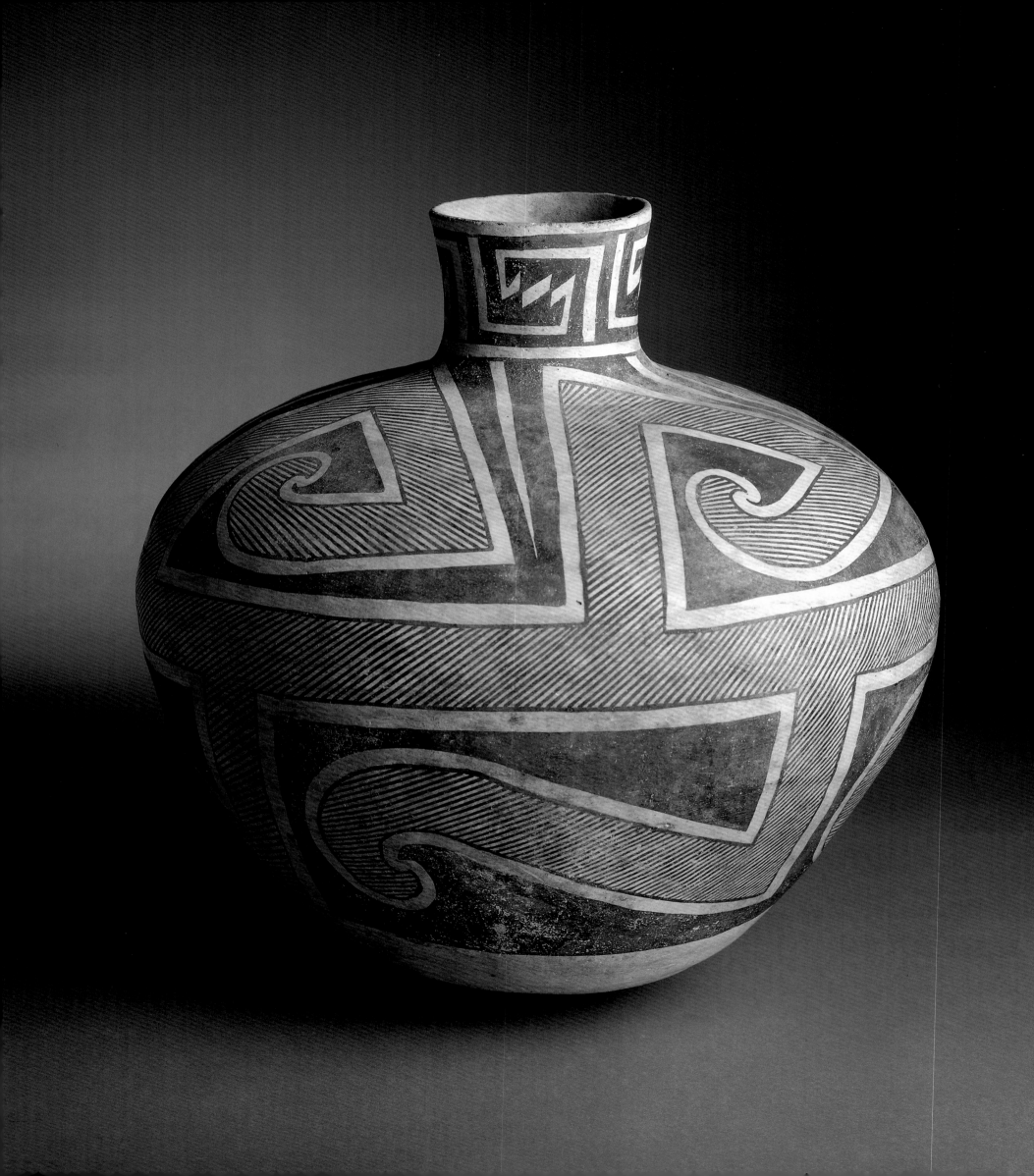

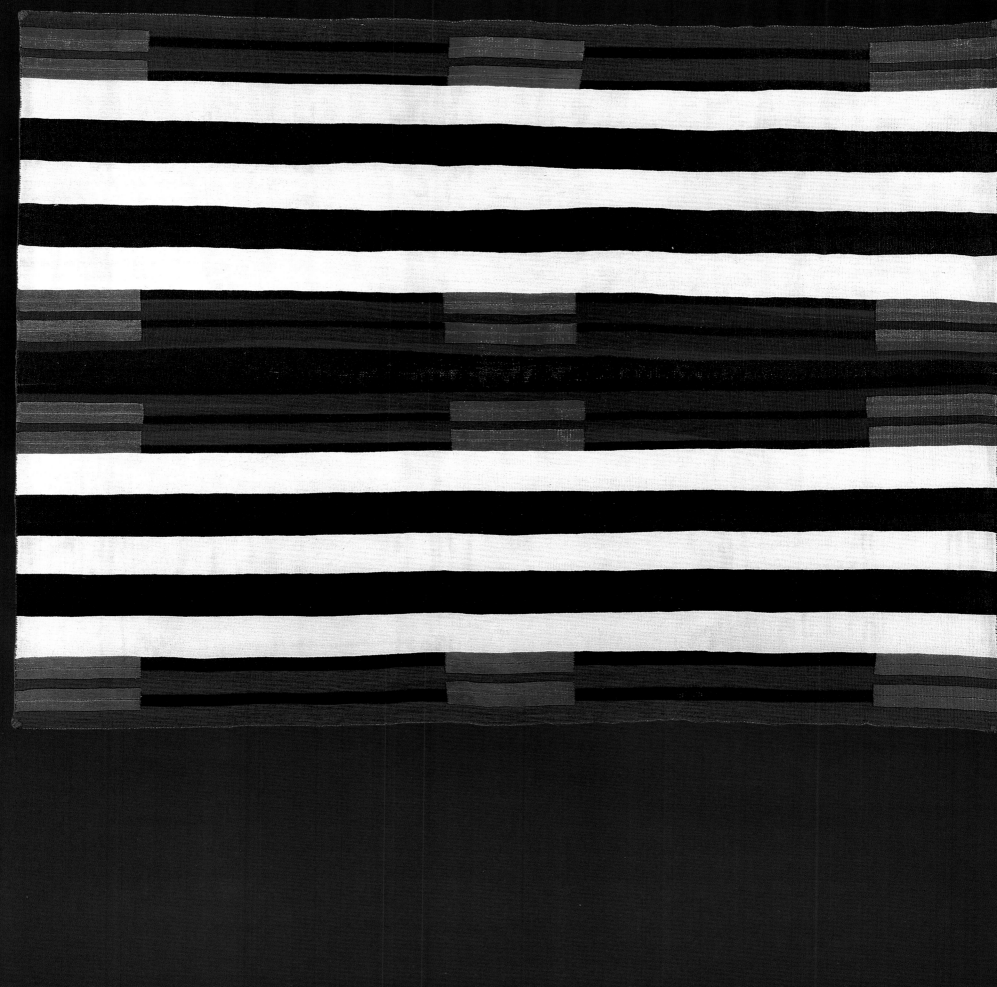

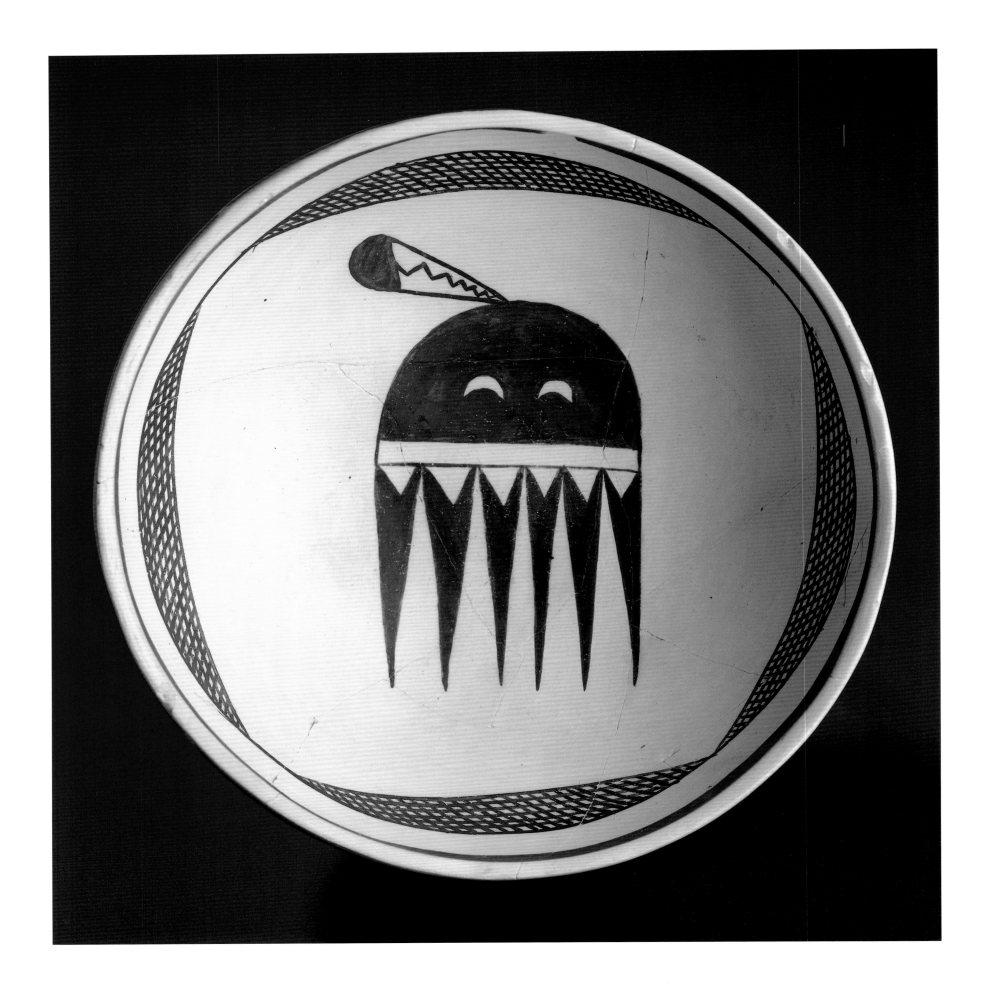

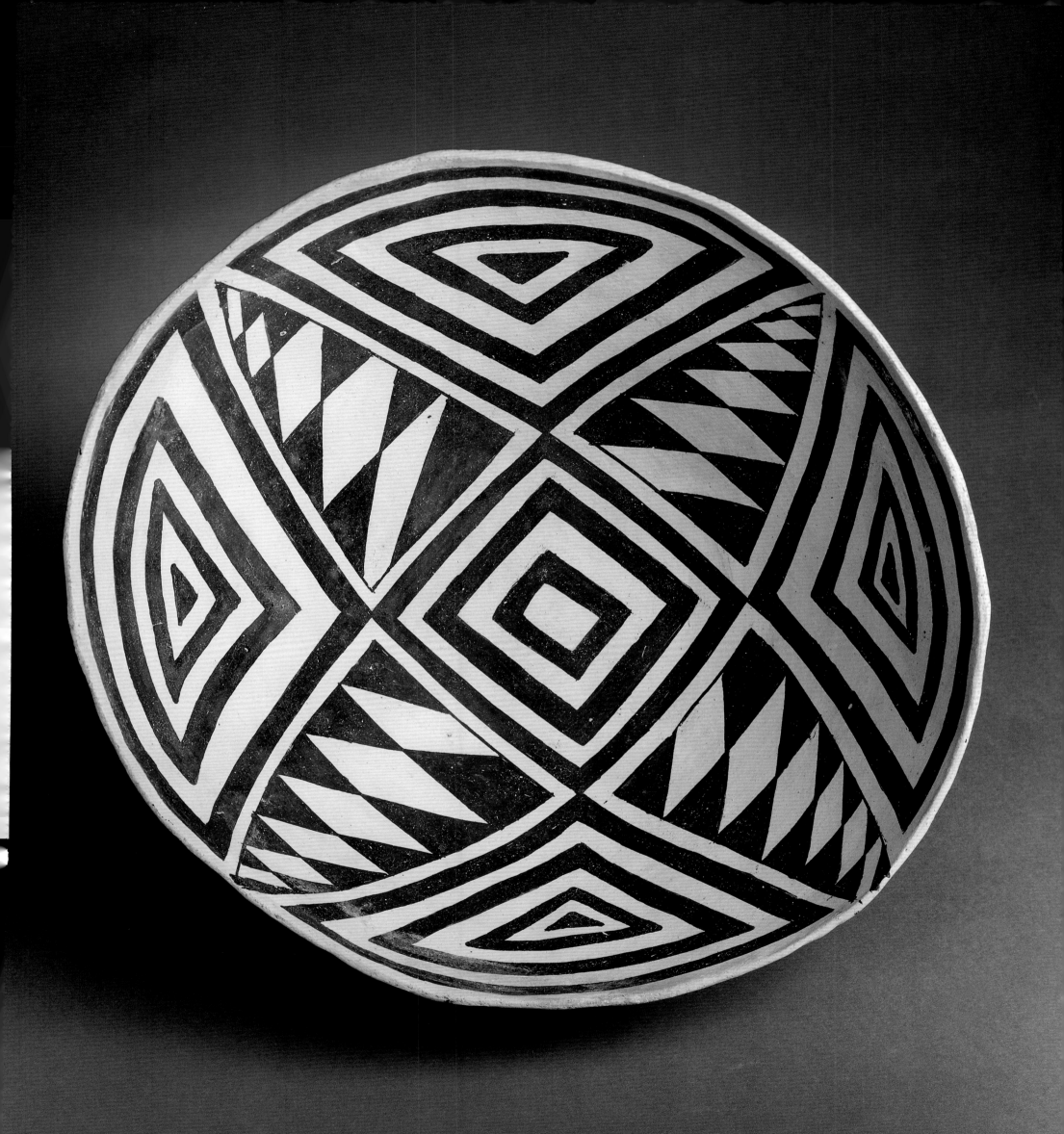

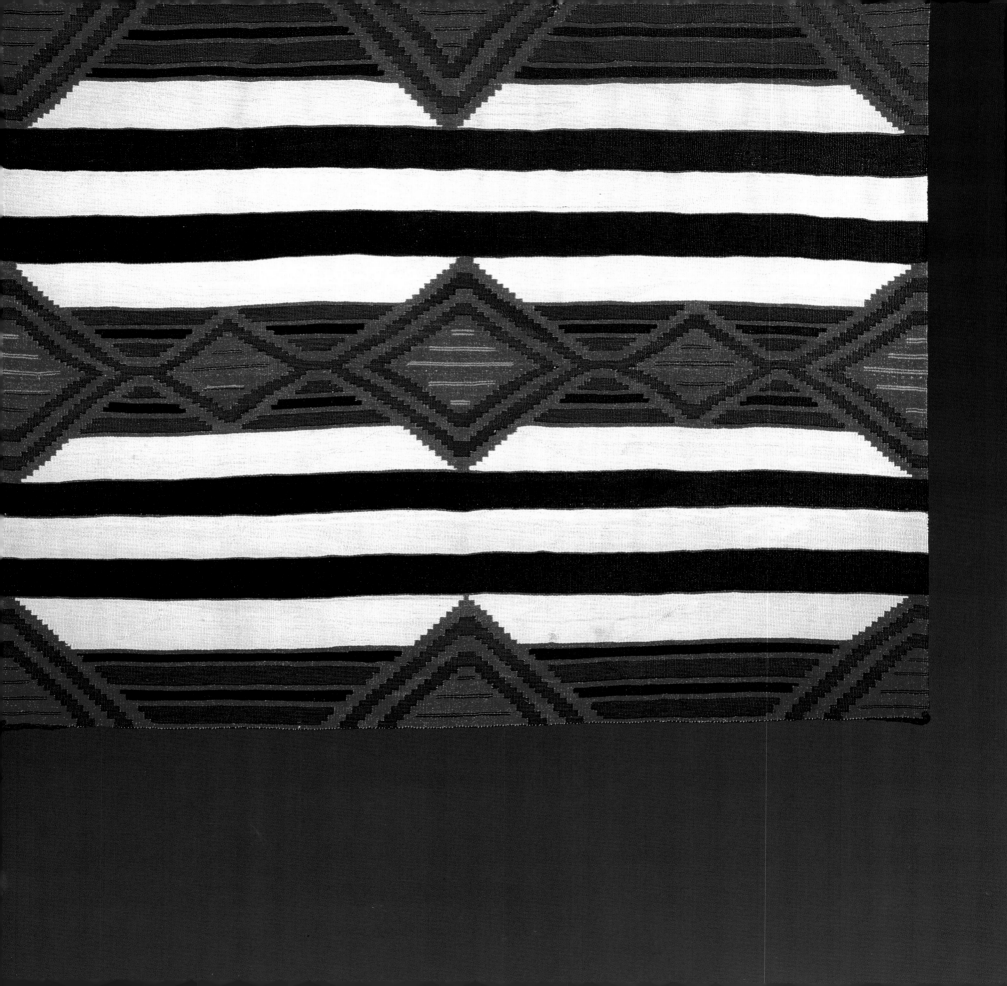

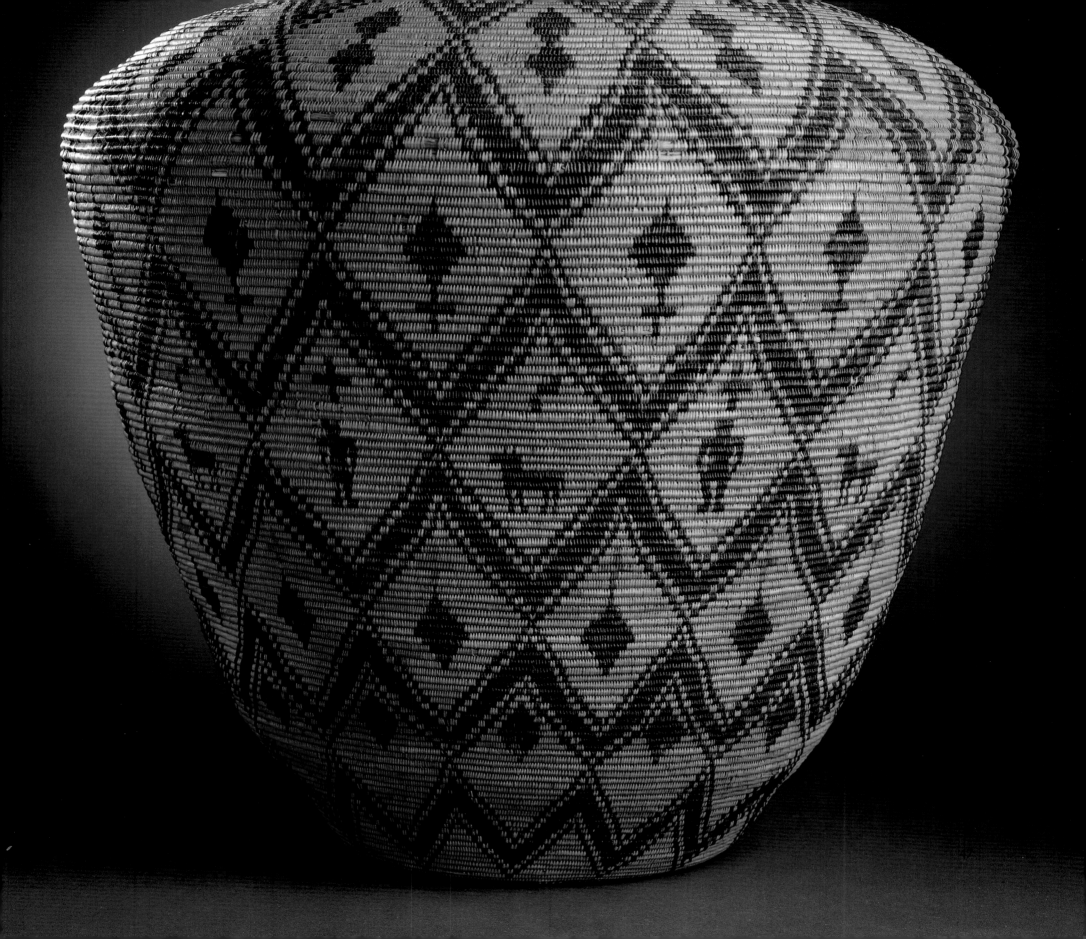

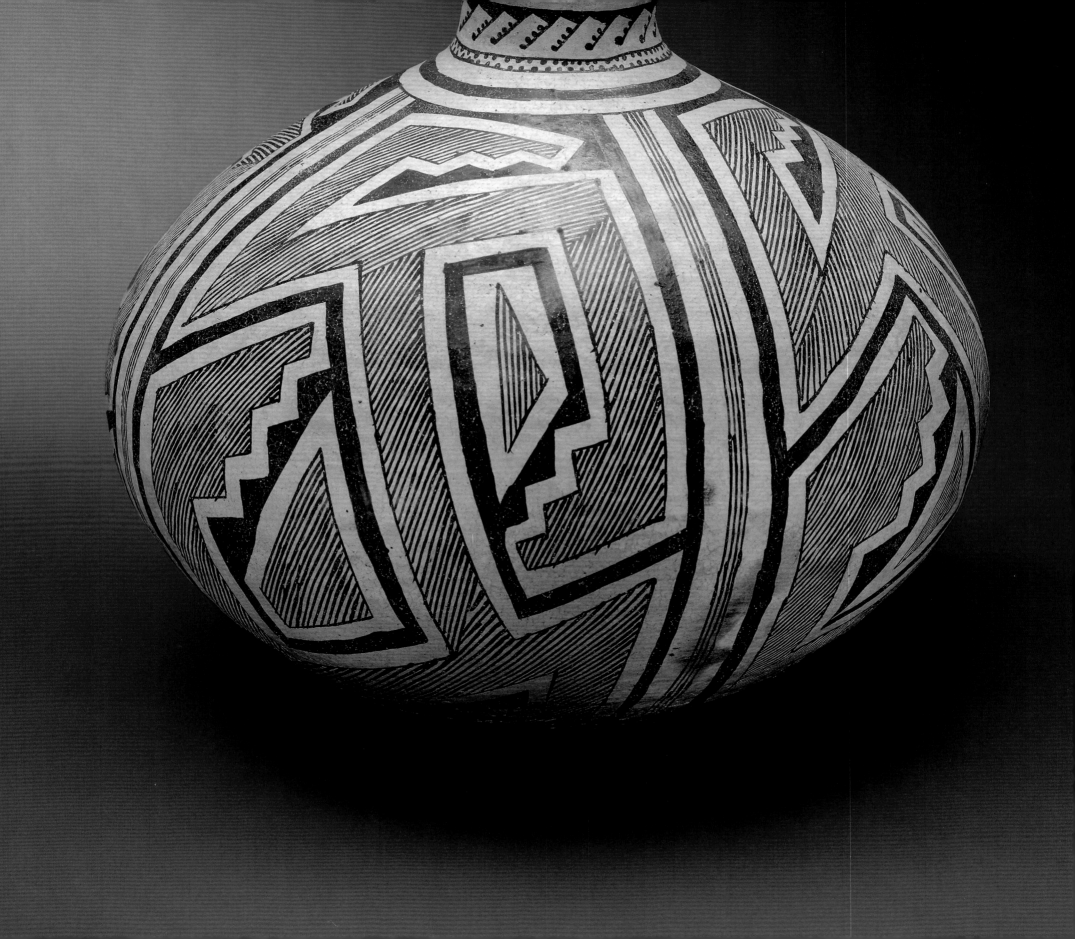

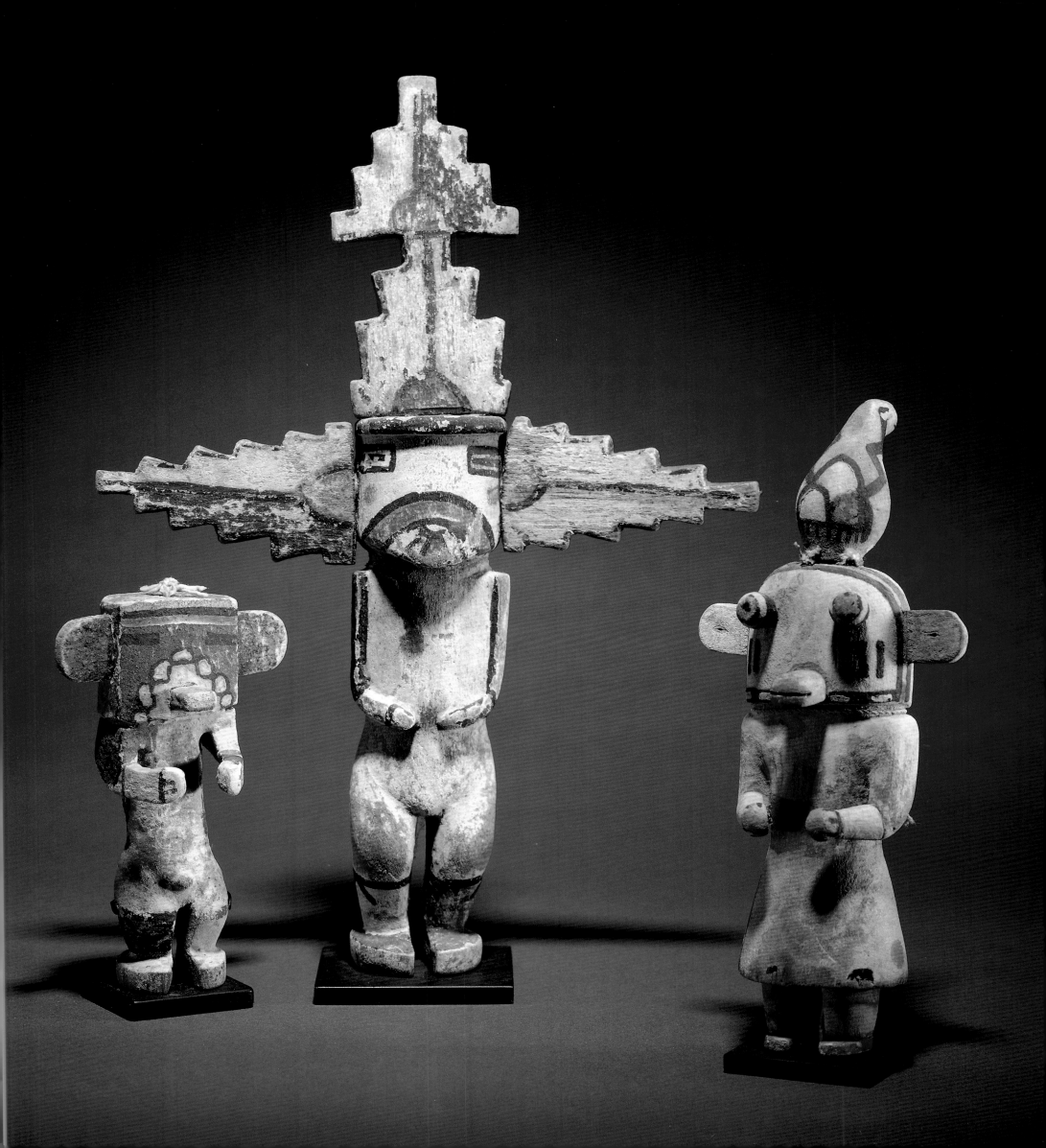

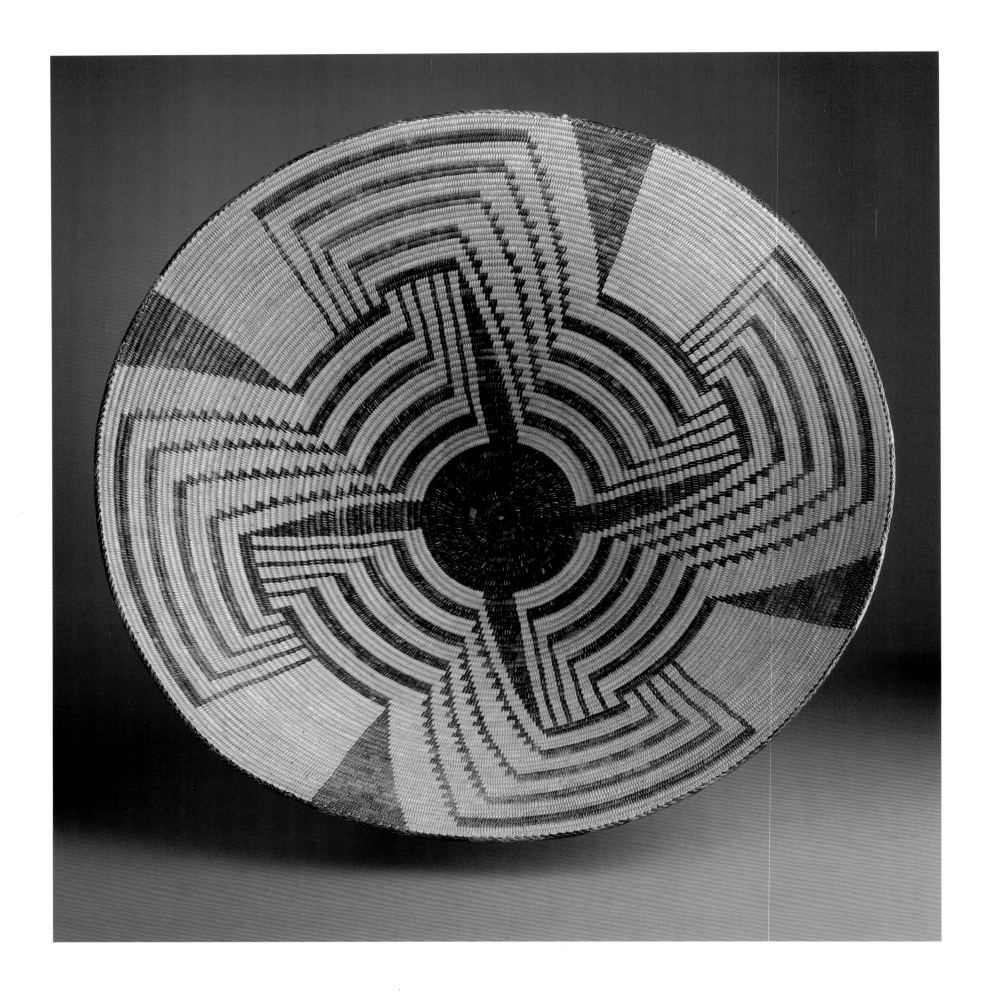

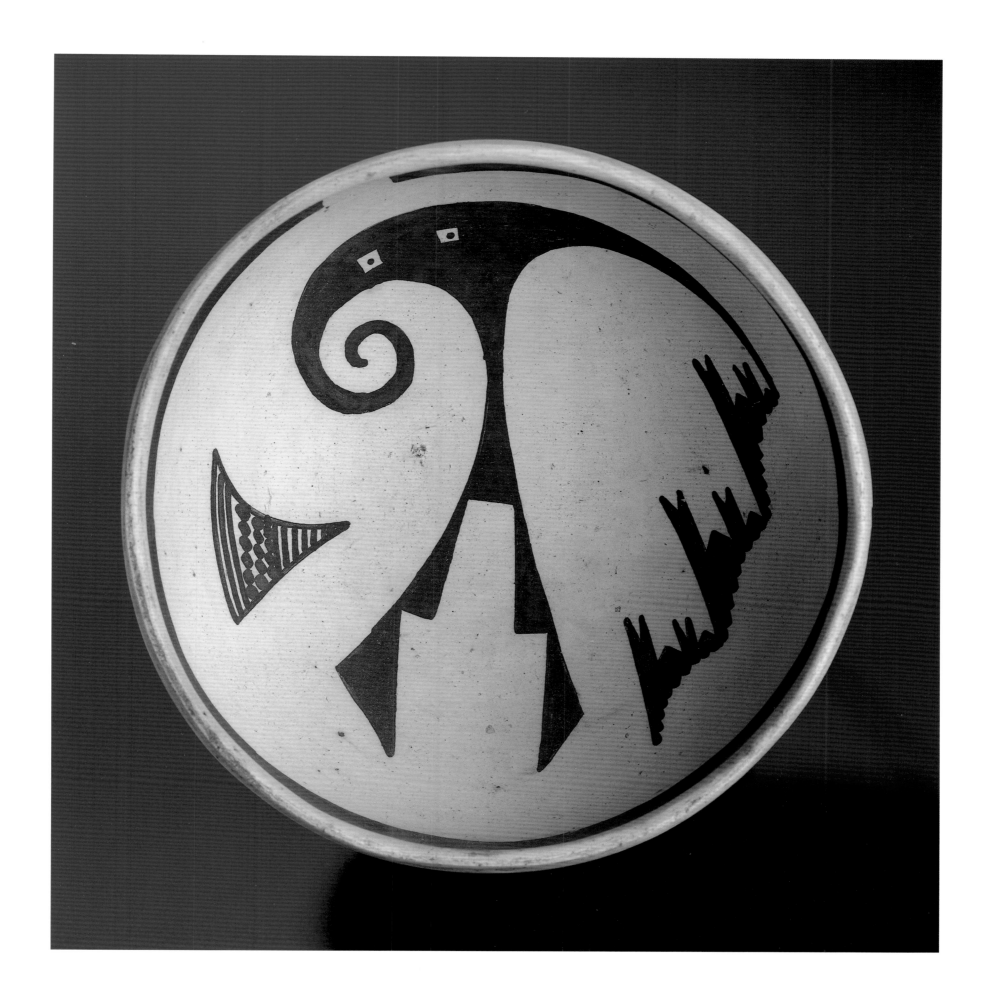

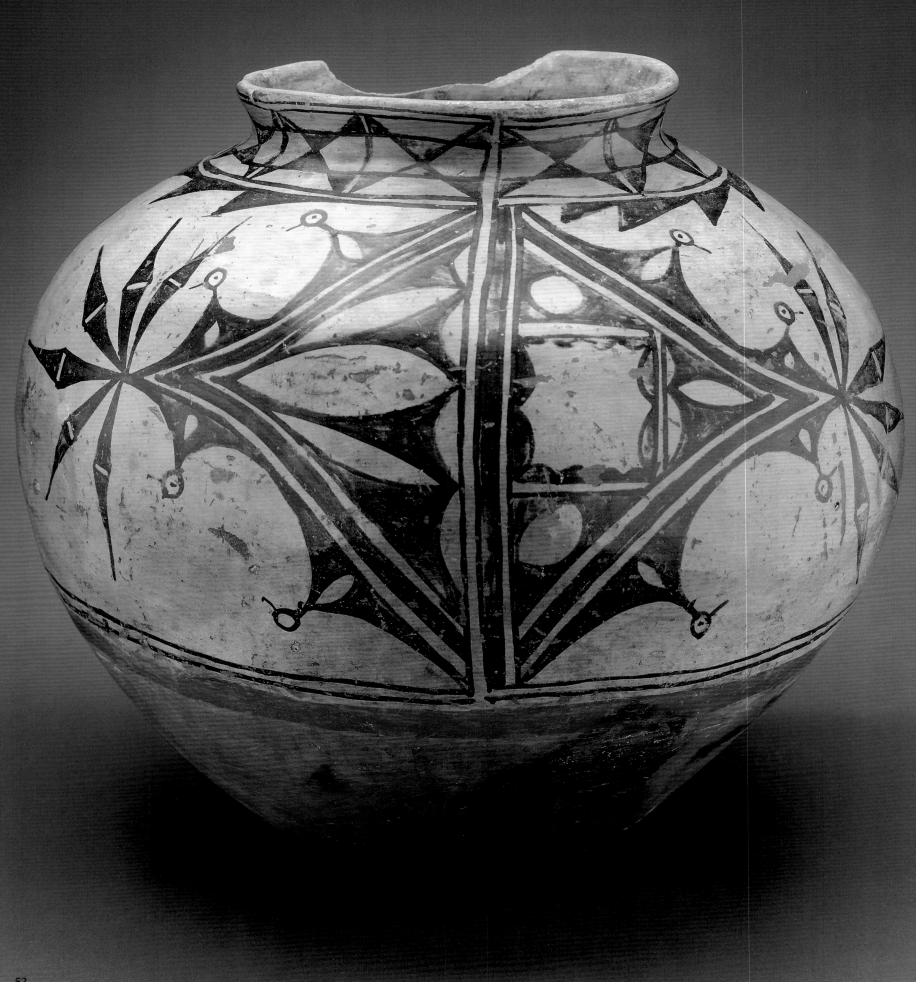

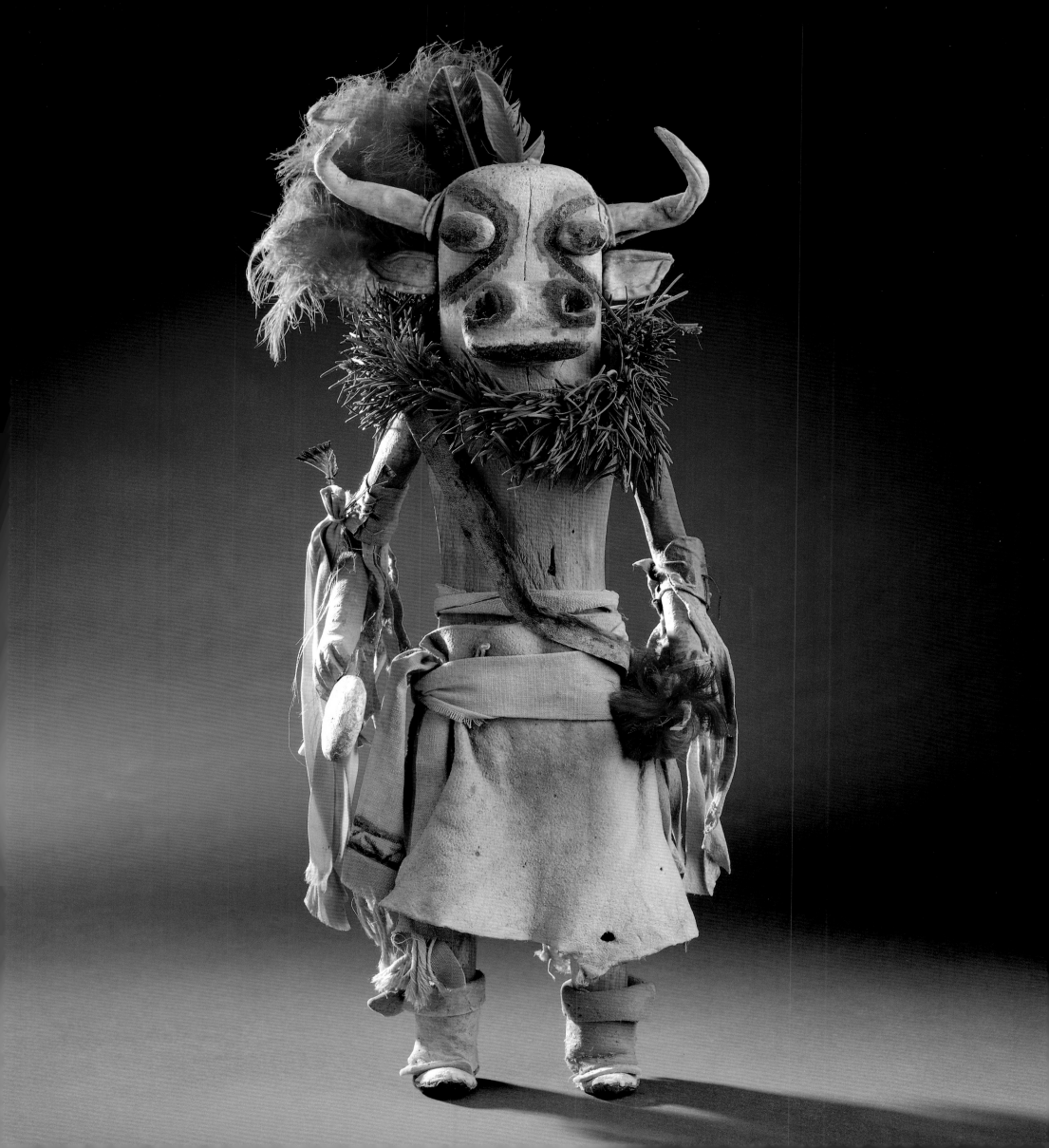

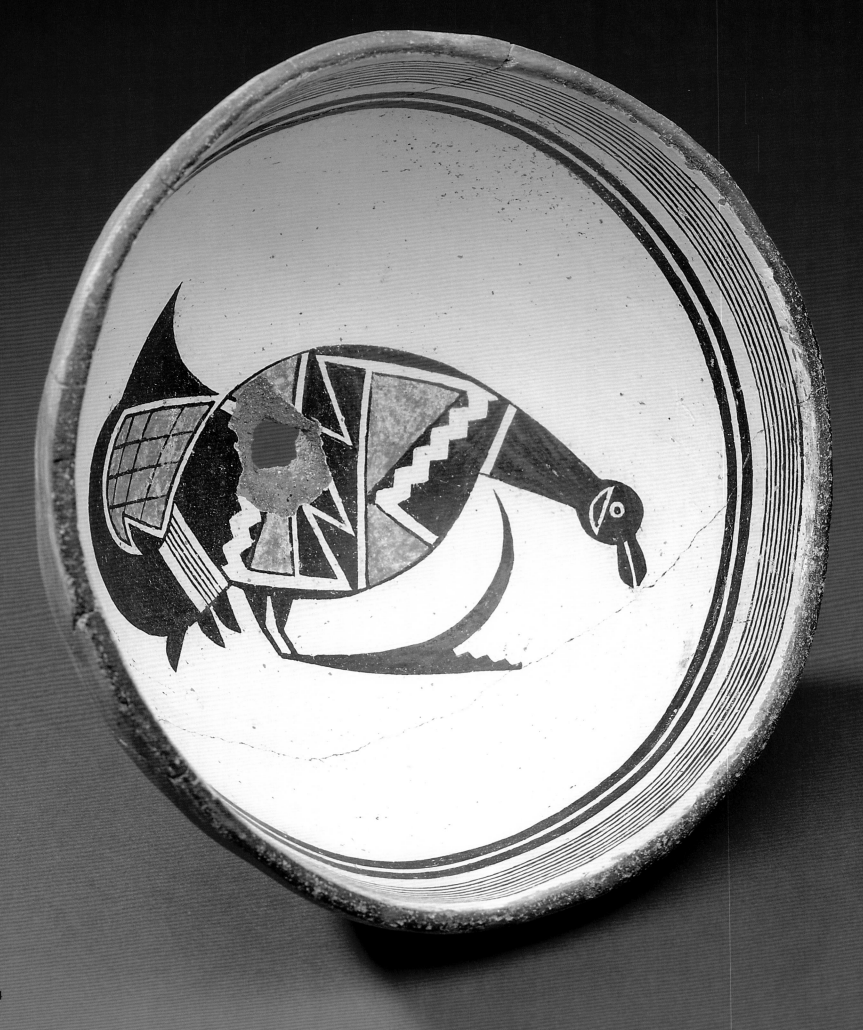

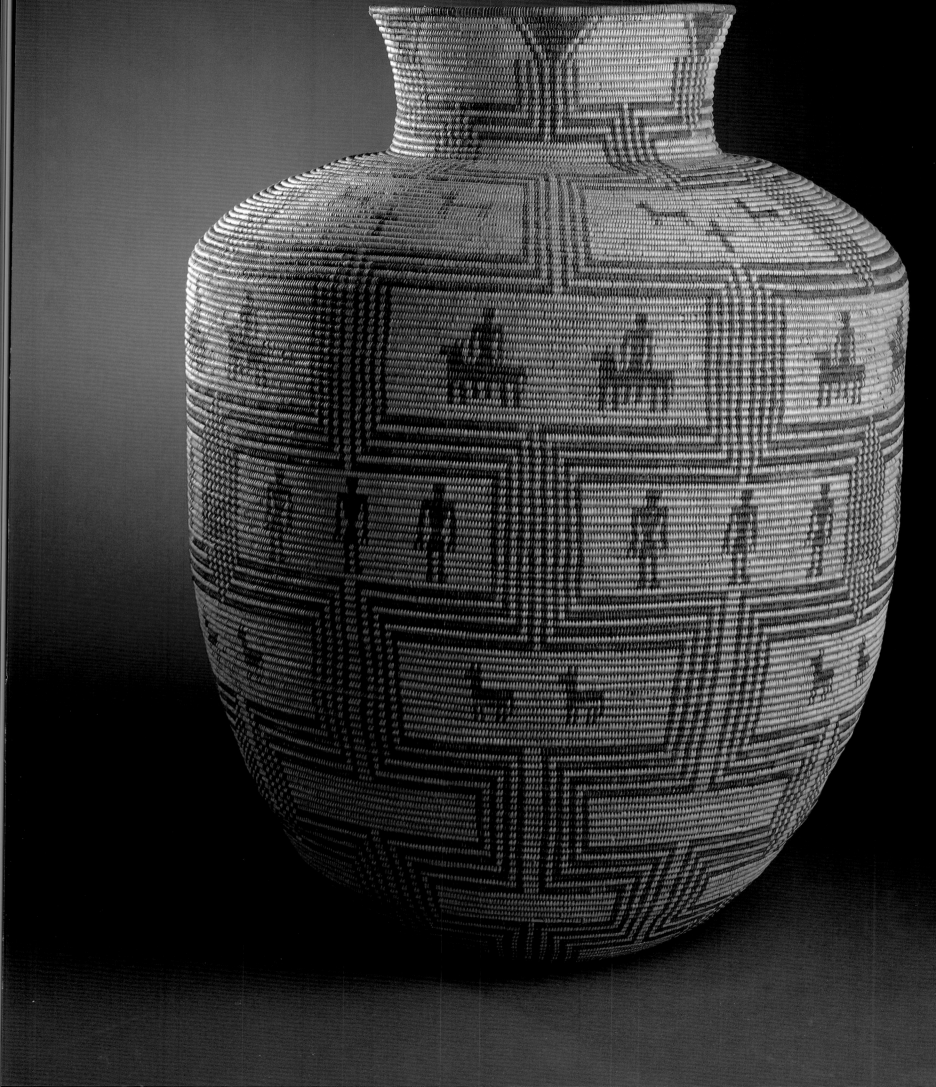

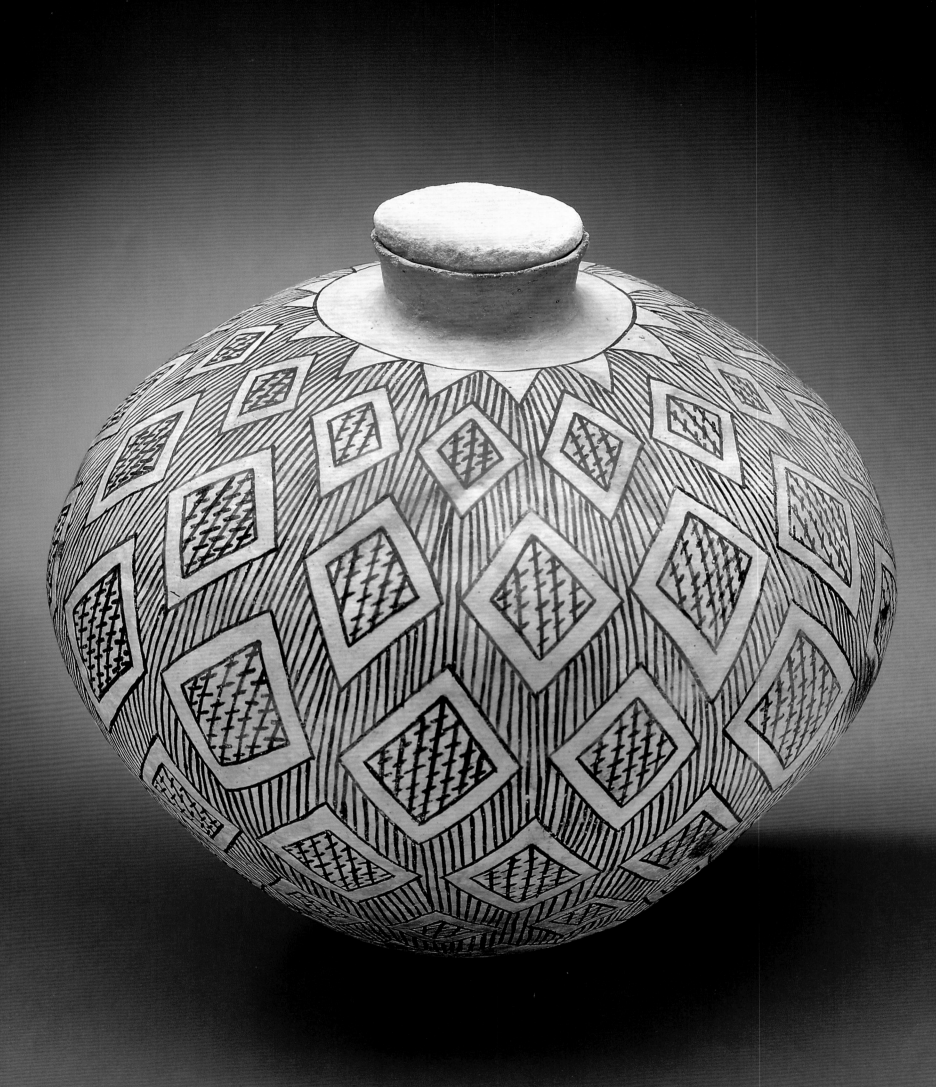

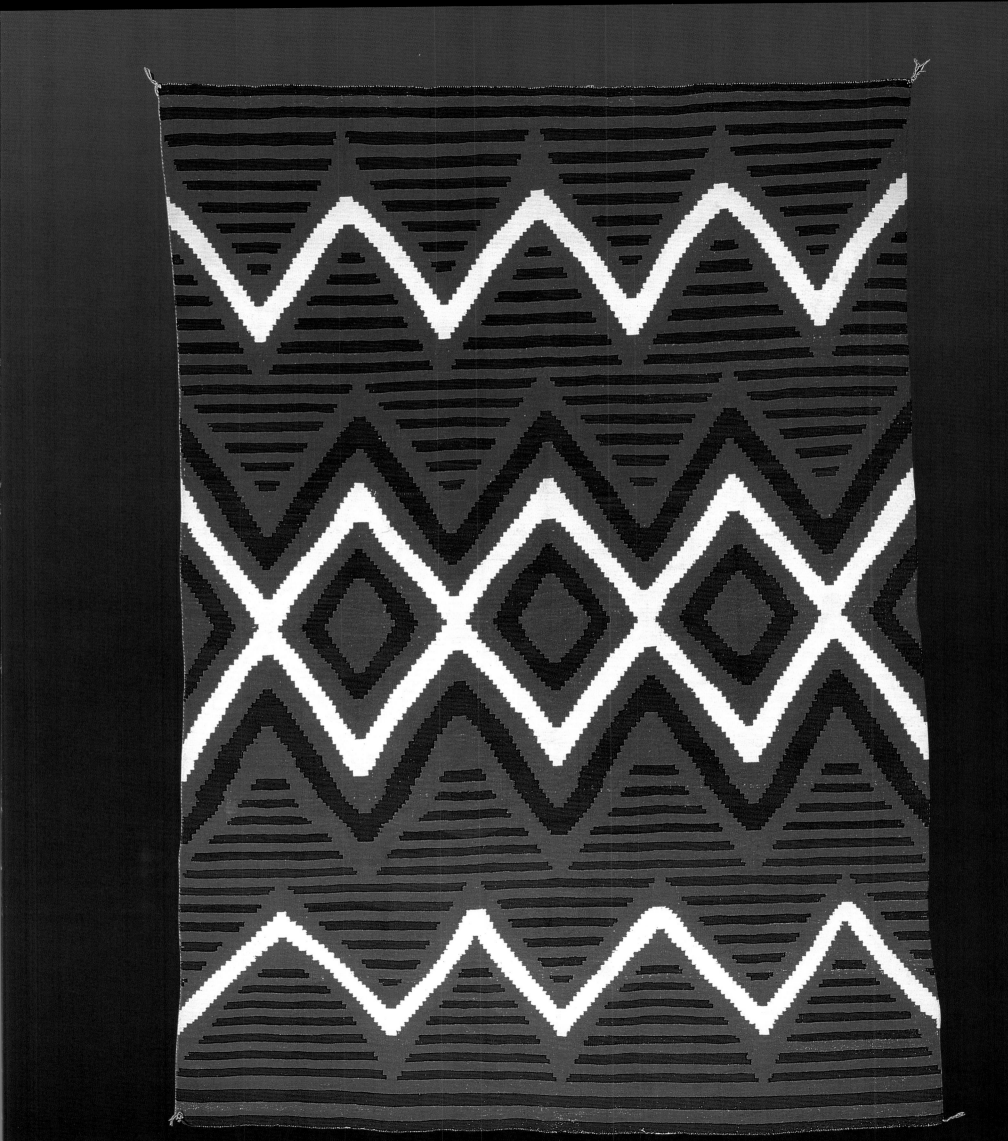

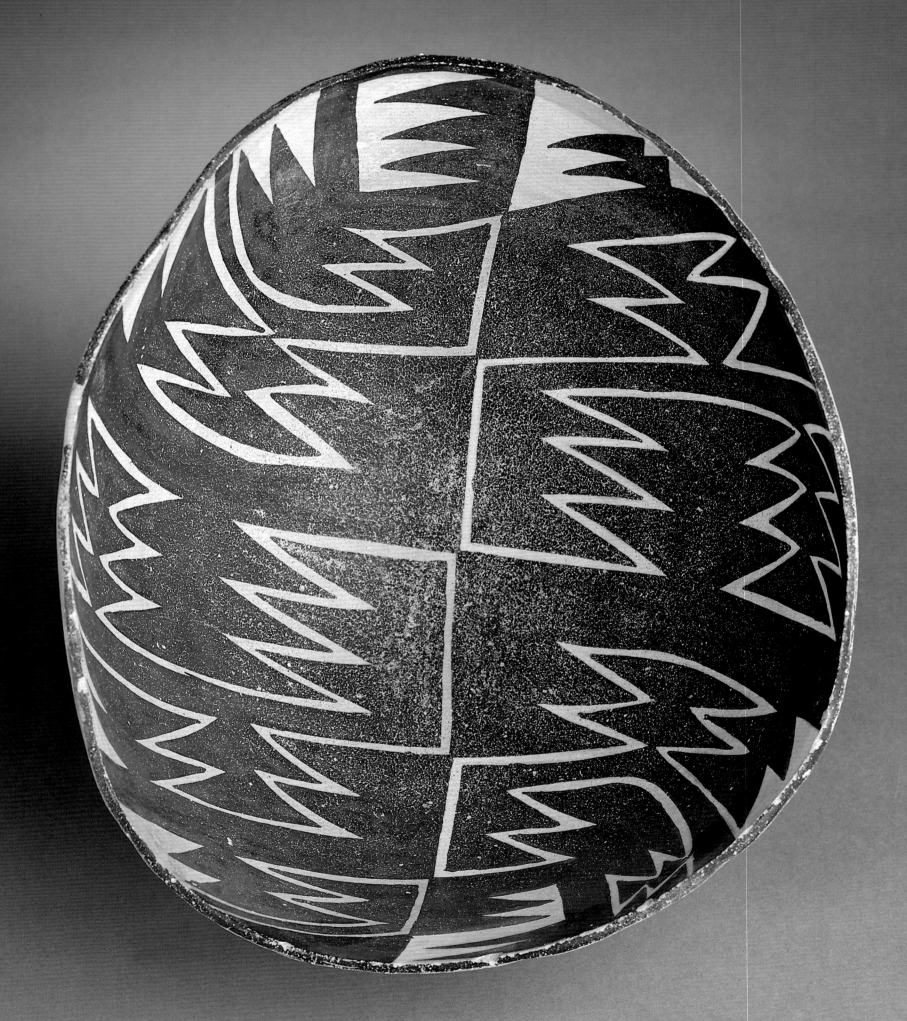

58

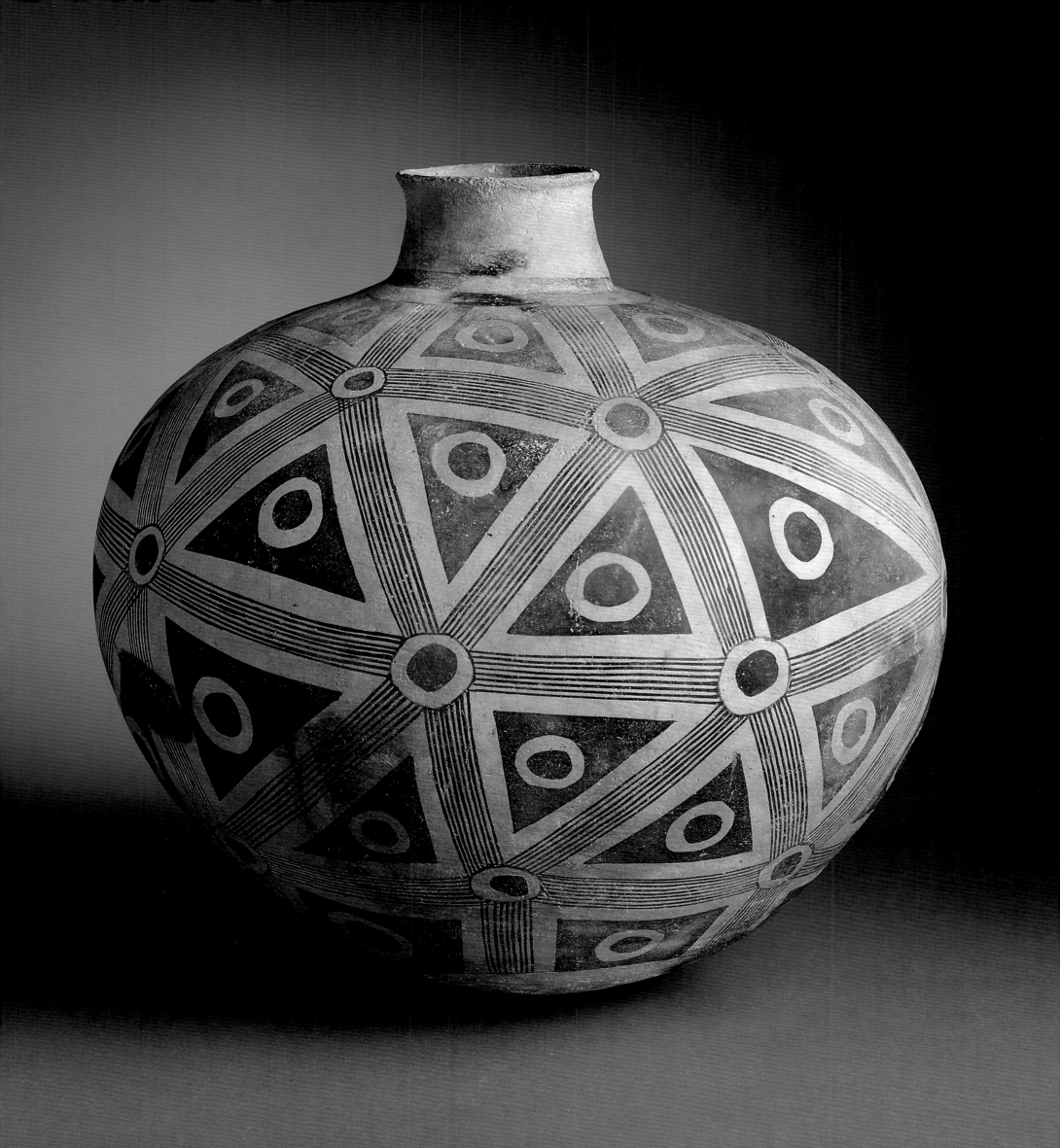

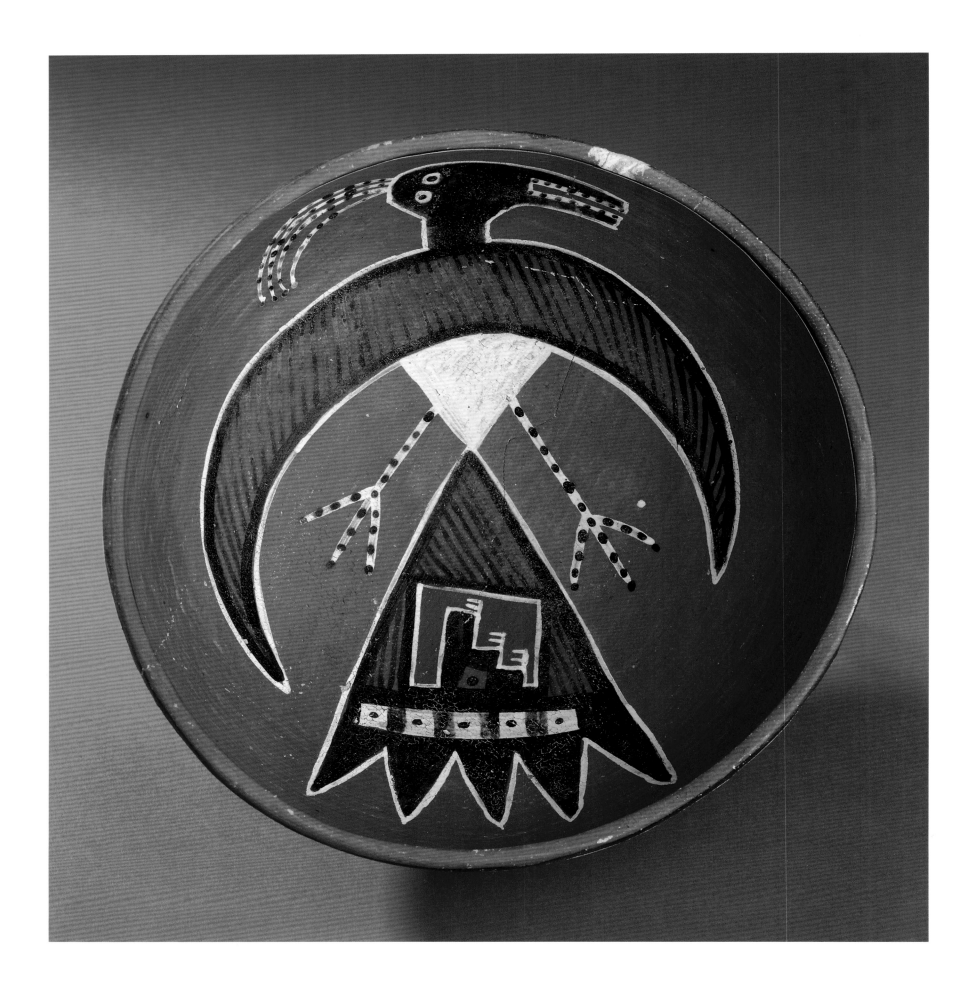

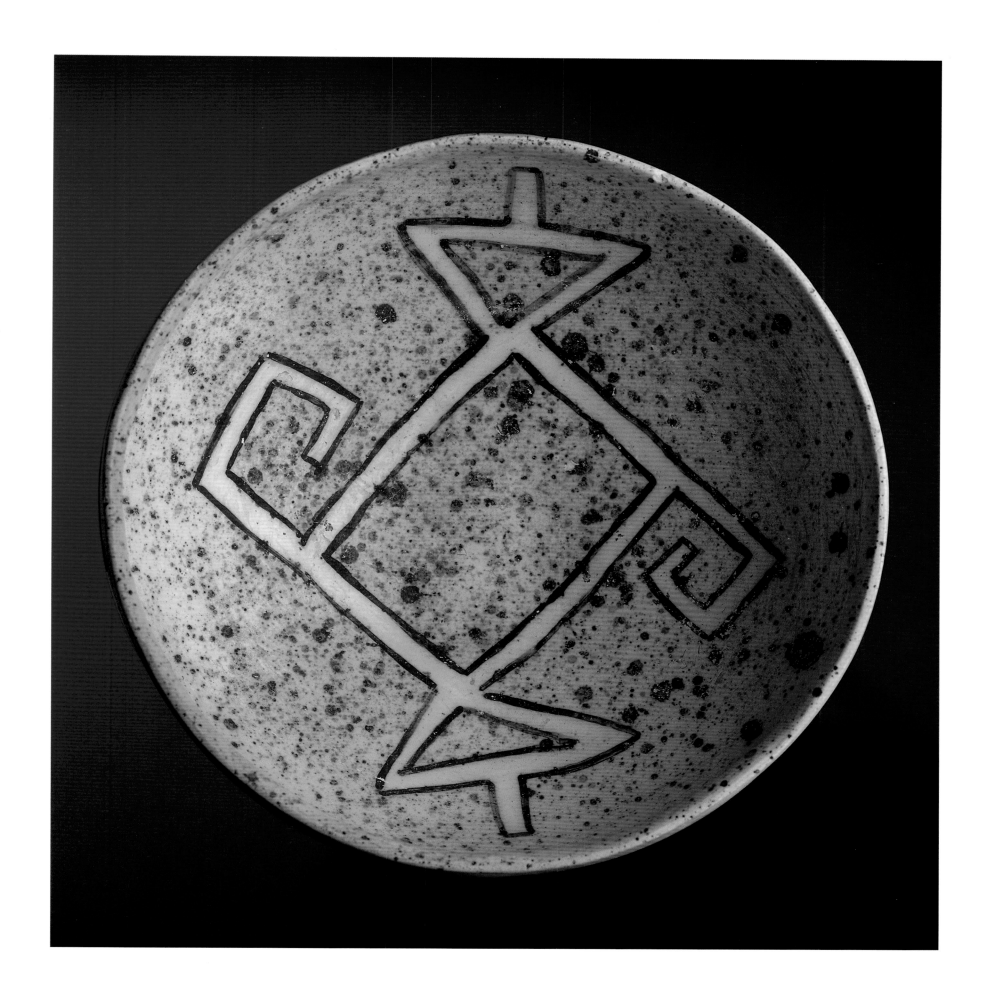

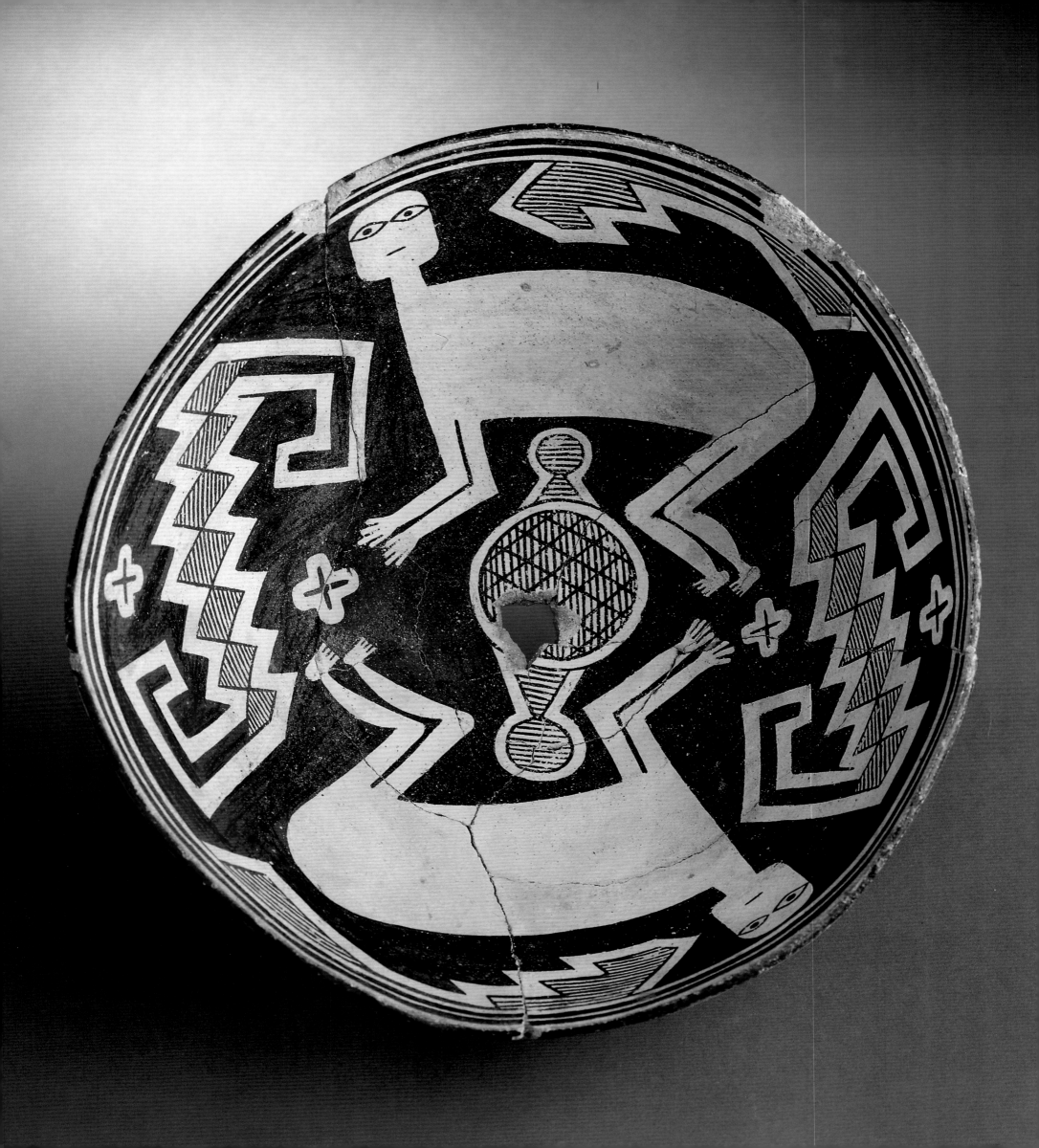

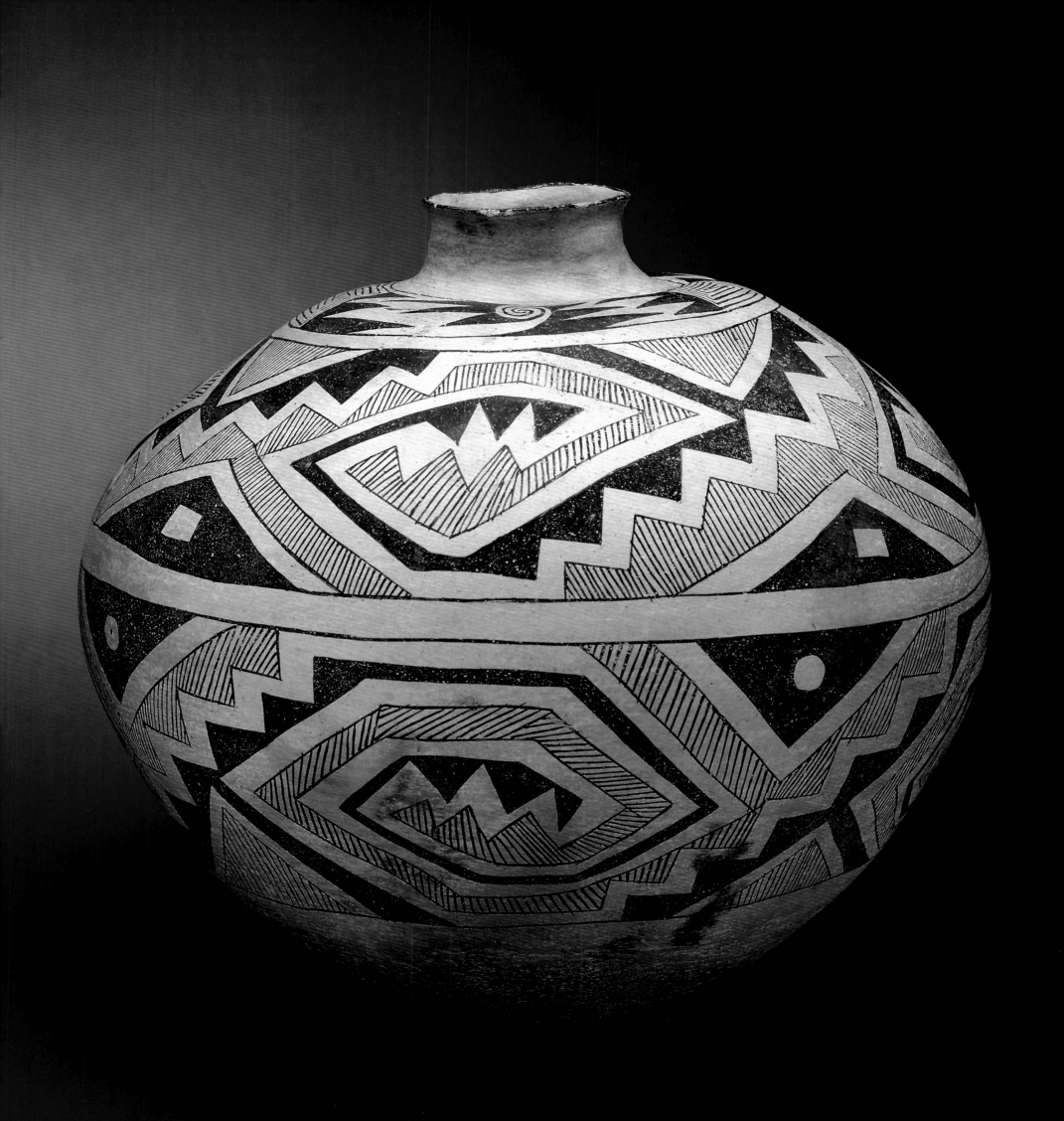

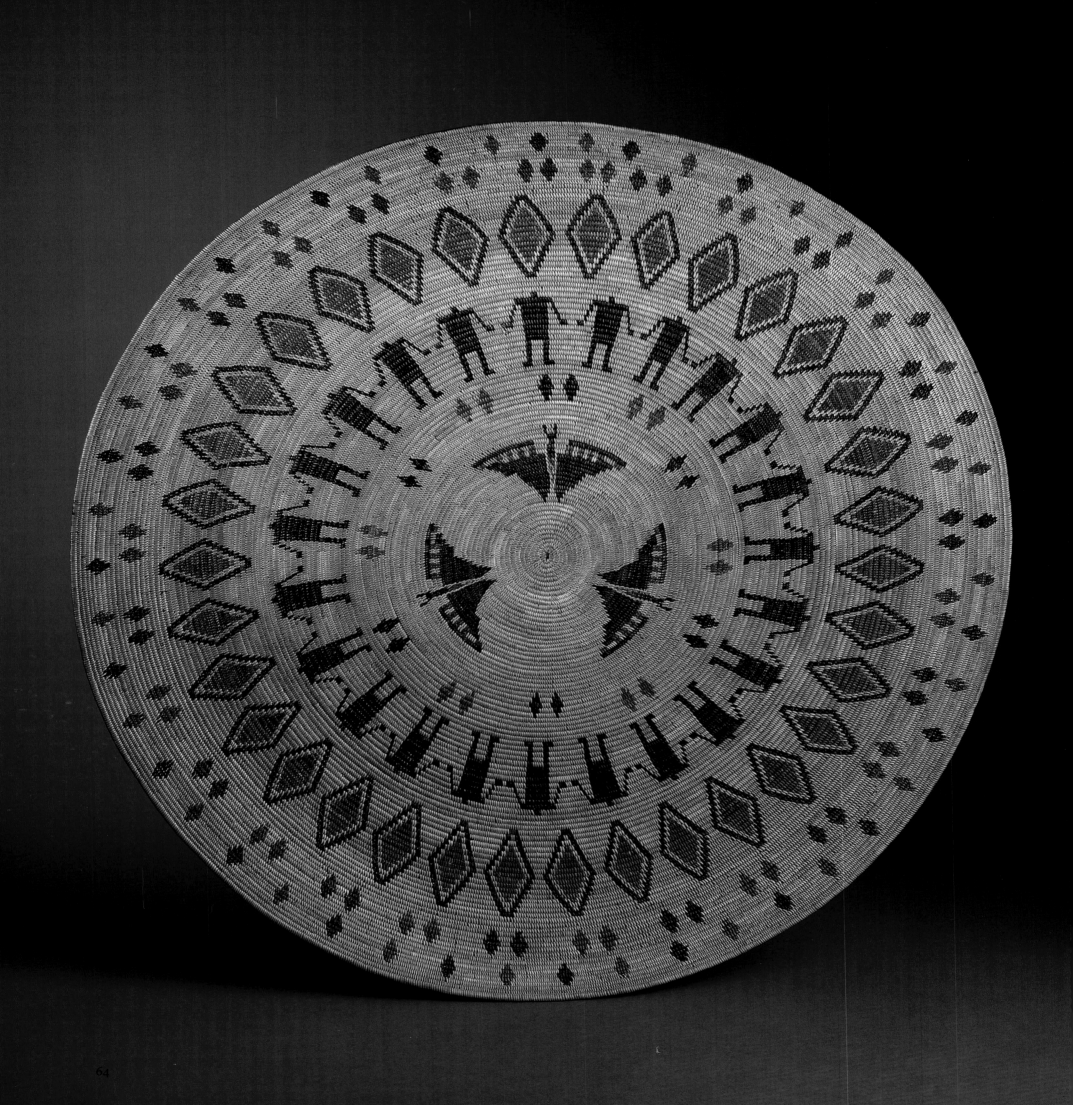

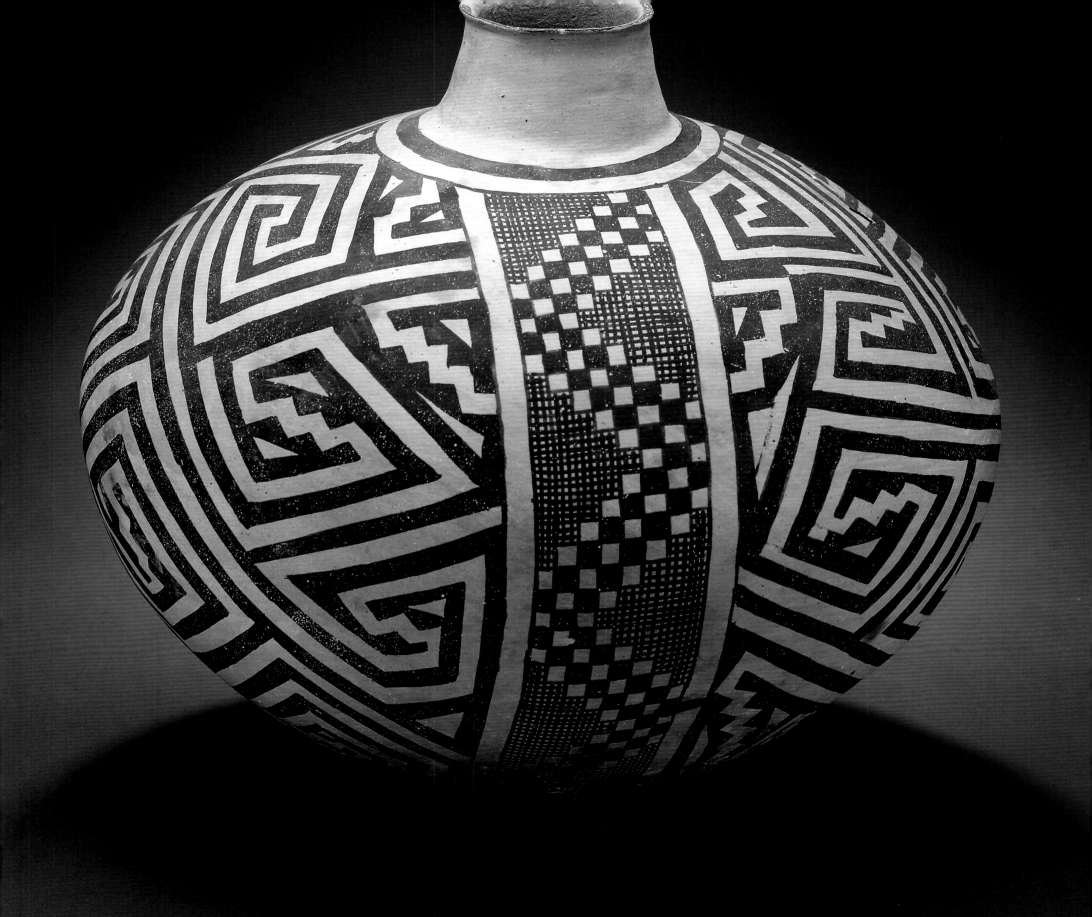

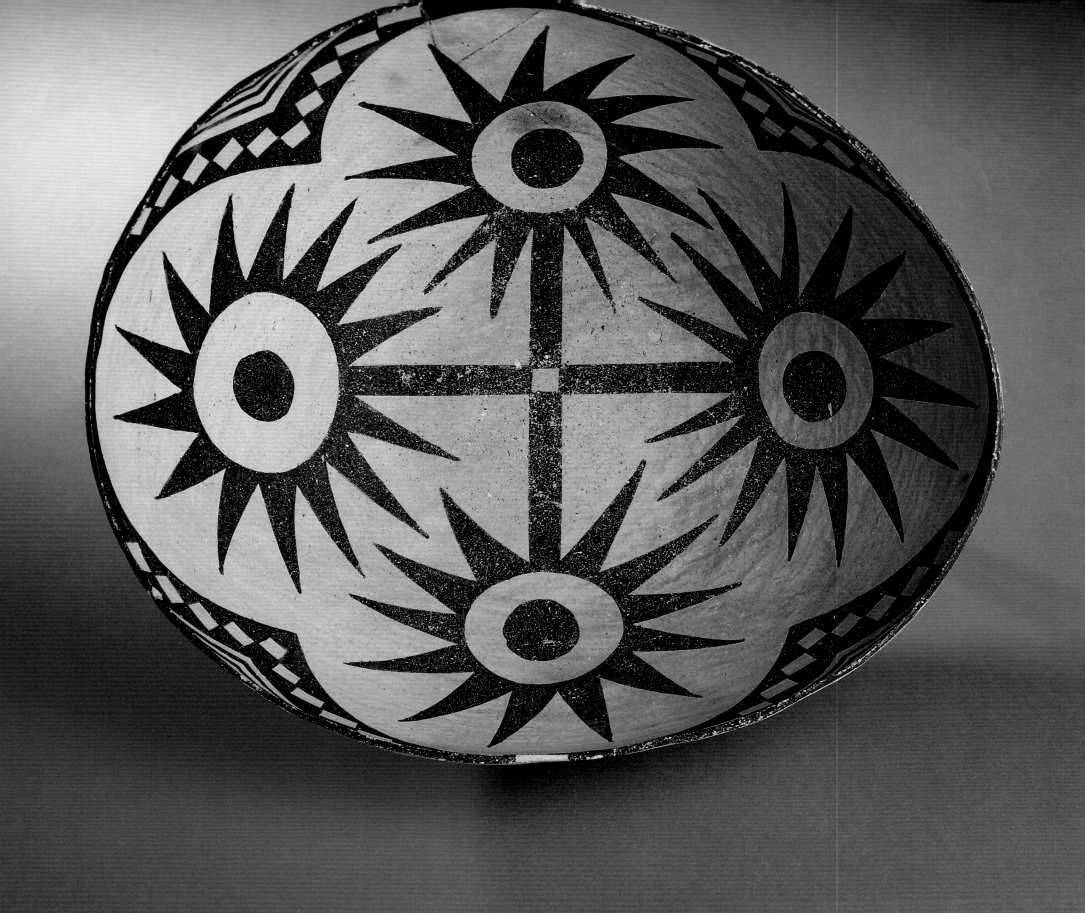

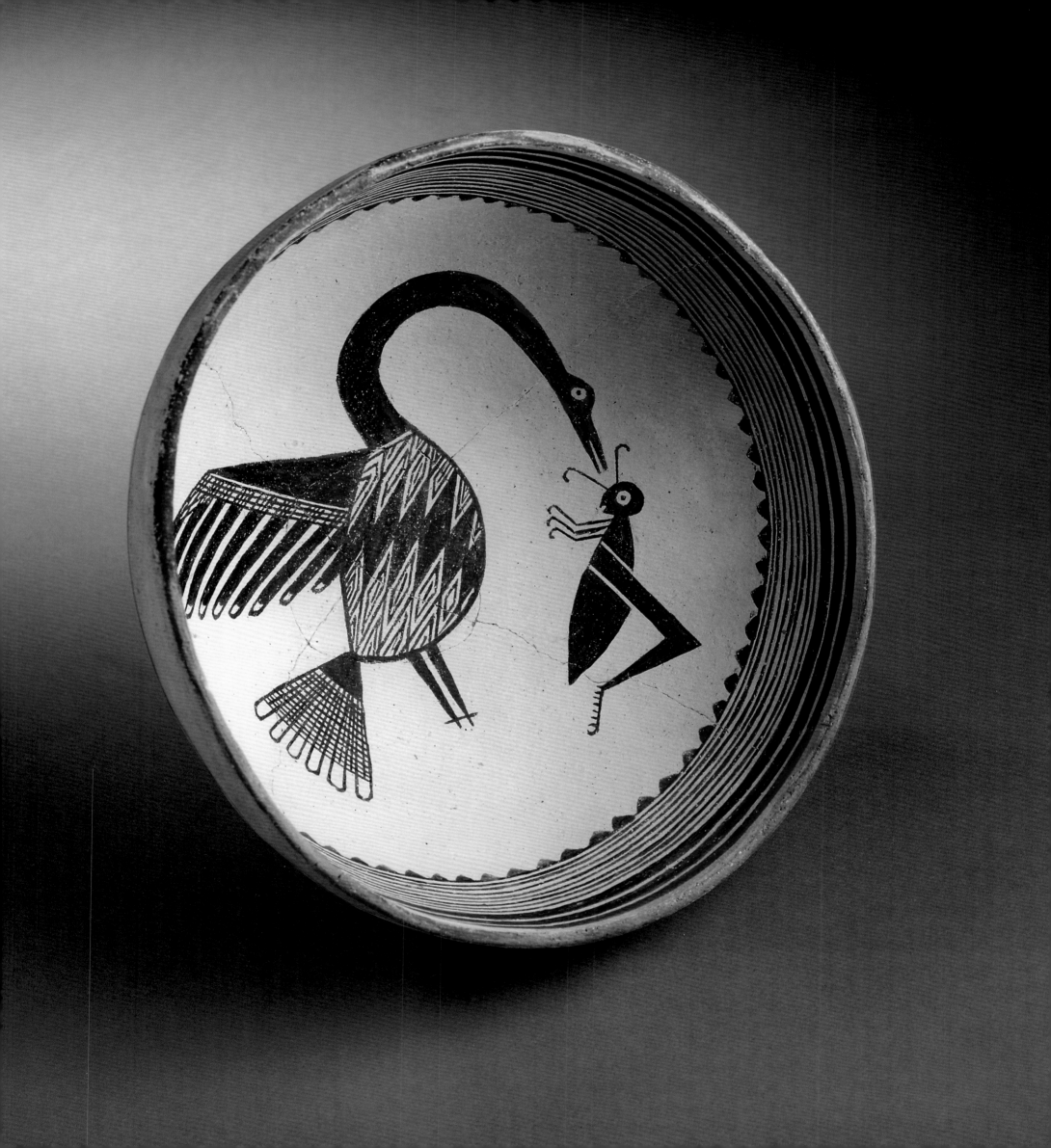

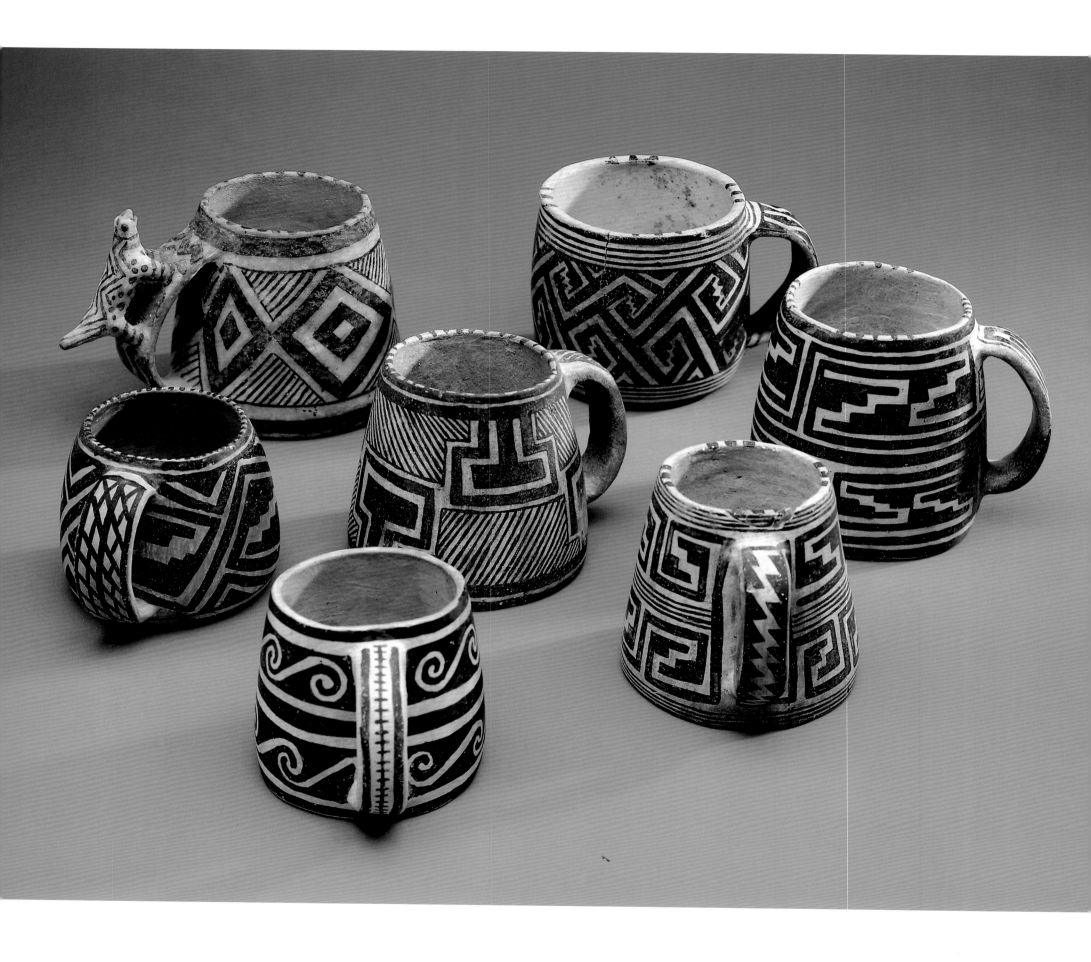

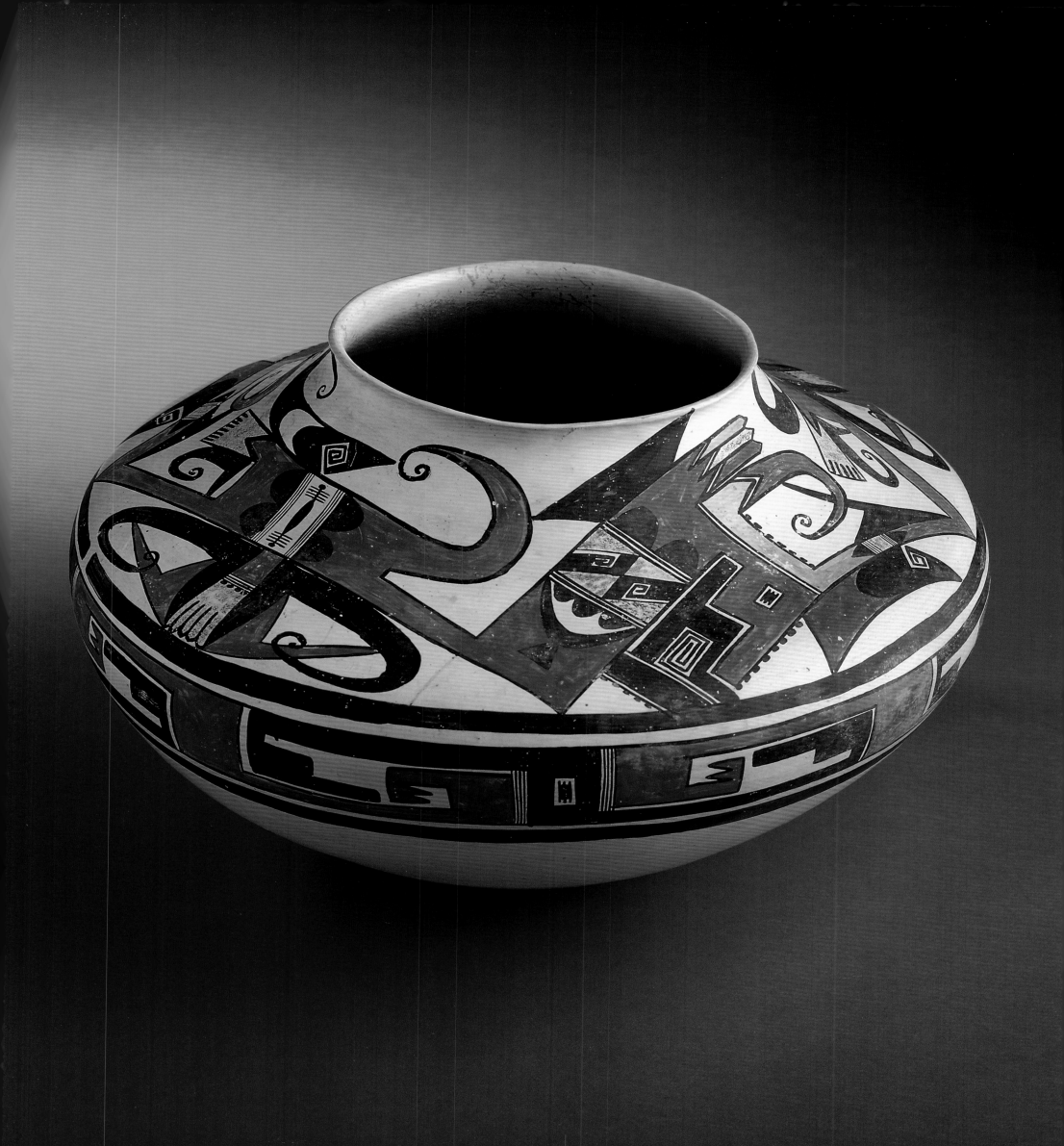

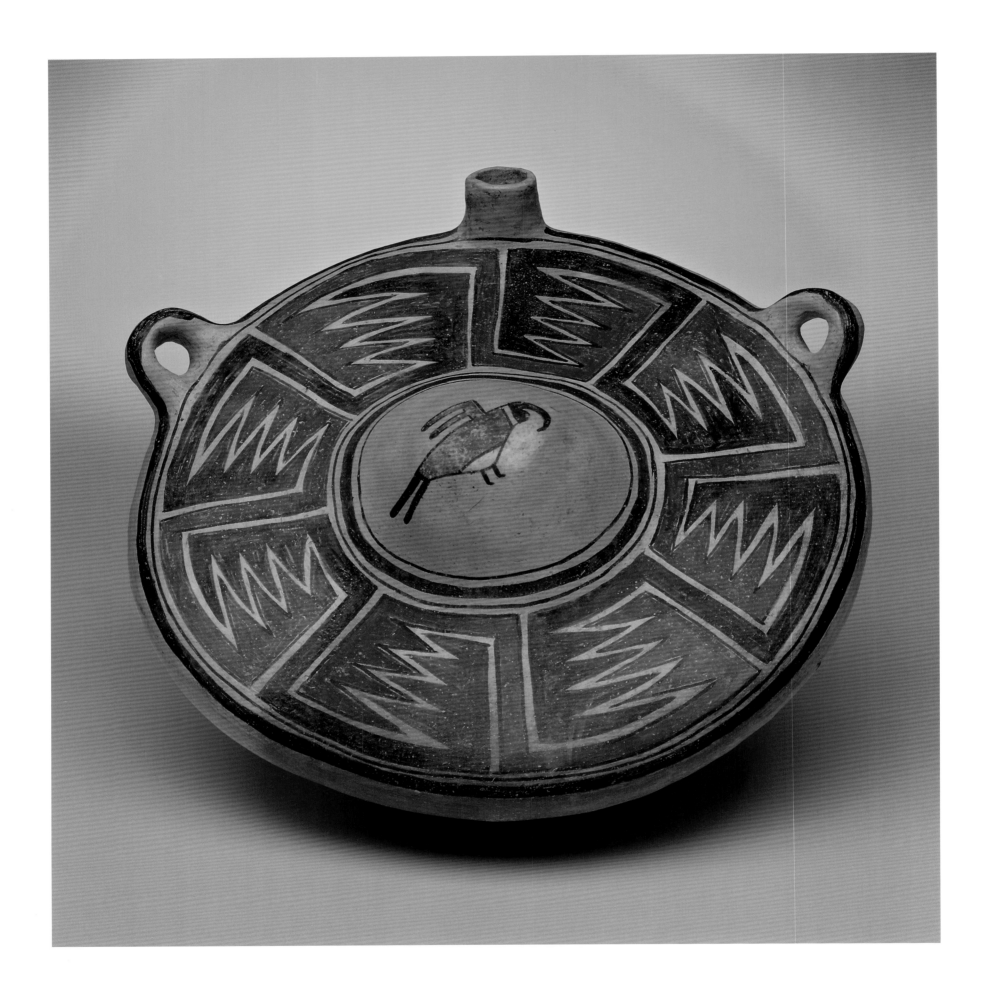

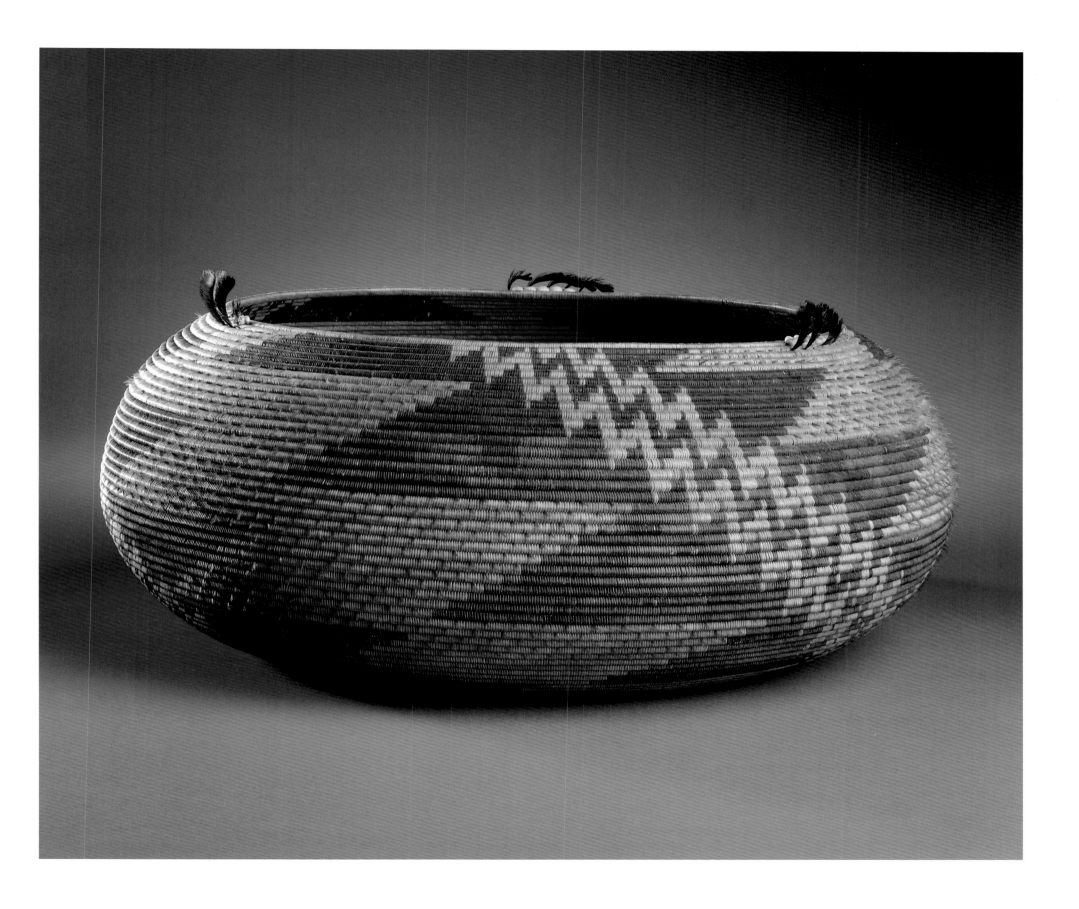

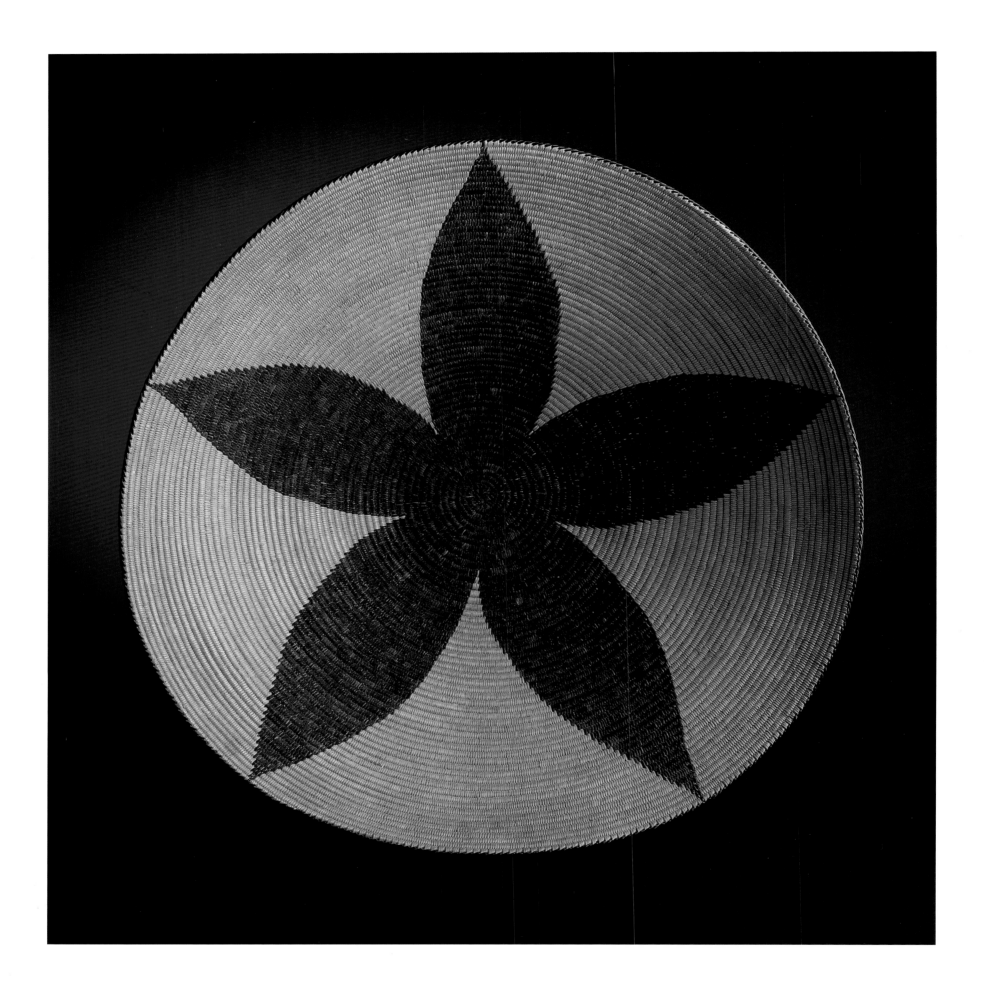

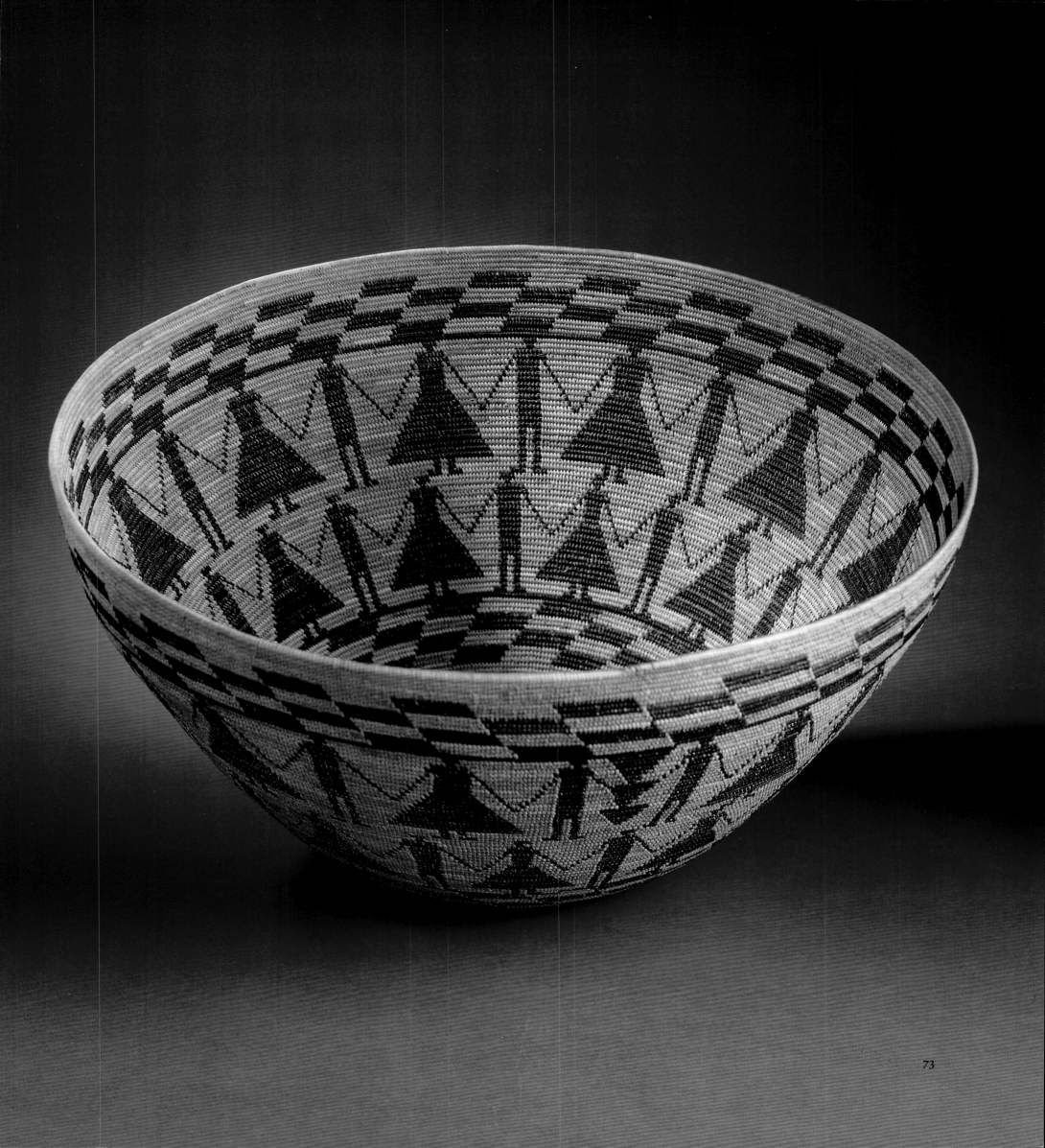

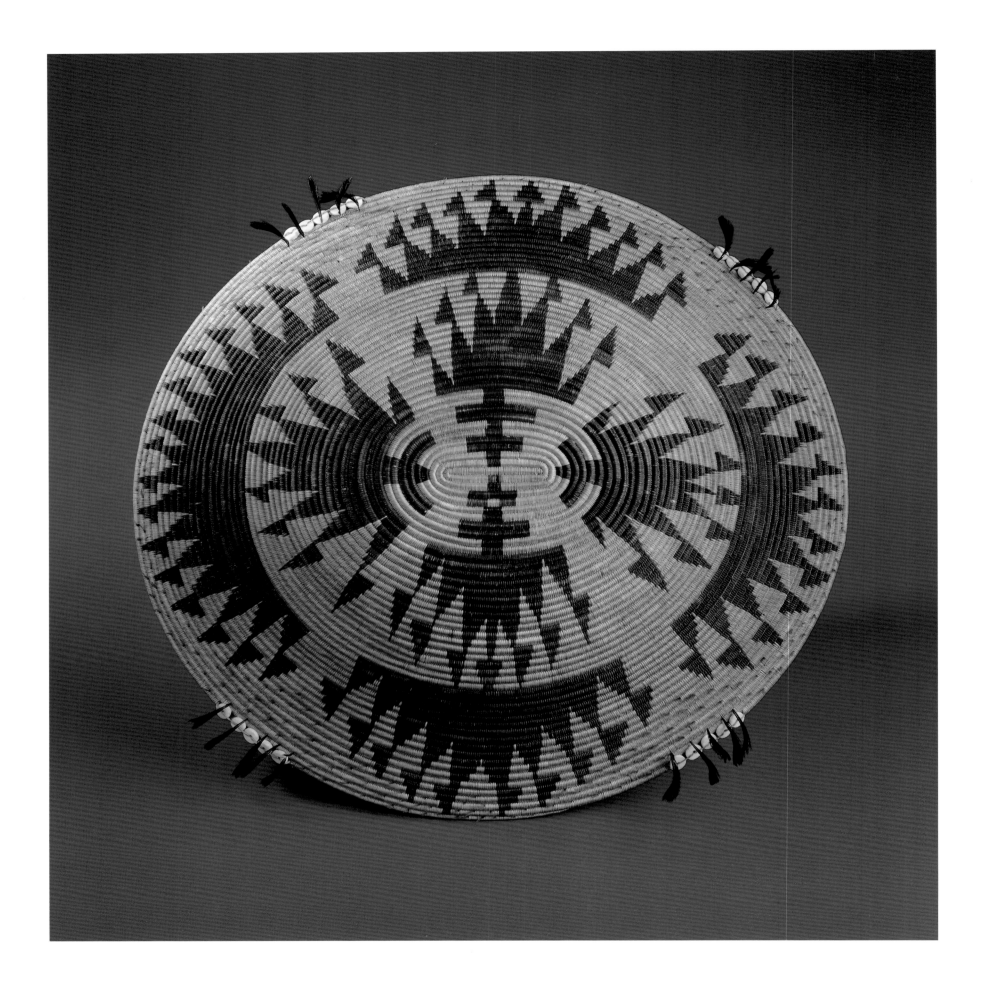

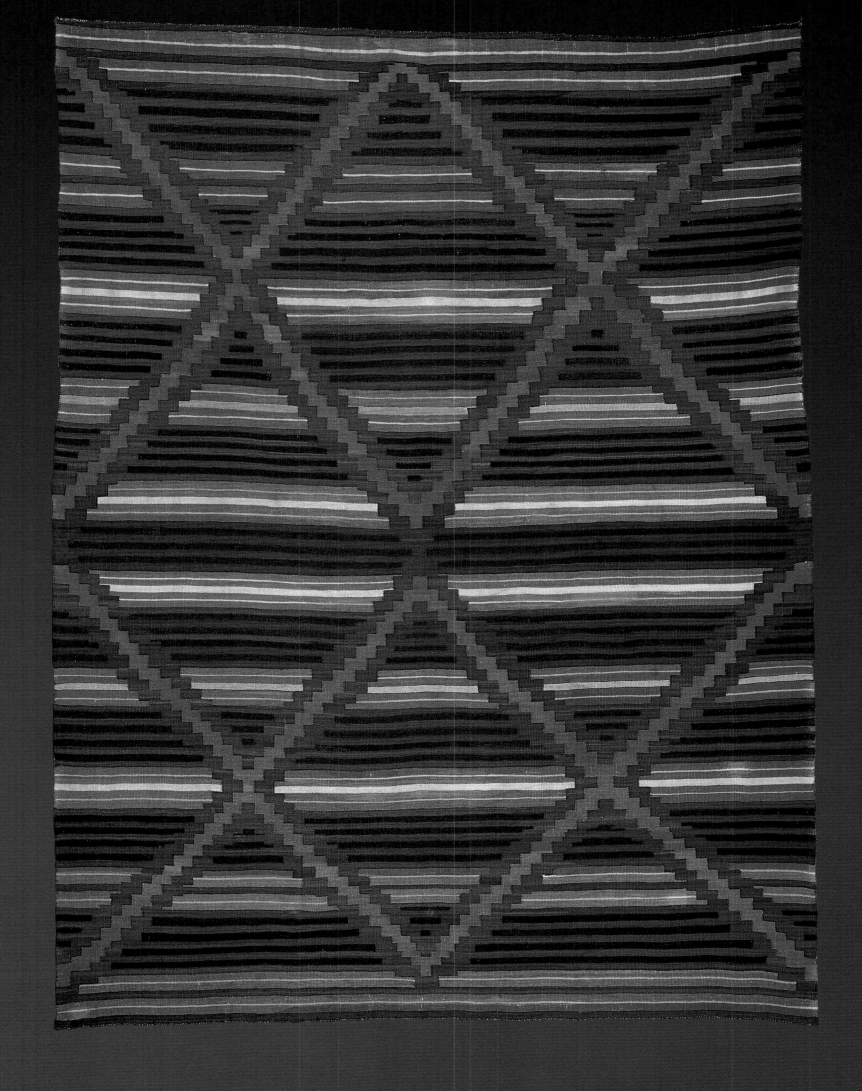

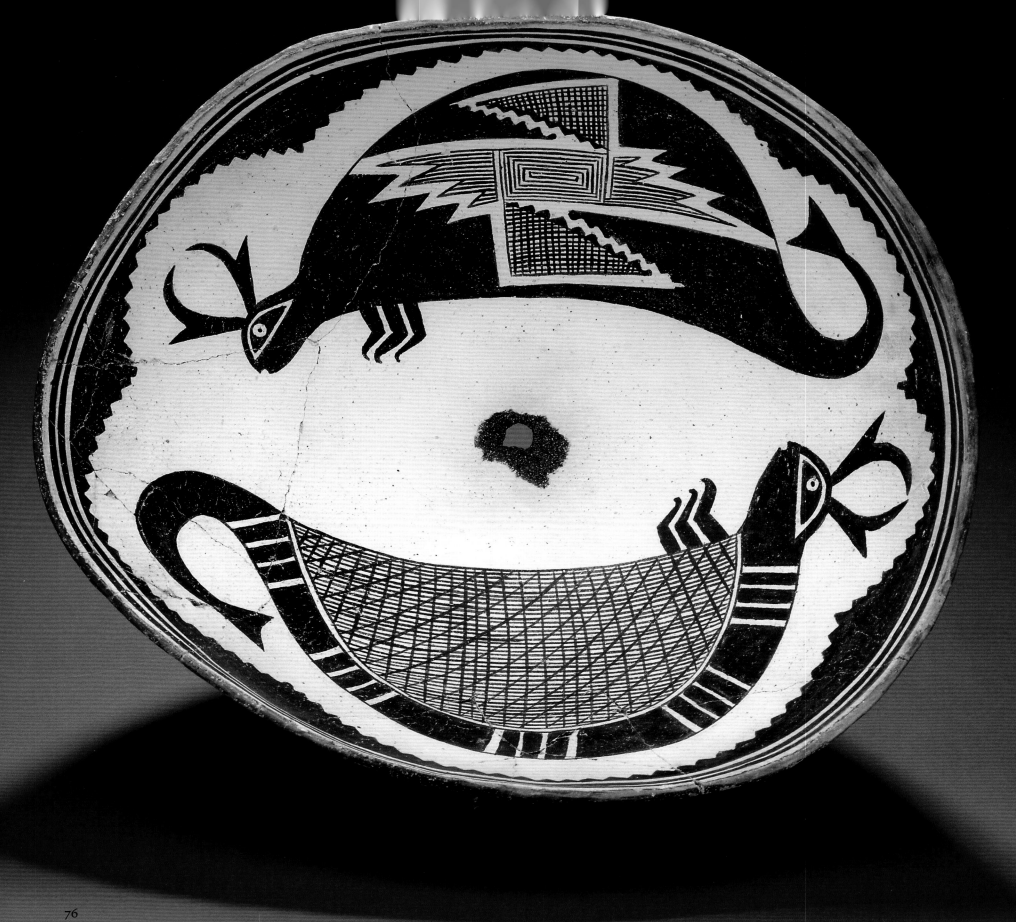

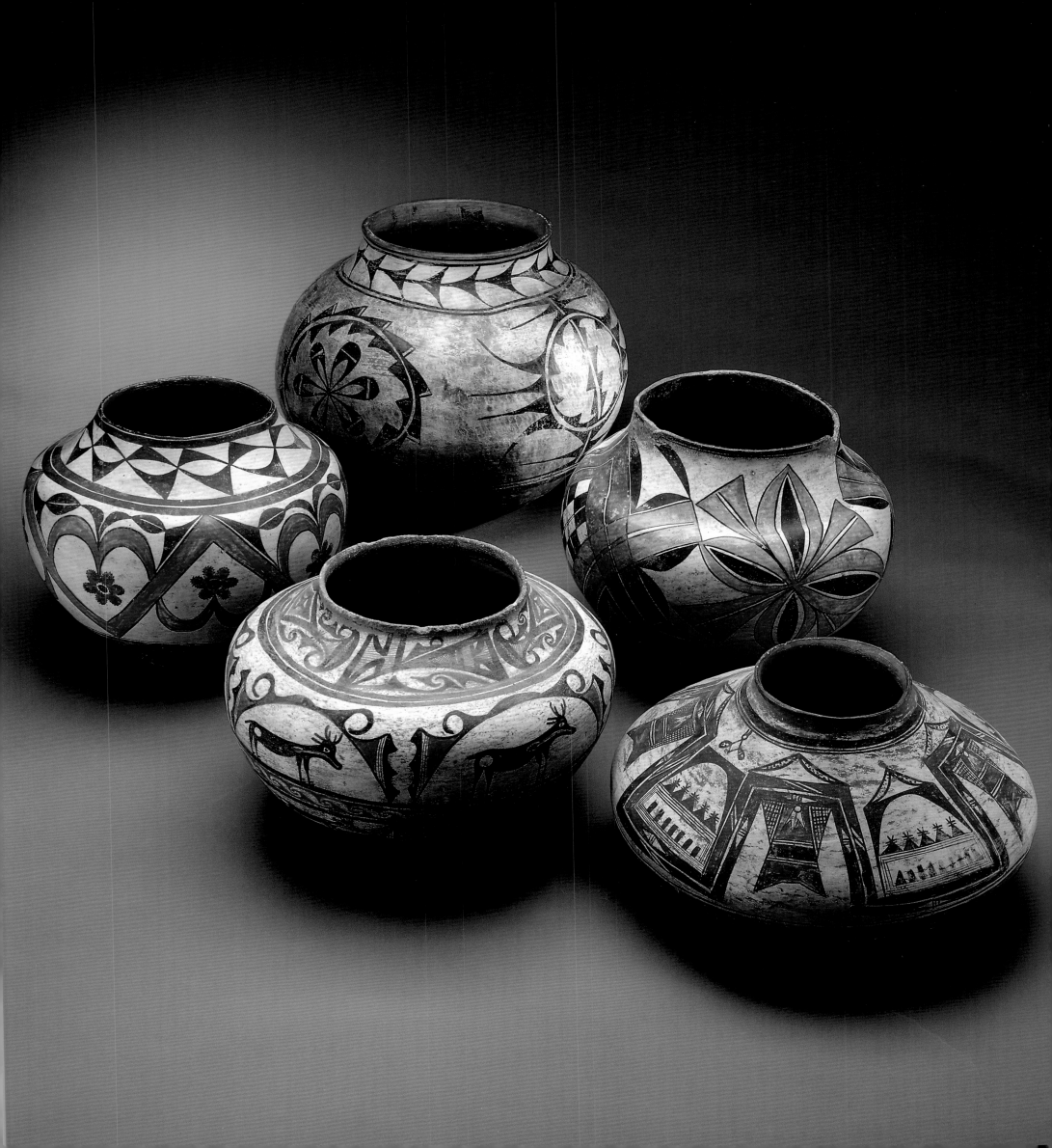

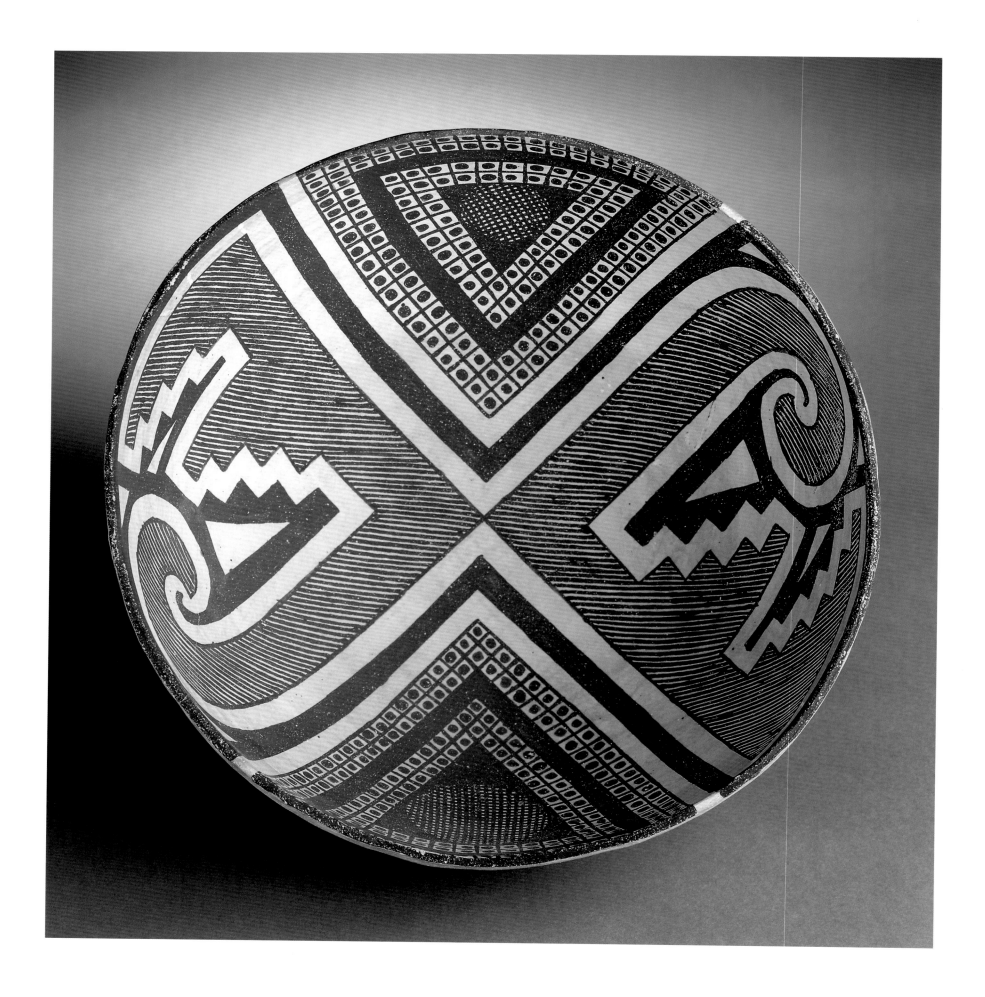

78

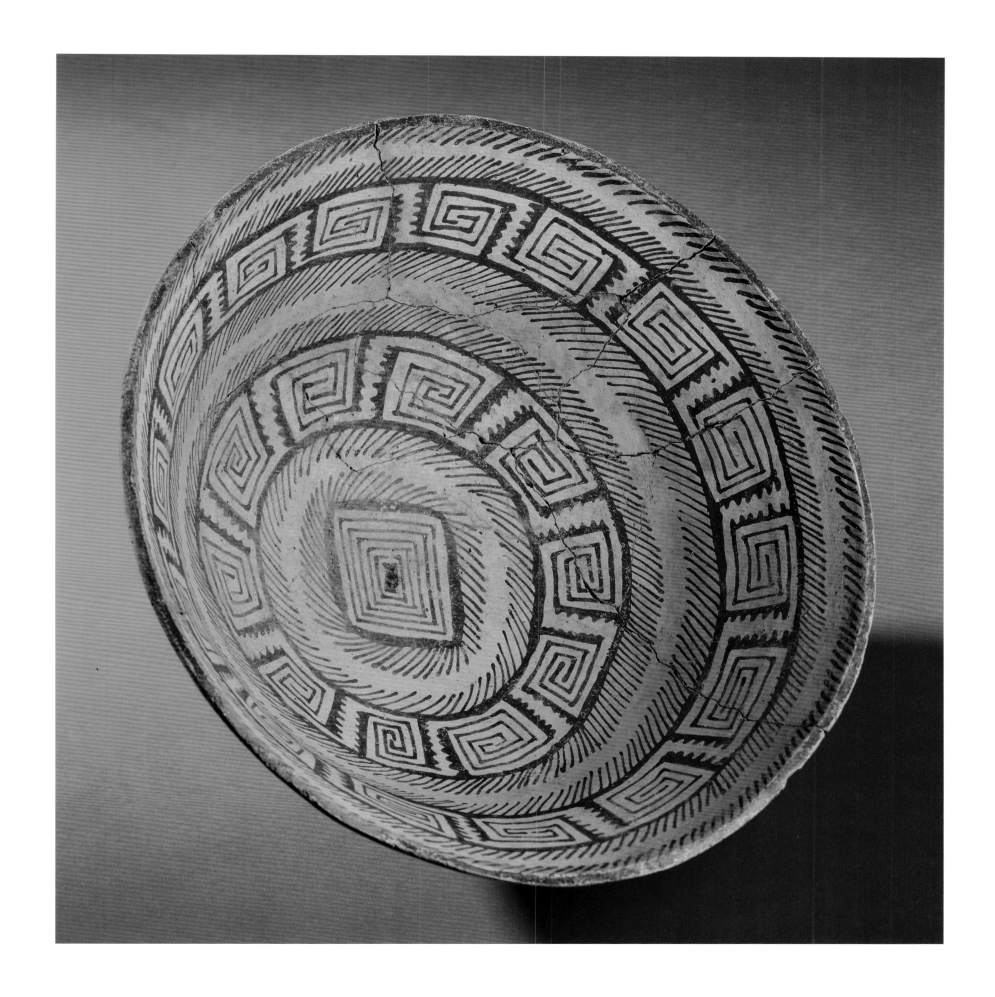

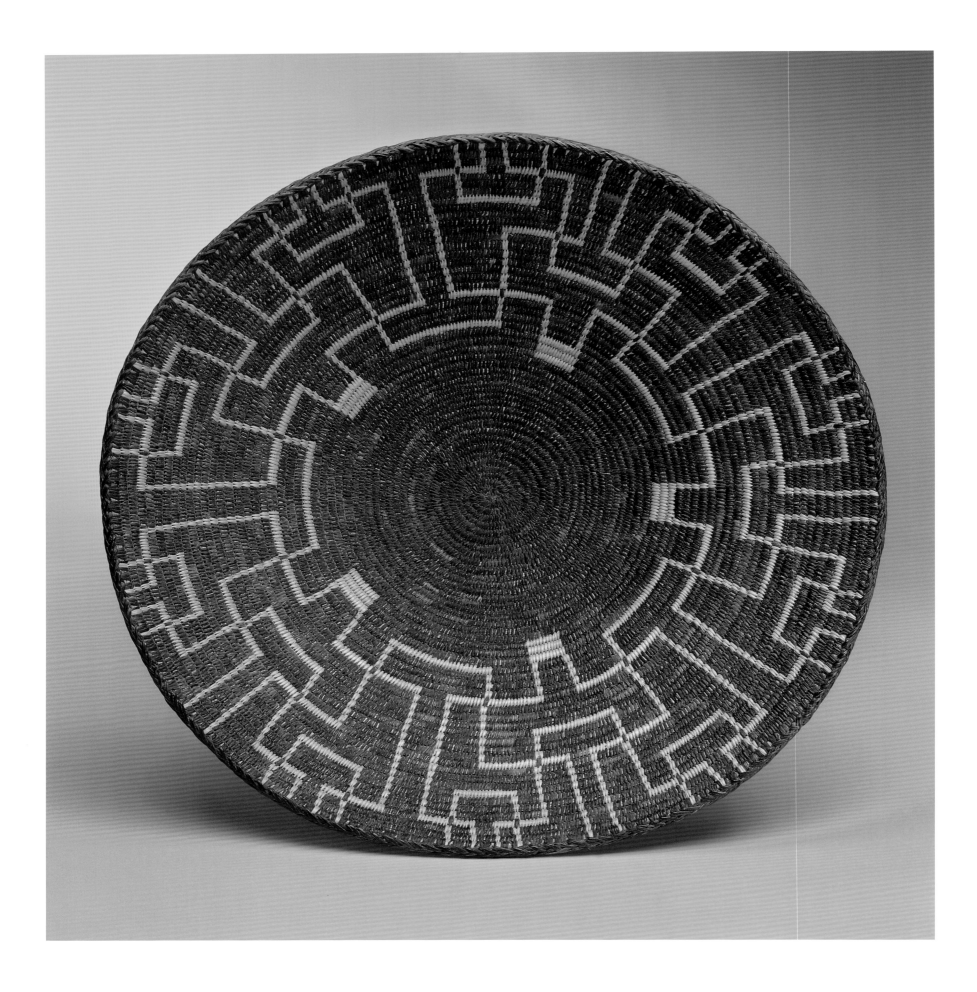

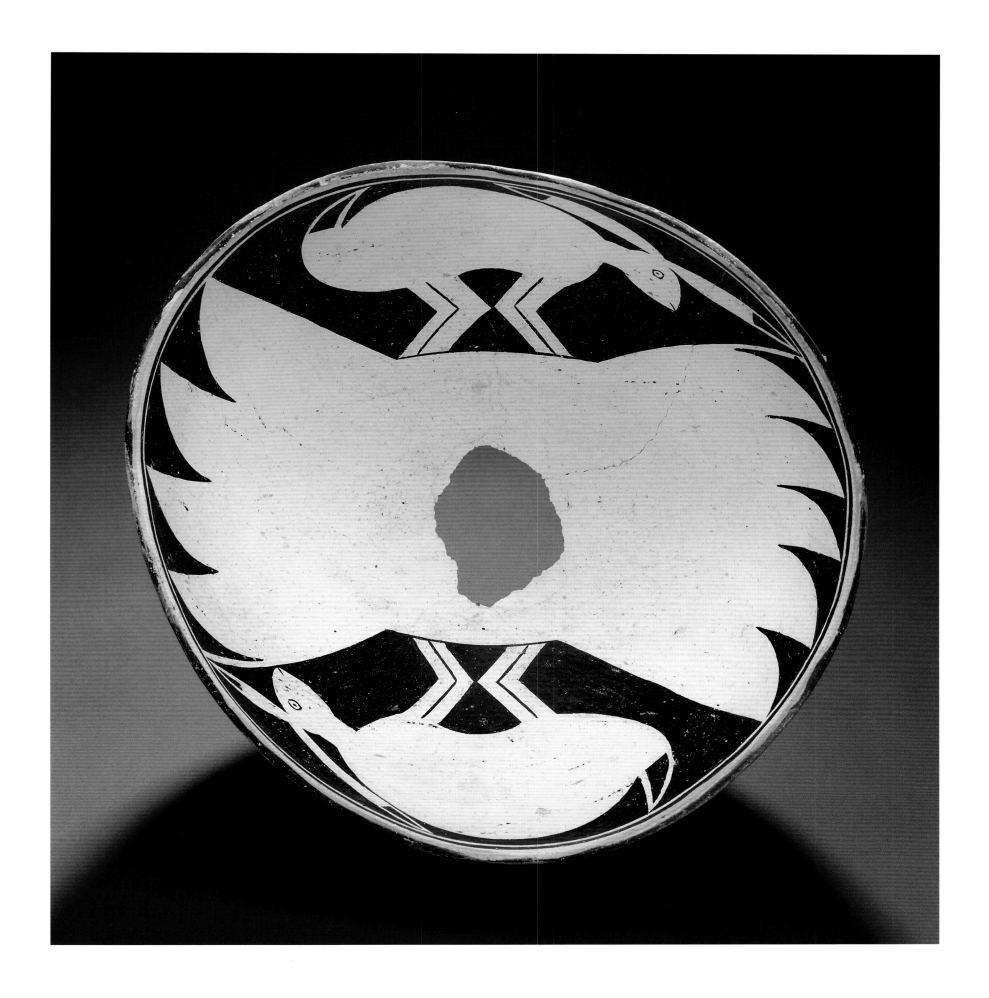

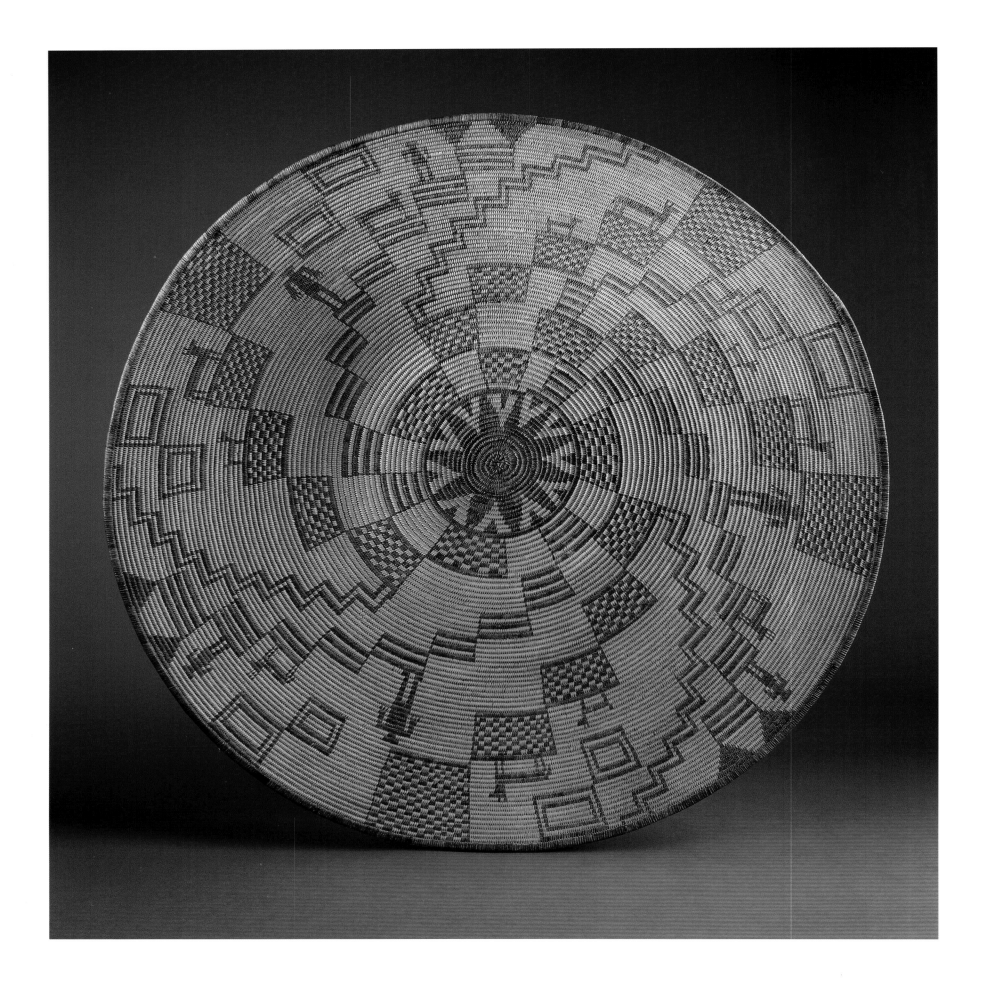

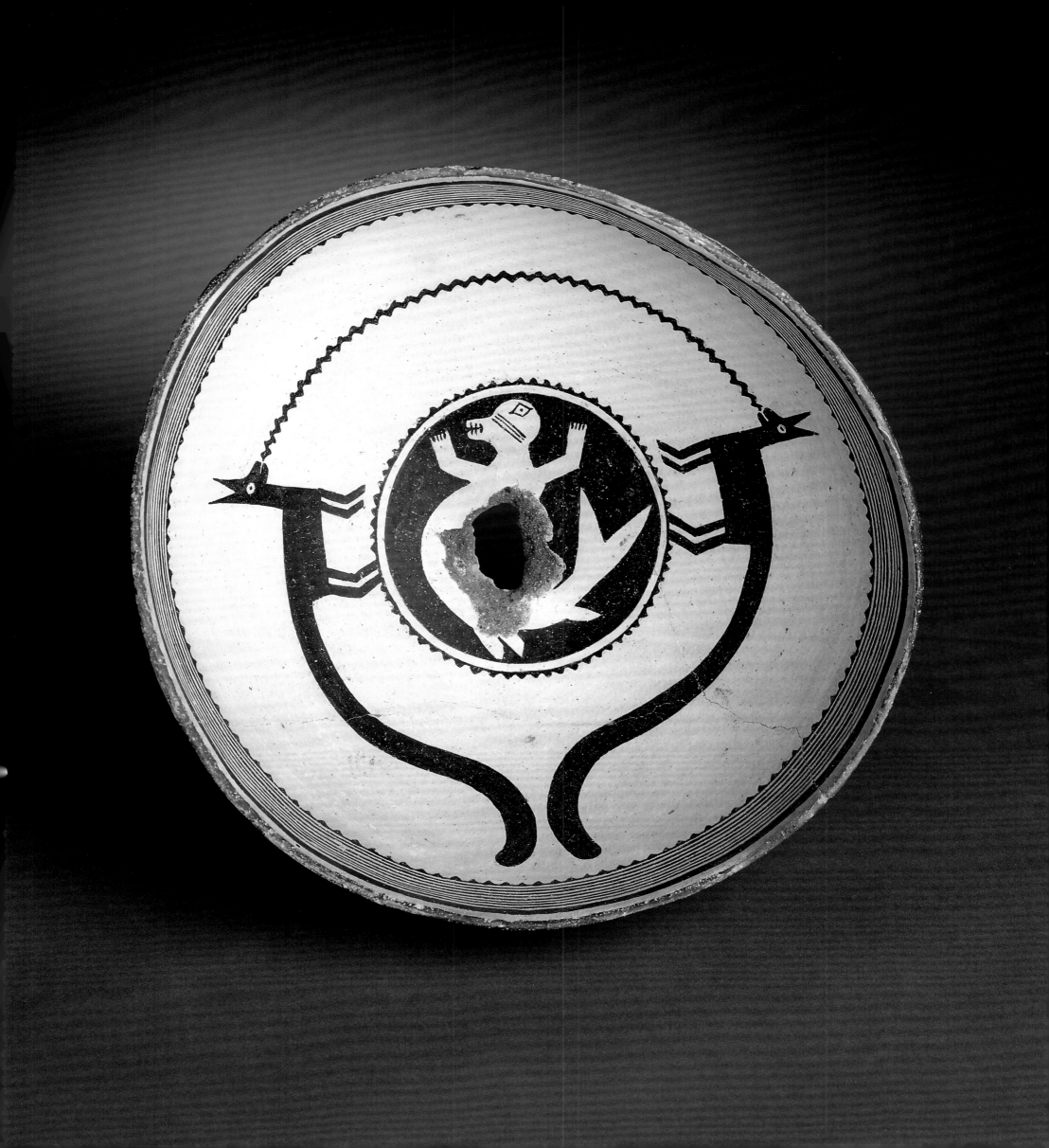

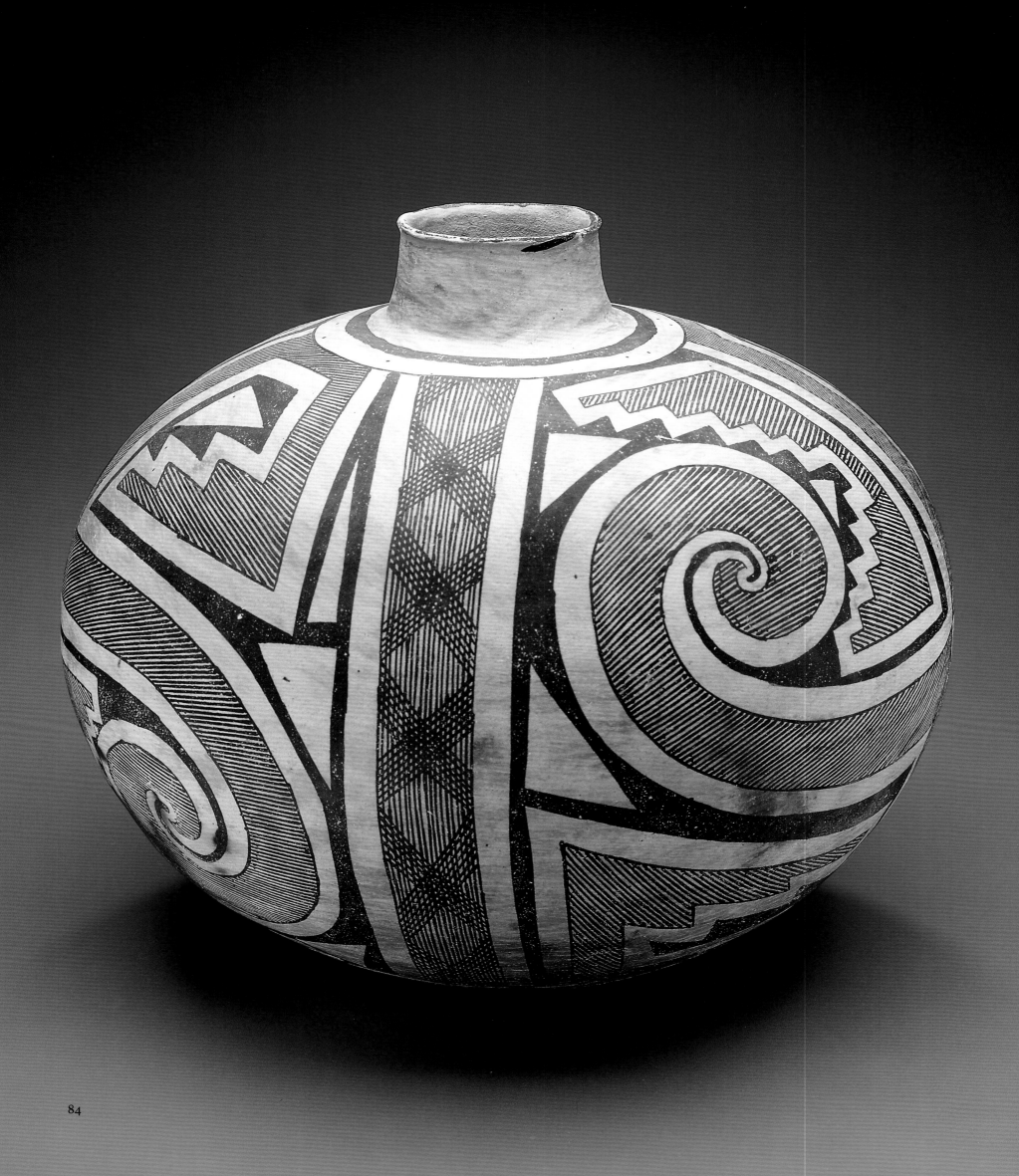

ALASKA AND

THE NORTHWEST COAST

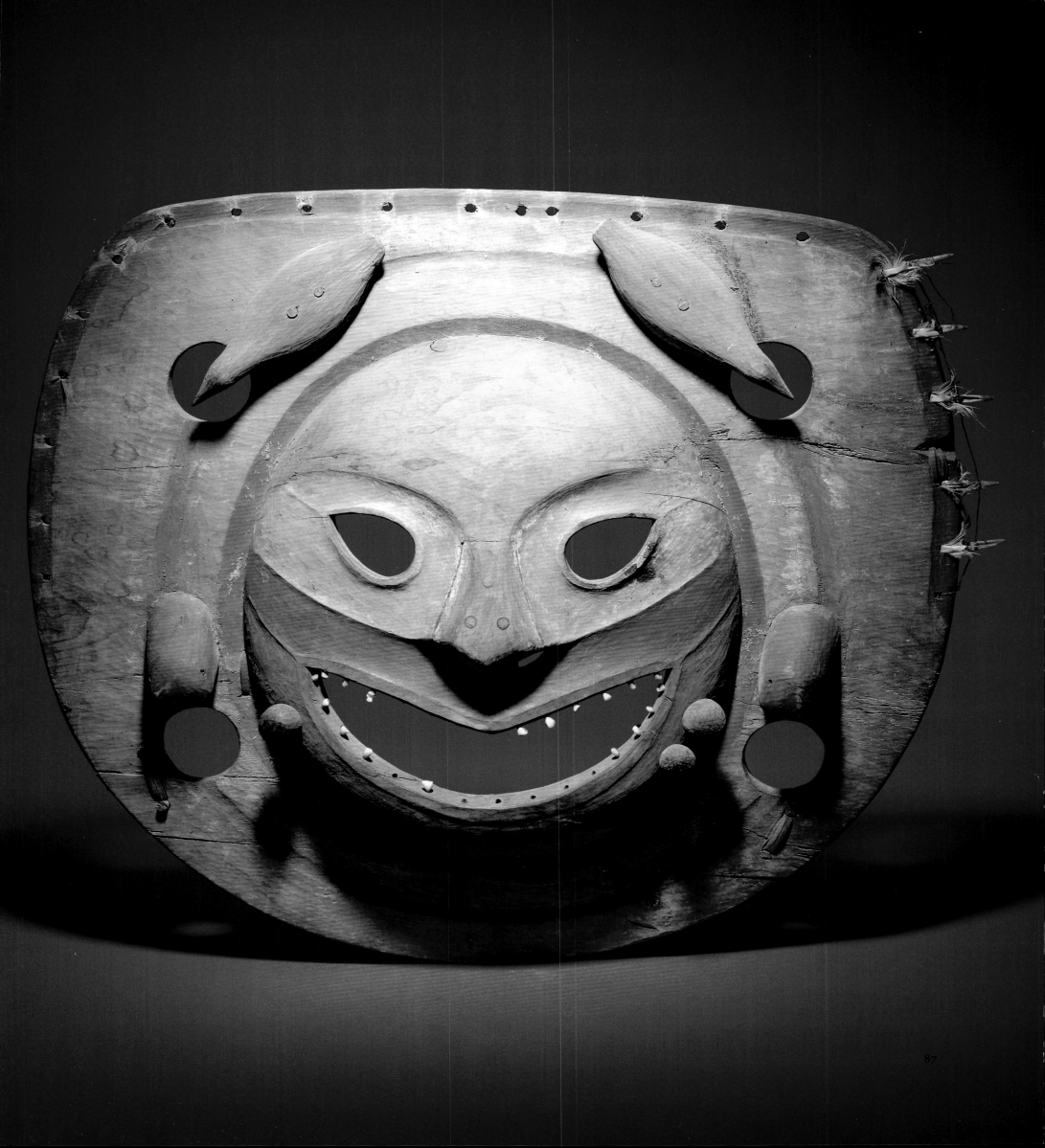

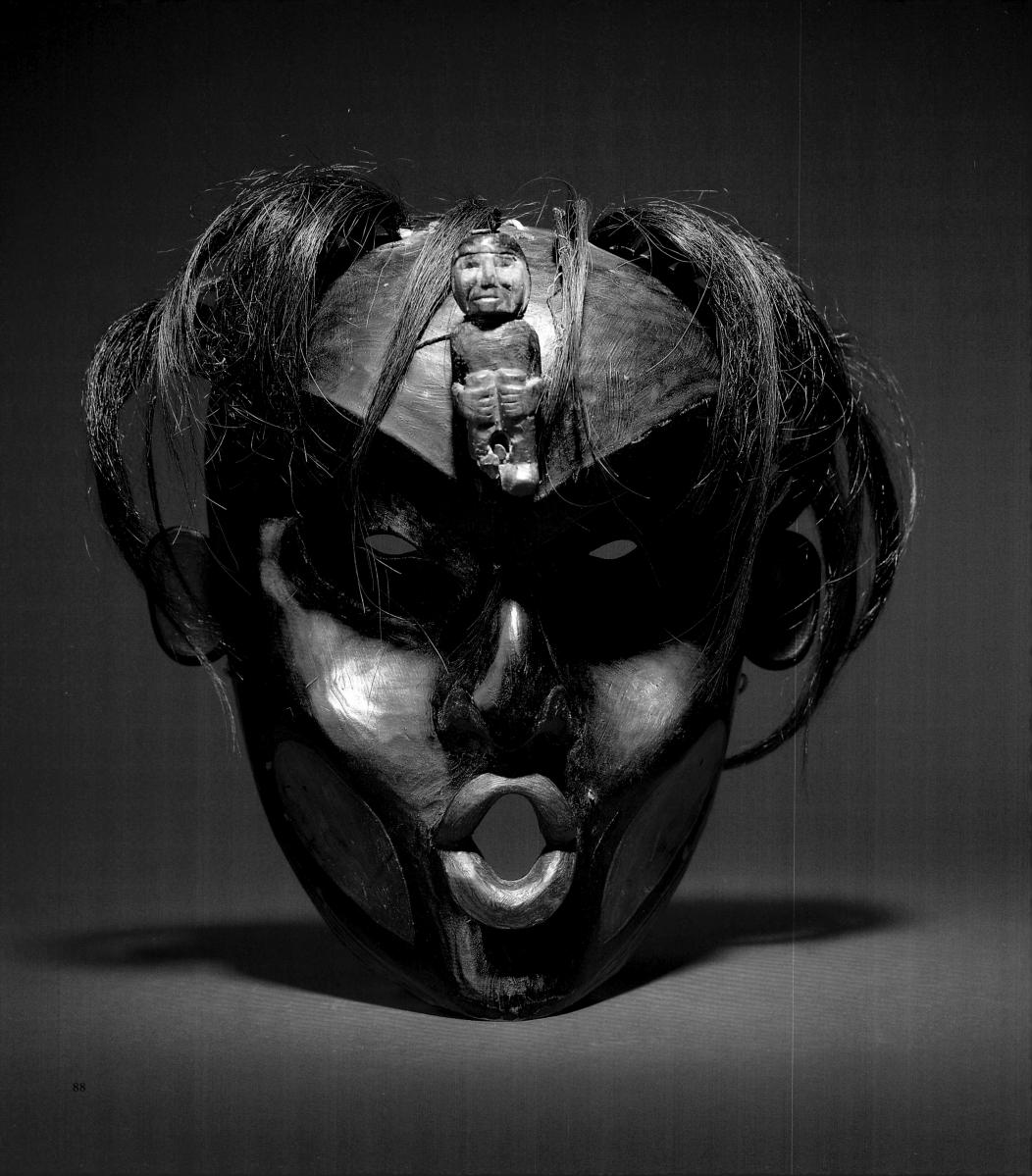

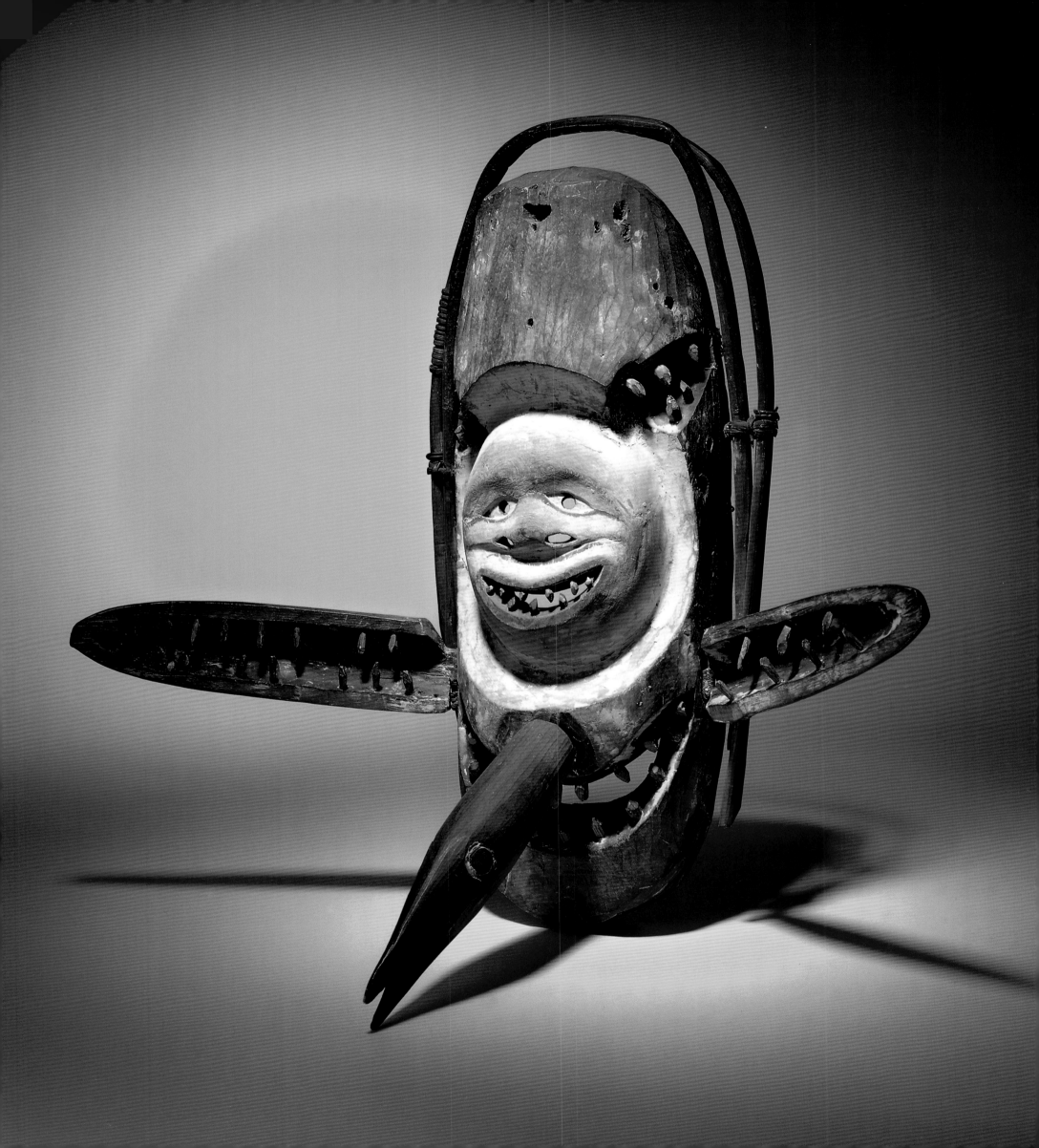

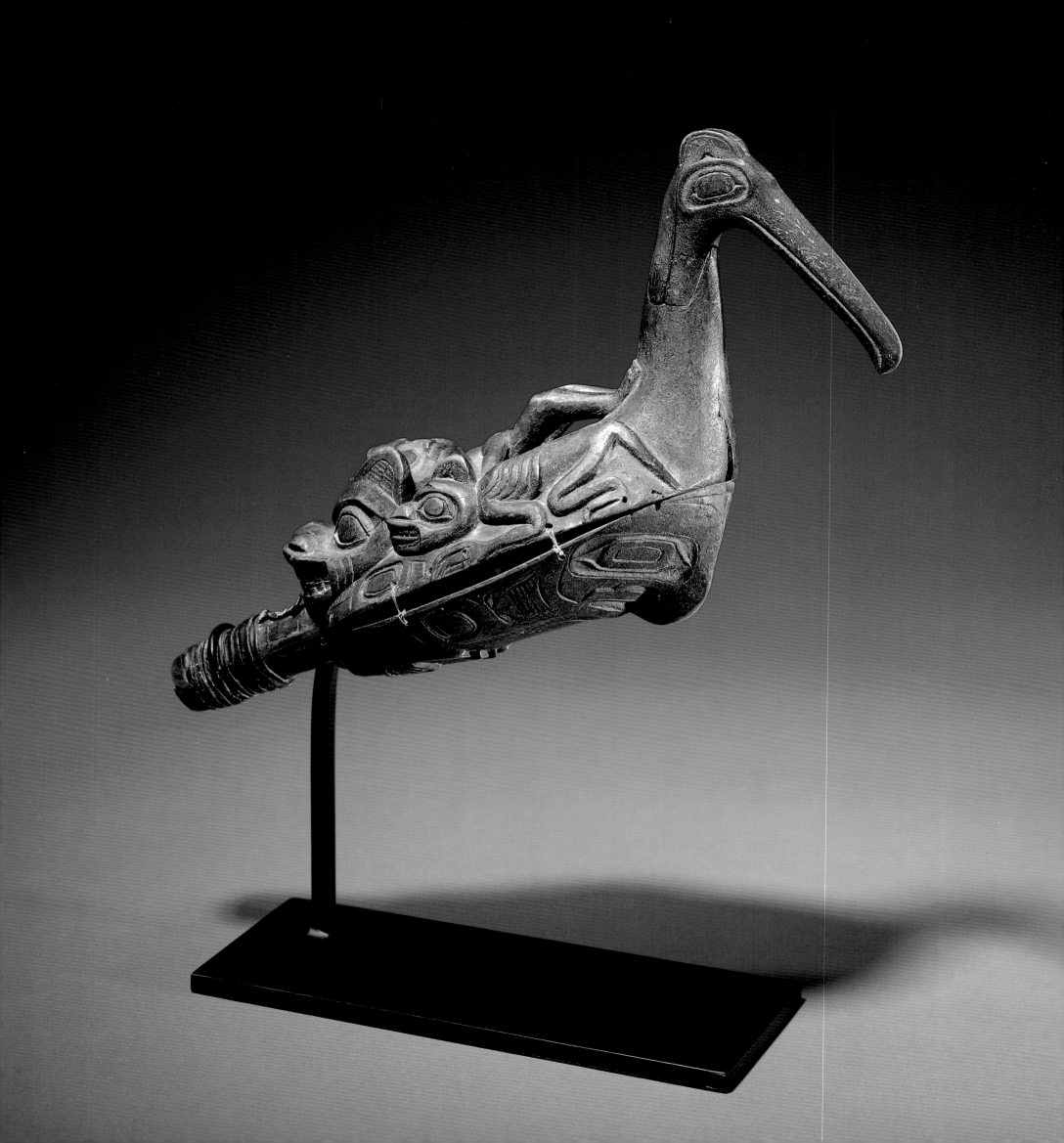

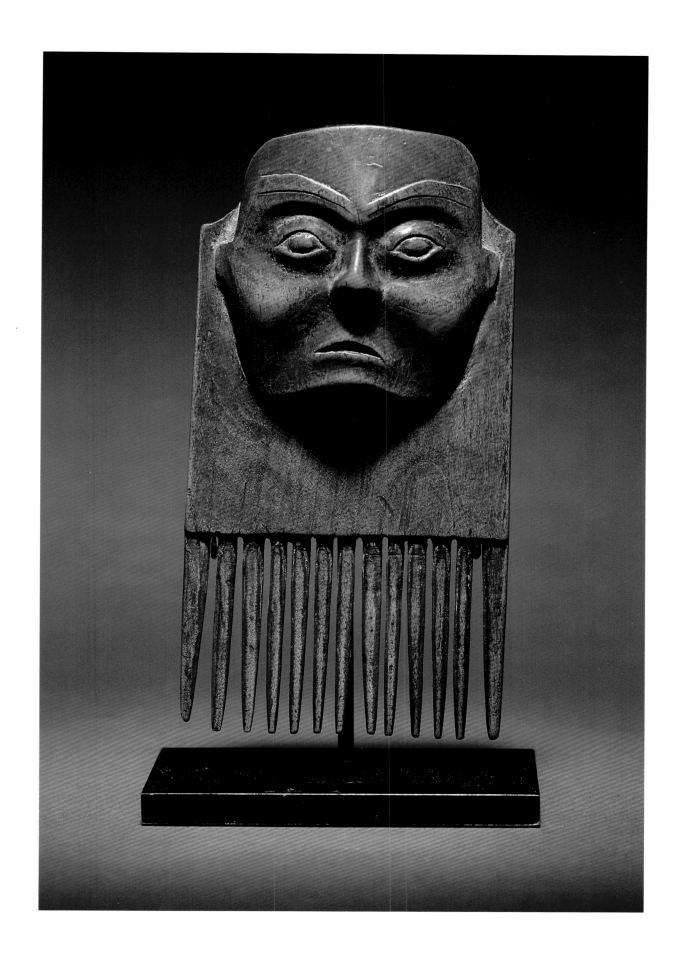

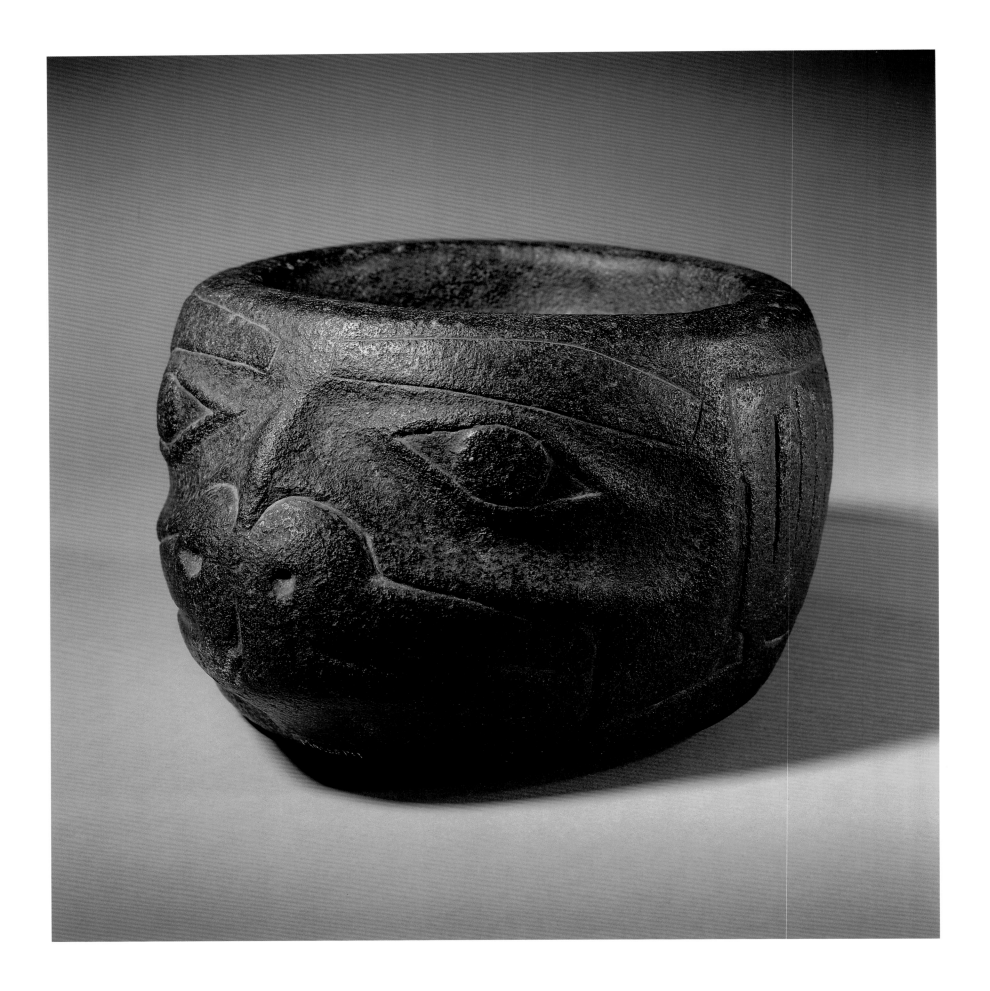

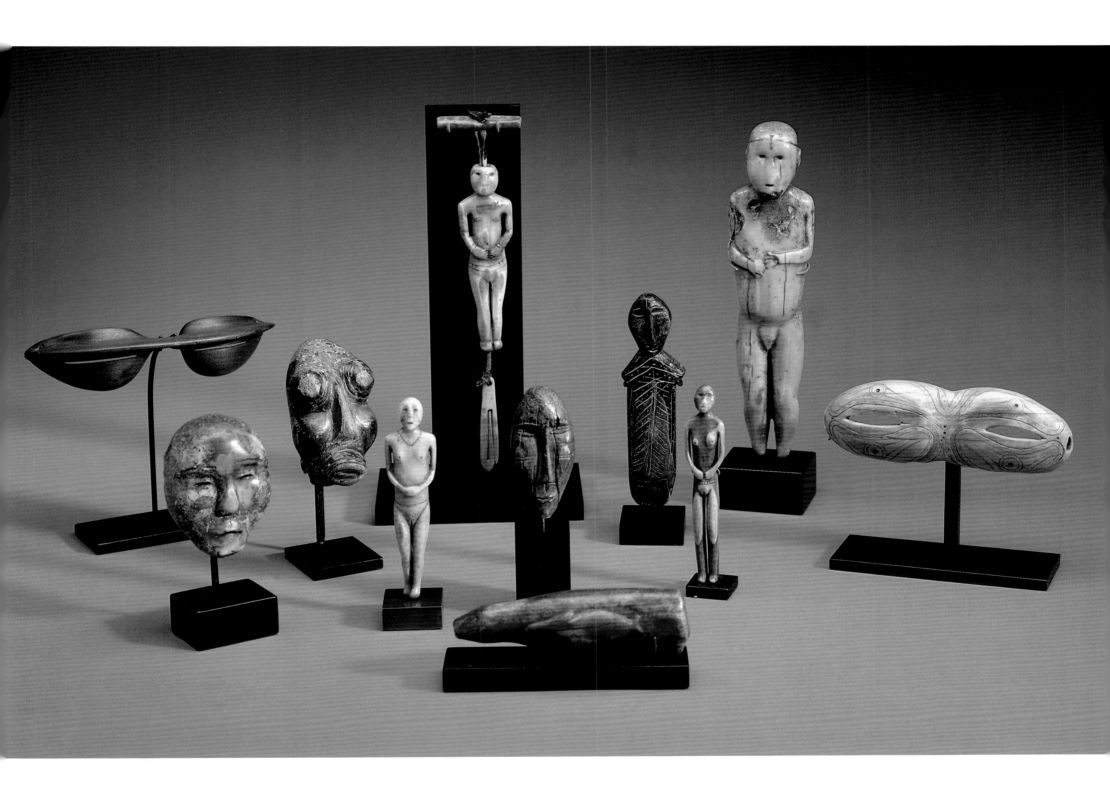

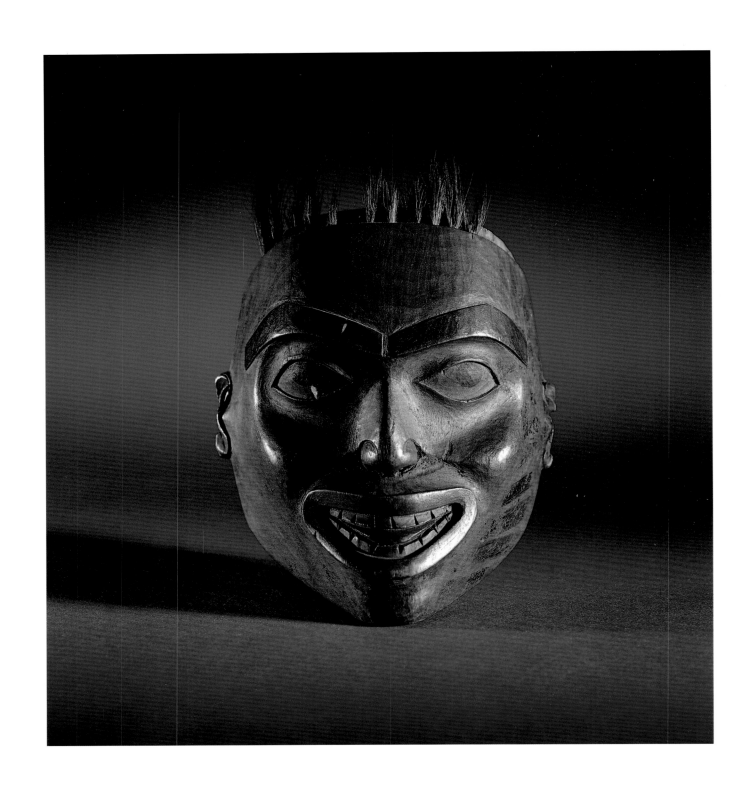

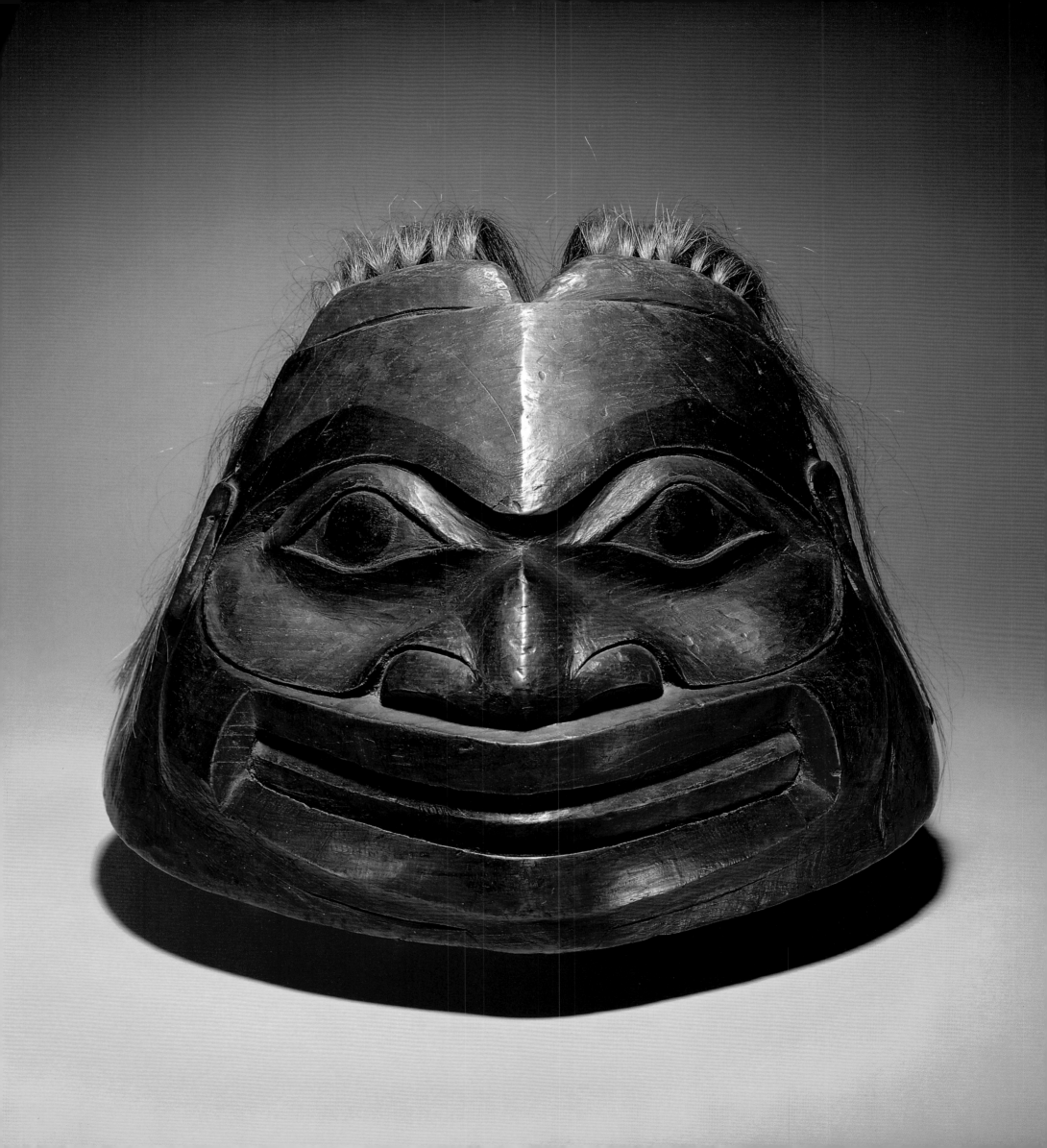

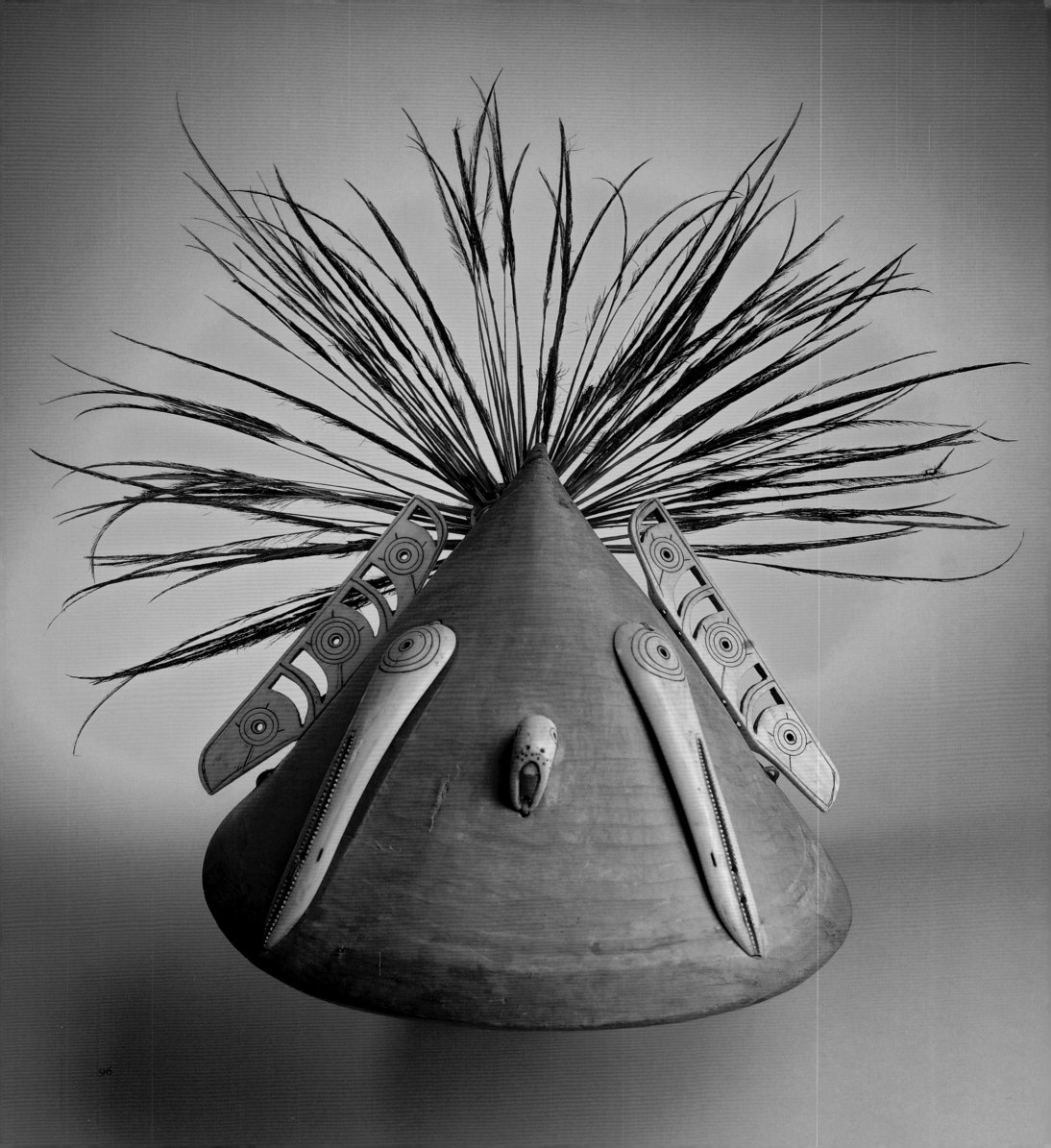

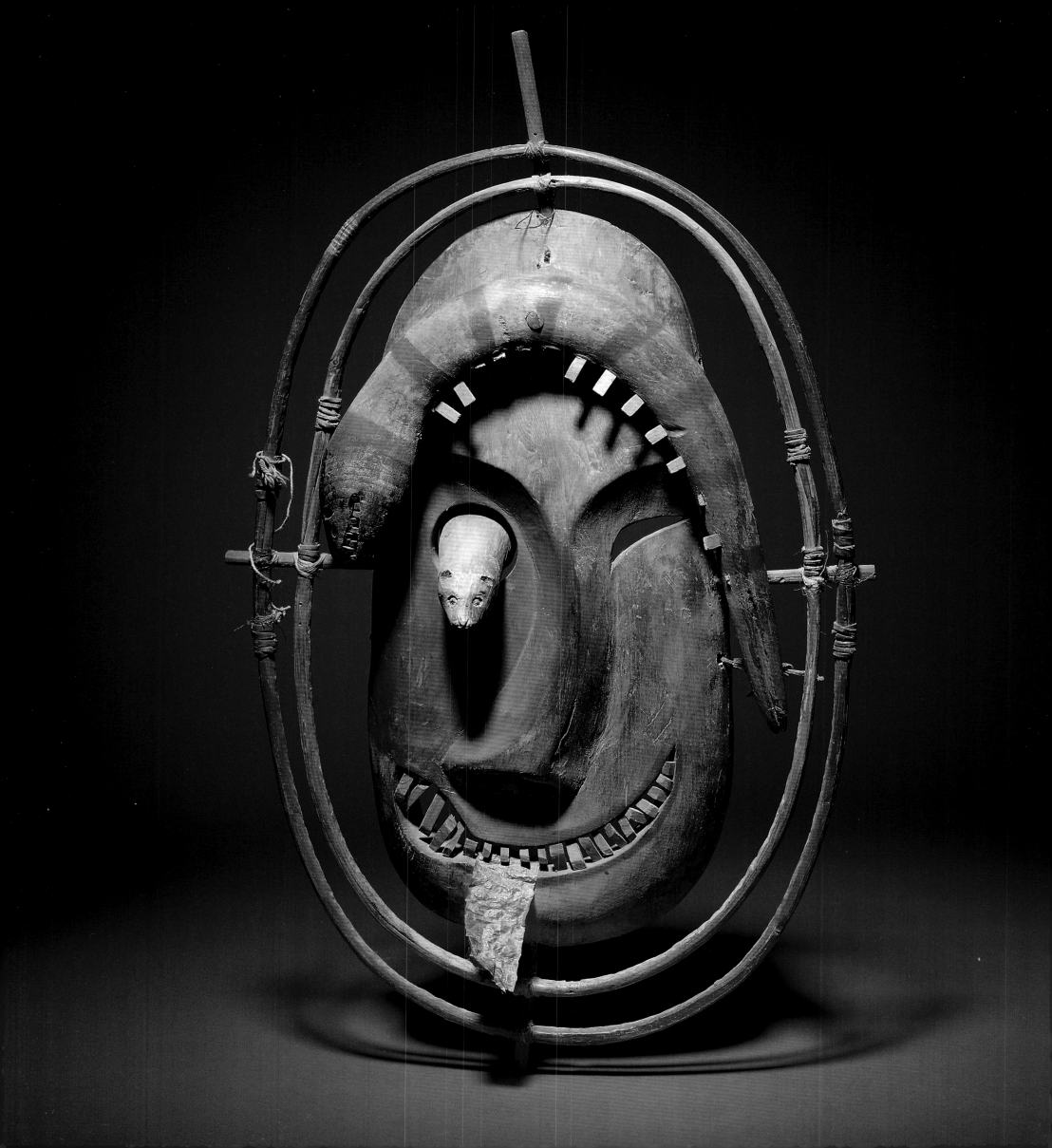

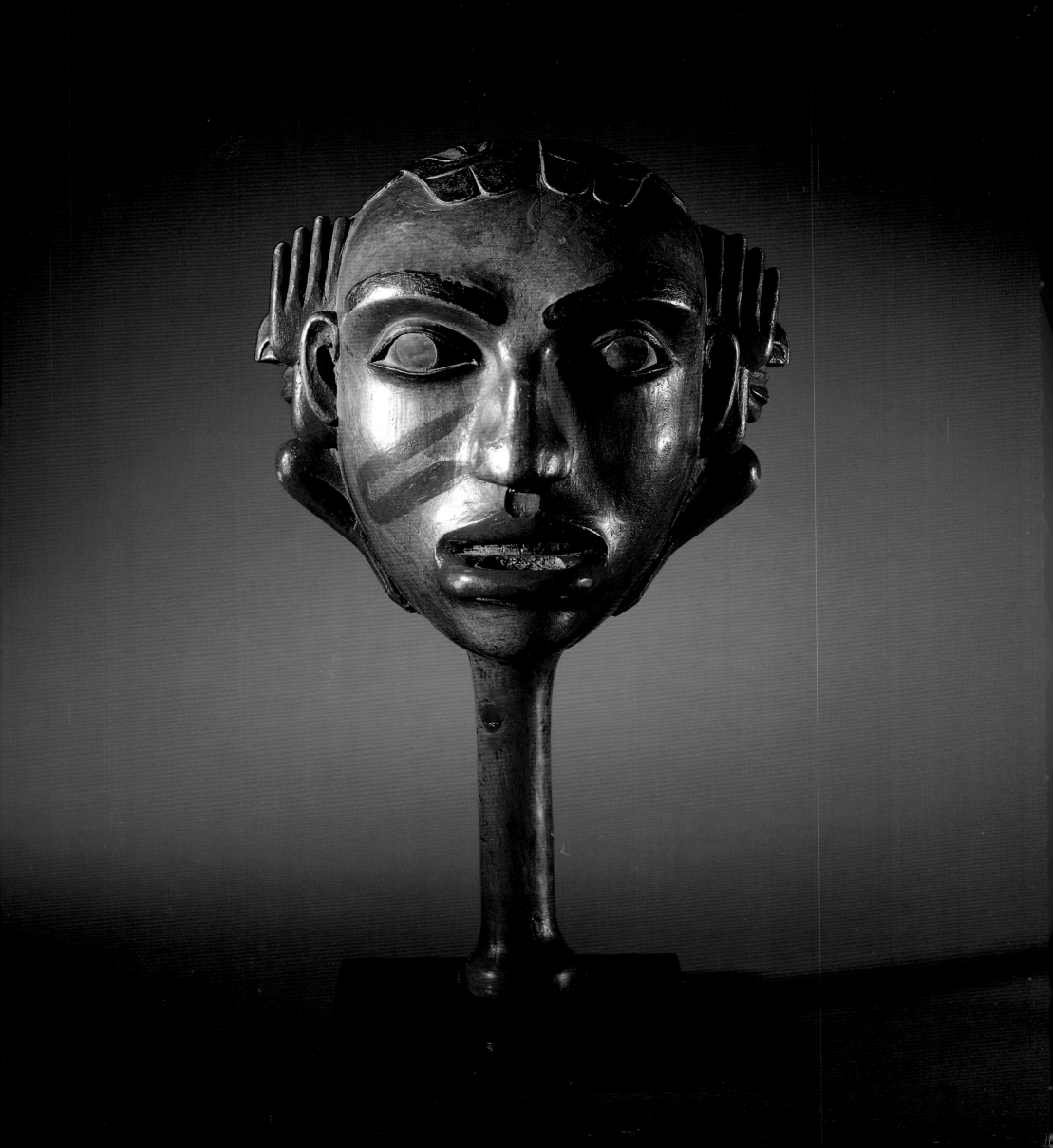

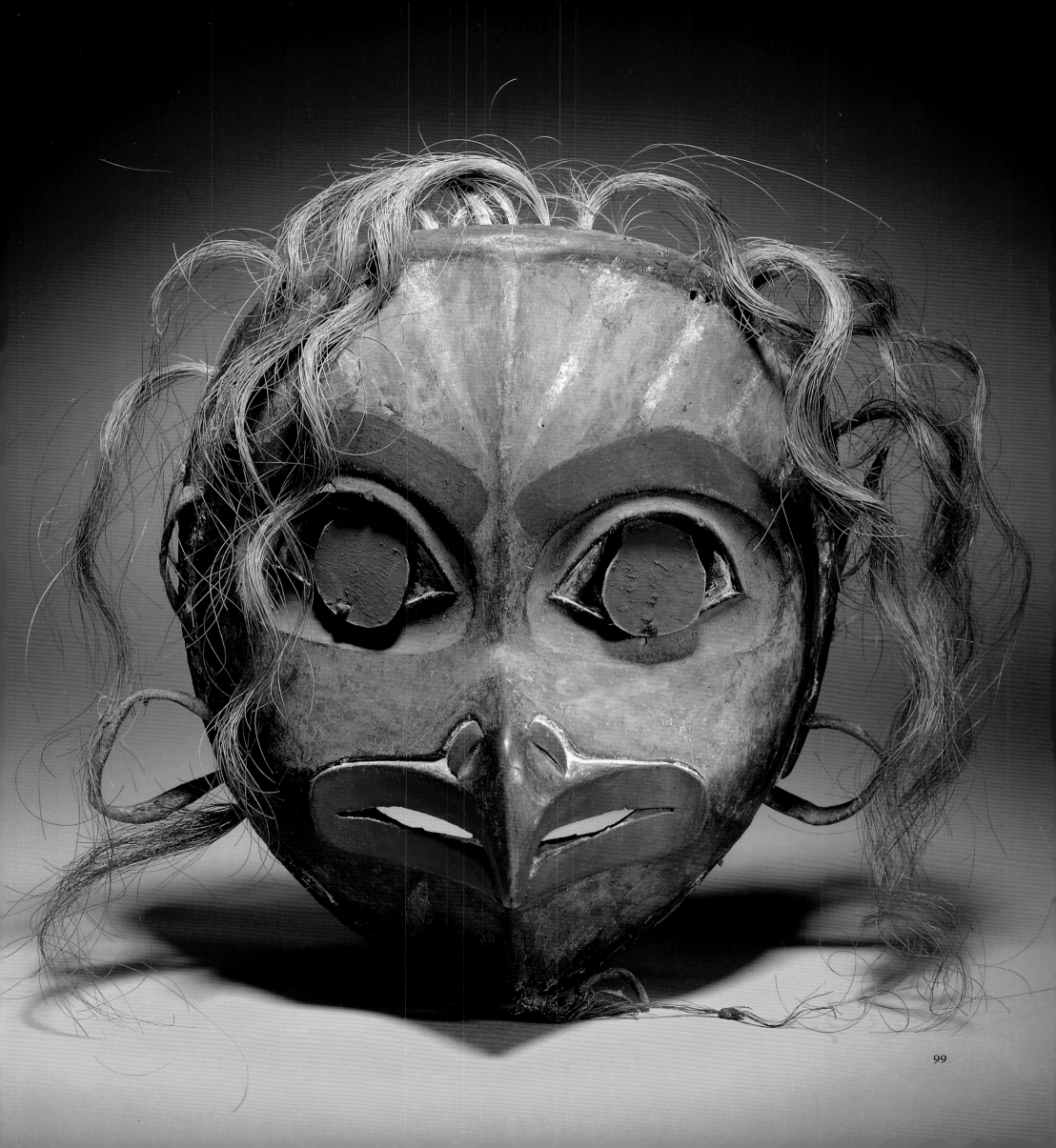

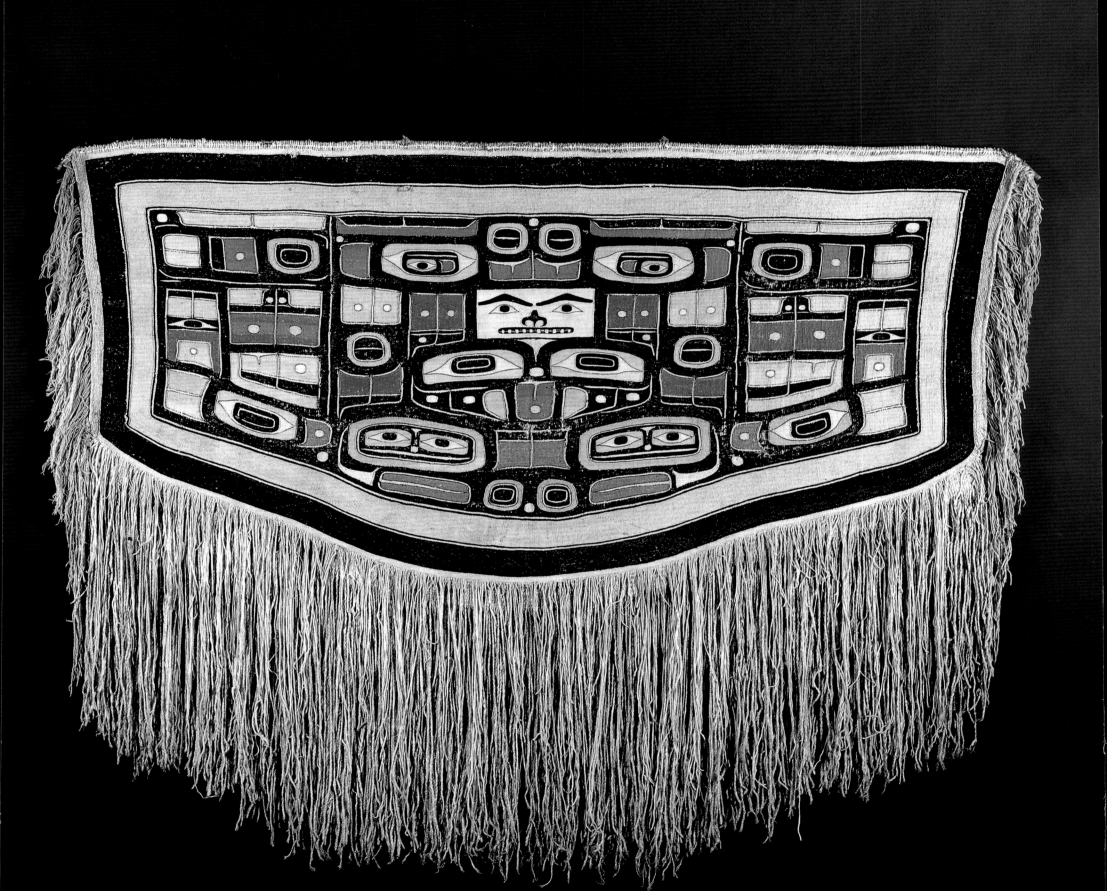

LIST OF PLATES AND
SELECTED BIBLIOGRAPHY

List of Plates

35. *Arapaho Painted Hide*
Colorado
1870
61 inches (length)

36. *Southern Cheyenne Girl's Dress*
Oklahoma Territory
1875
33 inches (height)

THE SOUTHWEST
AND CALIFORNIA

38. *Anasazi Textile*
Arizona
1200
55¼ x 49¼ inches

39. *Snowflake Black-on-White Jar*
Arizona
1150–1275
11 inches (height)

40. *Mimbres Bowl*
New Mexico
1000–1150
7 inches (diameter)

41. *Yavapai Basket*
Arizona
1890
20 inches (height)

42. *Socorro Black-on-White Jar*
New Mexico
1150–1275
13¼ inches (height)

43. *Navajo Second-Phase Chief Blanket*
Arizona
1860
56¾ x 75 inches

44. *Jeddito Bowl*
Arizona
1200–1450
9¼ inches (diameter)

45. *Socorro Black-on-White Bowl*
New Mexico
1150–1275
12¾ inches (diameter)

46. *Navajo Third-Phase Chief Blanket*
Arizona
1870
56½ x 70 inches

47. *Apache Basket*
Arizona
1905
29 inches (height)

48. *Socorro Black-on-White Jar*
New Mexico
1150–1275
13¾ inches (height)

49. *Three Hopi Kachina Dolls*
(left to right):

A. *Hopi Kachina Doll*
Arizona
1900
6¼ inches (height)

B. *Hopi Kachina Doll*
Arizona
1870
14¼ inches (height)

C. *Hopi Kachina Doll*
Arizona
1900
9¼ inches (height)

50. *Pima Basketry Tray*
Arizona
1900
30½ inches (diameter)

51. *Jeddito Bowl*
Arizona
1200–1450
8 inches (diameter)

52. *Powhoge Polychrome Pot*
(Tesuque or
San Ildefonso Pueblo)
New Mexico
1850
18 inches (height)

53. *Zuni Pueblo Kachina Doll*
New Mexico
1910
16 inches (height)

54. *Mimbres Bowl*
New Mexico
1000–1150
9 inches (diameter)

55. *Apache Basket*
Arizona
1890
27 inches (height)

56. *Chaco Black-on-White Jar*
New Mexico
950–1150
13¾ inches (height)

57. *Navajo Serape*
Arizona
1850
56 x 82¼ inches

58. *Socorro Black-on-White Bowl*
New Mexico
1150–1275
11½ inches (diameter)

59. *Socorro Black-on-White Jar*
New Mexico
1150–1275
14½ inches (height)

60. *Four-Mile Bowl*
Arizona
1300–1450
9½ inches (diameter)

61. *Jeddito Bowl*
Arizona
1250–1500
9¼ inches (diameter)

62. *Mimbres Bowl*
New Mexico
1000–1150
11¼ inches (diameter)

63. *Socorro Black-on-White Jar*
New Mexico
1150–1275
15 inches (height)

64. *Yokuts Basketry Gambling Tray*
California
1900
27 inches (diameter)

65. *Socorro Black-on-White Jar*
New Mexico
1150–1275
14½ inches (height)

66. *Socorro Black-on-White Bowl*
New Mexico
1150–1275
13 inches (diameter)

67. *Mimbres Bowl*
New Mexico
1000–1150
9 inches (diameter)

68. *Seven Mesa Verde Mugs*
(clockwise from top left):

A. *Mesa Verde Effigy Mug*
Colorado
1100–1300
4¼ inches (height)

B. *Mesa Verde Mug*
Colorado
1100–1300
3¾ inches (height)

C. *Mesa Verde Mug*
Colorado
1100–1300
4¼ inches (height)

D. *Mesa Verde Mug*
Colorado
1100–1300
3½ inches (height)

E. *Mesa Verde Mug*
Colorado
1100–1300
3 inches (height)

F. *Mesa Verde Mug*
Colorado
1100–1300
3¾ inches (height)

G. *Mesa Verde Mug* (center)
Colorado
1100–1300
3¾ inches (height)

69. *Sikyatki Jar*
Arizona
1400–1625
8½ inches (height)

70. *Sikyatki Canteen*
Arizona
1400–1625
11 inches (diameter)

71. *Pomo Basket*
California
1890
18 inches (diameter)

72. *Pima Basketry Tray*
Arizona
1900
26¼ inches (diameter)

73. *Yokuts Basket*
California
1900
10½ inches (height)

74. *Pomo Basket*
California
1900
14¼ inches (diameter)

75. *Navajo Serape*
Arizona
1860
57 x 78 inches

76. *Mimbres Bowl*
New Mexico
1000–1150
14½ inches (diameter)

77. *Five Historic Pots*
(counterclockwise from left):

A. *Laguna Pueblo Pot*
New Mexico
1885
9¾ inches (height)

B. *Zuni Pueblo Pot*
New Mexico
1875
8½ inches (height)

C. *Hopi Pueblo Pot*
Arizona
1890
7¼ inches (height)

D. *Acoma Pueblo Pot*
New Mexico
1875
10 inches (height)

E. *Powhoge Polychrome Pot*
(Tesuque or
San Ildefonso Pueblo)
New Mexico
1830
12¾ inches (height)

78. *Socorro Black-on-White Bowl*
New Mexico
1150–1275
11¼ inches (diameter)

79. *Hohokam Bowl*
Arizona
700–900
13¼ inches (diameter)

80. *Pima Basketry Tray*
Arizona
1900
16¾ inches (diameter)

81. *Mimbres Bowl*
New Mexico
1000–1150
12½ inches (diameter)

82. *Apache Basketry Tray*
Arizona
1890
23 inches (diameter)

83. *Mimbres Bowl*
New Mexico
1000–1150
9⅞ inches (diameter)

84. *Socorro Black-on-White Jar*
New Mexico
1150–1275
14½ inches (height)

ALASKA AND
THE NORTHWEST COAST

87. *Inuit Mask*
Alaska
1880
19 inches (height)

88. *Kwakiutl Mask*
British Columbia
1875
11 inches (height)

89. *Inuit Mask*
Alaska
1885
18 inches (height)

90. *Tlingit Rattle*
Alaska
1825
12 inches (length)

91. *Tsimshian Comb*
British Columbia
1875
11 inches (height)

92. *Haida Stone Bowl*
British Columbia
before 1770
5¼ inches (height)

93. *Eleven Inuit Carvings*
(left to right):

A. *Wooden Snow Goggles*
Alaska
1880
6 inches (width)

B. *Old Bering Sea II Ivory Head*
Alaska
100–300
3¾ inches (height)

C. *Okvik Ivory Head*
Alaska
200 B.C.– A.D. 100
4 inches (height)

D. *Ivory Figure*
Alaska
1400
4¾ inches (height)

E. *Ivory Needle Case*
Alaska
1400
9½ inches (height)

F. *Okvik Ivory Head*
Alaska
200 B.C.– A.D. 100
3 inches (height)

G. *Old Bering Sea II Ivory Bear*
Alaska
100–300
4¾ inches (length)

H. *Okvik Ivory Figure*
Alaska
200 B.C.– A.D. 100
5¾ inches (height)

I. *Ivory Female Figure*
Alaska
1300
4¾ inches (height)

J. *Old Bering Sea II Figure*
Alaska
100–300
9 inches (height)

K. *Old Bering Sea II
Ivory Snow Goggles*
Alaska
100–300
6 inches (length)

94. *Tlingit Maskette*
Alaska
1850
5 inches (height)

95. *Tlingit War Helmet*
Alaska
1825
7 inches (height)

96. *Inuit Hunting Hat*
Alaska
1860
10½ inches (height)

97. *Inuit Mask*
Alaska
1880
19½ inches (height)

98. *Haida Rattle*
British Columbia
1860
9¾ inches (height)

99. *Tlingit Mask*
Alaska
1860
9½ inches (height)

100. *Tsimshian Blanket*
British Columbia
1820
66 inches (width)

Selected Bibliography

Coe, Ralph T. *Sacred Circles: 2000 Years of North American Indian Art* (exh. cat., Hayward Gallery, London/Arts Council of Great Britain, 1977)

Fienup-Riordan, Ann. *The Living Tradition of Yup'ik Masks: Agayuliyararput, Our Way of Making Prayer* (University of Washington Press, Seattle and London, 1996)

Fitzhugh, William W.; and Aron Crowell. *Crossroads of Continents: Cultures of Siberia and Alaska* (exh. cat., Smithsonian Institution Press, Washington, D.C., and London, 1988)

Holm, Bill; and Bill Reid. *Indian Art of the Northwest Coast: A Dialogue on Craftsmanship and Aesthetics* (exh. cat., Institute for the Arts, Rice University, Houston/University of Washington Press, Seattle and London, 1975)

Holstein, Philip M.; and Donnelley Erdman. *Enduring Visions: 1000 Years of Southwestern Indian Art* (exh. cat., Aspen Center for the Visual Arts, Colorado, 1979)

Maurer, Evan M. *The Native American Heritage: A Survey of North American Indian Art* (exh. cat., The Art Institute of Chicago, 1977)

Maurer, Evan M. *Visions of the People: A Pictorial History of Plains Indian Life* (exh. cat., The Minneapolis Institute of Arts/University of Washington Press, Seattle and London, 1992)

McCoy, Ron. *With Beauty All Around Me: Art of the Native Southwest* (exh. cat., Scottsdale Center for the Arts, Arizona, 1998)

Penney, David W. *Art of the American Indian Frontier: The Chandler-Pohrt Collection* (University of Washington Press, Seattle and London, 1992)

Wardwell, Allen. *Tangible Visions: Northwest Coast Indian Shamanism and Its Art* (The Monacelli Press with the Corvus Press, New York, 1996)

Wardwell, Allen, ed. *Native Paths: American Indian Art from the Collection of Charles and Valerie Diker* (exh. cat., The Metropolitan Museum of Art, New York, 1998)

108